Print Journalism

Print Journalism

A Complete Book of Journalism

Charanjit Ahuja; Bharat Hiteshi

PARTRIDGE

Print information available on the last page.

To order additional copies of this book, contact
Partridge India
000 800 10062 62
orders.india@partridgepublishing.com

www.partridgepublishing.com/india

Contents

Dedicated to the memory of respected
SHAGAN LAL AHUJA, a true Gandhian
who devoted his entire life for the cause of
poor and for women empowerment

"Some books are to be tasted, others to be swallowed, and some few to be chewed and digested" that is some books are to be read only in parts, others to be read without curiosity while some to be read wholly and with diligence and attention.

-Francis Bacon,
English Author and philosopher
(From Essay 'Of Studies')

Preface

WELCOME TO THE WORLD
OF JOURNALISM!

There are not many books that can serve as useful guides to the students of journalism and more so for students of Print Journalism. Nor are there adequate textbooks on journalism that meet the exact requirements of the students of journalism.

In fact as one involved in teaching of journalism alongside working as full time journalists, we felt that teaching at journalism schools was completely bereft of practice and there was more emphasis on theoretical part. As a result most students with degrees or diplomas from different journalism schools, colleges and universities felt out of place when selected to do the desk or reporting jobs. It is this lacuna that two of us with experience of working with national dailies, have tried to fill.

Realising this dilemma, many newspapers and television channels have set up their own in house journalism schools to provide hands on training to students. Students of these schools freely interact with working journalists, go on assignments with reporters, work late hours with desk staff to learn editing, designing and layout of newspapers and go through the rough and tumble of media.

This book is a complete book of Print Journalism as authors have devoted special chapters on Print Journalism, What is News?, News Reporting, Feature and Middle writing, Writing of Headlines and Intros, Inverted Pyramid style of writing, Developmental Journalism, Investigative Journalism, Business

Journalism, Glossary of newspaper terms, Press Laws and self-regulation, Structure and departments of a newspaper and Yoga and Spirituality for more positivity in Mass Media.

Little doubt that if you are a student of journalism, mass communication, or interested in learning nuances of journalism, want to write as a contributor, as a free lancer or just want to learn flawless writing, this book can do wonders for you. Written in an easy to understand manner, this book would be your companion for years to come.

All the best!

Charanjit Ahuja & Bharat Hiteshi

Chapter I

PRINT JOURNALISM

Cynics say that it will not be long before print journalism which refers to the profession of reporting or editing news stories for newspapers and news magazines in the world including India will be replaced by online and mobile phone journalism. There are already 6,800,000,000 mobile phone subscribers in the world with a total population of 7,012,000,000. Roughly the world over, mobile penetration comes to about 97 per 100 and the number is growing by the day. China tops the mobile phone subscribers at 1,276,660,000 with a population of 1,369,811,000 followed by India with a subscriber base of 970,955,980 for a population of 1,267,402,000. The United States of America ranks third with subscriber base of 327,577,629 for a population of 71, 77,828 which accounts for 103 per cent penetration. They say that the audience has changed considerably. The technology is available at the finger tip of the common man; hence there is easy access to all types of news, anytime and anywhere.

This is the biggest challenge faced by print journalism. In the United States and Europe, people particularly youth has lost interest in reading newspapers. Newsrooms in the country blame it on the inability to have accepted the changes that were required of them.

In India, the situation is not very different. Modern technology is replacing the traditional methods of delivering and reading news. Another cause of concern particularly in developing countries is that post globalisation and with the rise of consumerism, several newspapers are being looked upon like any other commercial product. The press like any other institution is exposed

1

to forces released by the market economy and cultural of utilitarian values. Readers are being looked upon as consumer and not as members of the society to be communicated with. Little doubt the Editors are either taking a back seat or combining the role of Managers as Chief Executive Officers.

Popularity of Social Media

There is little doubt that social media is an ever-present force in most of our daily lives and it is used for almost anything from consuming the news to interacting with friends. Journalism, as whole, is a form of media which probably everyone sees in either a positive or negative light. Regardless of how you may view the media, journalism is the news and it is current. This is partly the reason why there is a big push being made to move all forms of journalism towards online platforms. For the most part, on social networking sites such as Twitter and Face Book people are finding and reading the news quickly as it is right at their fingertips. Another added benefit of online journalism is that it reaches a wider audience. People all over the world could be reading stories and sharing what they read with friends.

The youth story

The youth of today has turned to the internet. A growing news presence on major social networking sites can change that with more people actively engaging and participating in the news. Online media provides the opportunity to share, discuss, and debate right at the moment that a certain news event is occurring. This may not always be the case with every news event, but the case to be made is that there is overall wider communication and interaction taking place for news stories or shared ideas. There may be some that are against online journalism, though most of these people actually read a real newspaper and may not be as actively engaged on social media sites.

While print journalism may have been vastly popular years ago and still may be with some people, it has little chance of survival in a society that is becoming more and more digital.

Digitisation is putting pressure on print to change. For decades, newspapers were built on a model where readers would come and engage with the stories to reach the advertised product or message. Digitisation has disrupted that model. Now advertisers do not need to use doors to reach their target as they

can reach out to them directly. The online revolution is very young but in the next decade will be more viable and newer models will evolve.

And the decline begins

The decline began with the advent of Radio and TV and accelerated with the coming up of online journalism with the advent of radio and later TV, newspaper circulation began a gradual but steady decline. In the current times, the audiences do not have to solely rely on newspapers as their source of news anymore. That is especially true in case of breaking news, which could be conveyed much more quickly via broadcast media, television journalism or online media.

Emergence of the Internet

We all are very well aware of the growing importance of internet medium in our life for our various purposes. Internet has become such a platform, the importance of which cannot be denied by any possibility. This medium has definitely made working of both our personal and professional life very easy and convenient. It caters to our various needs like getting information on wide range of topic, sending and checking mails, increasing your professional networks and your business online, making friends, playing games and watching movies, getting news and information about the major happenings of your city and many more.

As we can see that with the growing technology and digitalization, the print media is losing its importance in major cities; people choose the digital medium over the newspapers to satisfy their news and information need to a larger extent.

Post recession scenario

The recent economic hard times have only accelerated the problem. Revenue from print advertisement has plunged. With profits plunging, newspaper publishers have responded with layoffs and cutbacks.

Indeed, that's the conundrum facing newspapers and their readers. All agree that newspapers still represent an unrivalled source of in-depth news, analysis and opinion, and that if papers disappear entirely, there will be nothing to take their place.

To keep in pace with the technological advances, it is high time that print journalism in the country accepts the change. In a country like India which has 60 per cent of the population under 35, it is mandatory that journalism caters to the needs of a young population. For this, a major change is essential. There is need to deconstruct a story to make it easier for the public to comprehend. One must tell the reader why it is necessary for him to take the story seriously and also give him an impression that it is mandatory he should care about the story. Facts are sacred and it is necessary that the truth be always told, in spite of the immense pressures.

Editor's predicament

Print journalism will only succeed if more people took the time to read it. People want news now and they don't always need the full story. Editors are confronted with the predicament of less space in the print edition, dwindling advertising revenues, downsizing of staff, diminishing newsroom resources, outdated technology and an aging readership in a city with a shrinking population.

How they responded to these familiar trends was neither innovation nor constructive. Editors ask reporters to adopt tighter writing and then shave their copies even more. When they could have utilized the arsenal of multimedia tools to enhance stories' relevance and accessibility, they failed to do so. For anyone interested in the news business, it's hard to avoid the sense that newspapers are at death's door. Every day brings more news of layoffs, bankruptcies, and closings in the print journalism industry.

But why are things so dire for newspapers at the moment?

In-depth stories

But even with TV grabbing more and more audience and advertising revenue, newspapers still managed to survive. Papers couldn't compete with television in terms of speed, but they could provide the kind of in-depth news coverage that TV news never could.

So editors thought of innovation and retooled papers with this in mind. More stories were written with a feature-type approach that emphasized storytelling over breaking news, and papers were redesigned to be more visually appealing, with a greater emphasis on clean layouts and graphic design.

What the Future Holds

Will newspapers still exist? Would print that requires huge newsprint made from chopping down trees now running into huge losses due to far-flung distribution networks and threat from new journalism soon go out? Will a sustainable business model for newspapers be found?

All said newspapers are going to be around a lot longer than many thought. I think there is an elegant simplicity to newsprint that has not yet been matched, even by the latest gadgets. Read it, fold it, tear it, toss it or recycle it, there's beauty in the utility of the printed page. The iPad and Kindle are wonderful devices. I just don't think they will ever totally replace newspapers and books.

Those in the profession must not forget that they are privileged to be in a noble profession because Journalism is both an art and a profession that serves three fold purpose-to inform, to instruct and to entertain. It is called history in the making because an important event that takes place today becomes history tomorrow. Little doubt that journalism records events and opinions and seeks to interpret and mould them for the benefit of people. The main purpose of journalism is to provide readers accurate and reliable information, interpret it for their benefit to serve as a watchdog. As Truth concerns us all, the first and foremost task of a journalist is to unravel truth, to cross check facts because facts are sacred and to work in the best interests of the society. Journalists are supposed to provide news without any fear or favour. The news reports must be written objectively and without any ulterior motives.

For Print Journalism to survive the journalists must set a benchmark and make people aware of the contemporary world. Inform, educate and entertain, help people in decision making, sensitise people on social issues, instil good moral values and make people aware of their rights.

Print still the most effective medium

The Indian Newspapers Society agrees to the fact that the changing dynamics of the Indian media scenario have seen a shift in media planning strategies. The IMRB International, modelled on the lines of British Market Research Bureau, formerly Indian Market Research Bureau, a multi-country market research, survey and business consultancy, headquartered in Mumbai with operations in 15 countries has found that "despite the rise of television, print media remains the most effective medium". The Indian Newspapers

Society too toes similar line. The survey "Impact Multiplier" measured how print and television work on the basis of impact multiplier theory and concluded that "Print especially when combined with the electronic medium created the highest brand salience and top of the mind (TOM) effect.

The study declared that print medium has great significance and is irreplaceable in the communication mix. The combination of print and television has been proven as one medium makes up for the failings of the other media and thus covers all aspects of media reach and effectiveness. The Business Times Singapore carried findings of research carried out by a global information service company Experian recently. It questioned: How important is print media in your company's marketing campaign? If your answer is "not very", it might be time to tweak your advertising strategy as according to research conducted by global information Services Company Experian, even in this highly digitized age, 86% of consumers in Singapore identified print media as the most valuable information source for customers to find out about a brand or product.

There are vast numbers of people who are not very much aware with this technology oriented medium and hence they could not access to the internet technology for their information needs. Therefore for these kinds of people, the best source of information is the newspaper because there are several issues which are not being considered by the television as they cover news on the larger scale.

However, to satisfy the specific news and information requirements of the people, there are several traditional newspapers which are still working keeping the specific area related news need of people in mind. These traditional newspapers understand the specific topic related news requirement of people which cannot access to the medium like internet or television.

The major problem with these digital medium is that they don't cater to the area specific news; instead they are more concerned with the news at national or global level. In this scenario people are unable to fulfil their news requirement of their own area. The result is that most publications have now come out with local editions or what we call city editions to satiate the urge for local news because proximity binds people.

The traditional newspapers offer various news and latest happenings to the people about their own area. It helps people in getting informed on the various issues where they can contribute in the development of their particular area by

contributing in the decisions and opinion affecting the growth of their area. They keep people updated on various activities taking place in their area and various other events and also inform about the various sales offers, movies and parks where you can enjoy your day spending in various recreational activities.

The traditional newspapers properly serve to all the specific news requirements of various communities of the Austin city to make them aware with the ongoing scenario of their area so that they can effectively contribute towards its development.

Print is still breathing strong in India while it may be gasping for life in some parts of the globe. the A wave of acquisitions and expansions through multiple editions have been supported by the raising of capital from initial public offerings (IPOs) and private equity firms. Heightened activity is driven by increasing literacy rates, consumer spending and the growth of regional markets.

Rising circulation of newspapers

The encouraging fact is that newspapers have seen 6 to 20 per cent growth in sales, while TV news channels have seen losses. In some cases English newspaper circulation has grow by 70 per cent. but readership grows by 2 per cent. The print medium is still a thriving business in the eastern countries like Japan and Singapore. The picture is however, not very encouraging in western countries like the US where print newspaper advertisements have declined from $60 billion in the late '90s to $20 billion in 2011. Internet has impacted most newspapers in the last decade in the US. In India, the picture is not very clear. How audience is going to behave in the next decade remains a question. For newspapers to survive, they will have to be more innovative and will have to diversify into other portfolios.

Advertising is still the primary source of income for print. The business model needs to be tweaked to fit into the new market environment. Internationally, the business model is subscription-led. At some point of time, India will have to move towards that model. Significantly, Ad spends have grown from Rs 150 billion to Rs 300 billion during the past five years. The share of the print media has remained the same – around 40 per cent.

Surely, despite the growth of TV and Internet, the print medium has held forte. There is certainly buoyancy in the print market as digital technology was still confined primarily to the English-speaking market and would take

time to reach the masses that are already hooked to the print medium, mainly because of its availability in regional and vernacular languages.

There is a need for amazing writing: from a technical standpoint--by the major print journals. The good writers and they often check a variety of sources and strive for an objective viewpoint, in as much as that is possible. There is also a need for print journalists to take risks to provide in-depth, investigative stories to bring back readers. This needs to be done urgently or else the internet which has ushered in a new kind of journalism in which ordinary citizens play a greater role in the process of news making as Citizen Reporters, would gradually replace Print Journalism. Today people, who double up as citizen reporters with video camera equipped smart phones to record footage of news events and upload them onto channels like YouTube, would make Print Journalism redundant. The silver lining is that despite and advent of electronic media, the print media has not lost its charm and impact on the minds of readers with in-depth reporting and exhaustive articles written by experts and well known columnists. The Print has the lasting value and would continue to hold forte along the new media.

Chapter II

WHAT IS NEWS?

To understand what news is, we must understand first what communication is because the very purpose of news is dissemination or communication of some information which is new or hitherto not known. The communication is verbalisation of tidings, thoughts, information. There are numerous research papers that suggest that those who communicate effectively are more successful in life than those who are unable to express themselves.

The word 'Communication' has been evolved from Latin word communicare that refers to something that is being shared or common. Interestingly, whenever there is pre-fix "co" before a word it means together. Co means together as we find in words like co-education, where boys and girls study together, co-existence where all communities live together. Co-accused, co-brother, co-partner, co-relate, concord, concurrent, concur, cohesion, togetherness, cohabit-relations of man with a woman, community, collision, contemporary, concur, consent and so on. There are one thousand four hundred and eighty five words beginning with co as a prefix. In a single day you can learn as many words.

This is what is required. Average adult's vocabulary stops growing after the age of 20 or 25. One tends to forget as many words as one adds. There is a need to make a conscious effort to learn new words and that too with speed.

Similarly we will find hundreds of words with prefix ex which means out. Like ex-communicate, exodus (exit of large number of people), exit, exhume (ex means out and humus means earth), extempore (ex out, tempore, time or temper), exhale (ex out halare in Latin means breathe), expunge (ex plus

pungare in Latin to prick), excavate, exorcise, exclude, excreta, excrete, expel, excursion, exonerate, exhaust and so on. You may say so and so is ex-Akashian. He is an ex-student. He is an ex-serviceman. Ex-servicemen Association, ex-president of India, ex-Prime Minister and so on. Exit is combination of ex and it. Ex-communicate is from ex and communicate, exhume is from ex and hume or human. Ex-onerate is from ex and onus or responsibility for a thing or act.

In simple words communication is sending of a message by a sender to a receiver. So it pre-supposes that if there is no sender and a receiver there cannot be any communication.

In a nutshell, we can say that communication is sending, giving or exchanging information or passing on of news and views. To be in touch by words, signals, and gestures is the art of communication.

Related words like communicative which is an adjective convey that one is willing to talk. Communion refers to sublime exchange, partaking of sacred bread and wine. There are several words beginning with co as a prefix. Co refers to along with or together. This is used before education to make it co-education, before existence to make it co-existence. Then there are words like coherent, consistent, coincide meaning taking place at the same time, co-incidence, collaboration, when we work in cooperation, collide, strike against one another, collision, colony, a country under control of another country. Commute refers to exchange, companion means person in the company of another, compatible is able to co-exist, concoct prepare by combining usually false things, confluence means moving together or where two rivers meet. Co would always mean together like in conform to be in agreement, convent, community of nuns living apart from others,

corroborate to confirm, couple, husband, wife of two things, covenant which is solemn agreement.

There is inter-personal communication like suppose you talk to someone in personal capacity it is interpersonal communication. Colloquy is conference of scholars or specialists. Soliloquy is act of speaking loud in solitude when there are no listeners. Solo means alone and solus by oneself while loquacious refers to talkative.

Interestingly there are some exceptions in this case like the use of soliloquies that often heighten the effect of communication. Suppose we talk to a friend in the corridor, it is intra personal communication. We converse in the class room. It is called colloquy or scholarly discussion in which we can ask questions. Significantly when a child is born or when a child arrives in this world, the first thing, the first activity that child does is to howl or cry and that is child's first lesson in communication. The child announces to the world that she has arrived. This communication continues with us whole of our lives.

Not only normal people, but even deaf and dumb people communicate through gestures. Even birds, even animals communicate by making different sounds only they can understand. Communication begins and ends with our lives.

To equip ourselves to be accomplished journalists, we need to understand from where the words come. Like the origin of all species, all human beings, everything in nature, words too have their origin and etymology. To give you an example:

Tantalize comes from a character called Tantalus who commits some crime and is confined to jail. He asks for water. The water bearer brings water near him, throws some drops but does not allow Tantalus to quench his thirst. Now you understand that if someone brings you near the object but does not allow you to touch it. It is tantalization.

There are different tools of communication which we use when we want to communicate with more people with masses. Like there is public address system, exhibitions, broadcast medium, print medium, audio-visual and internet.

There is an evidence of early use of public relations by Eve to persuade Adam to eat the apple from forbidden tree. There is a story to explain difference between public relations and journalism. The story is about a man who dies and goes to heaven. He, however, finds it boring. He asks Gods that he would

like to experiment with hell. He is sent to hell to have a look. At the gate of hell he finds beautiful women dancing and singing. He is naturally enticed and asks Gods to send him to hell. However, inside the hell, he finds it like a burning inferno. He cries in pain and asks, everything was pleasant and bewitching outside and inside it is an inferno? He is told that outside what he saw was public relations and inside is reality-the journalism.

Traditionally the role of press has been to inform, educate and entertain. However, no body has far laid down the exact proportion.

Entertainment is as much a part of life as education is, though a right mix of information, education and entertainment would be ideal. Though we agree on the role of press as the thrzee fold one, there is no simple definition of what news is.

The changing concept is news for daily newspapers or morning newspapers is what happened yesterday or before the publication of the newspaper. News is what happened during this very day.

For news magazines which are monthly magazines, news is what happened during the month. Similarly for fortnightly and weekly magazines, news is what happened during that fortnight or during that week.

For audio visual media the television, news is what happened a moment ago. For internet and broadcast medium, same rules apply. In fact it is easier to identify news than to define it.

News can be broadly categorised under following heads:

1. **News is that interests people:**
 Earlier newspapers and electronic media used to write mainly on the lives of rich, wealthy, fashionable and wicked people or politicians. That made news. Now realisation has come that public interest demands something more. With changing life style, standard of living, the world turning into a global village, readers and viewers are more concerned about ecology, environment, social security, unemployment health, education, NASDAQ affecting global markets. So news is the tiding or the information that affects more subjects or more people.
2. News is NEWS: News is that comes from north, east, west and south. It must have necessary ingredients that make the information newsworthy.

3. A catalogue of bad information: Is news a catalogue of bad information? No doubt earthquakes, storms, disasters, catastrophe, thefts, bribery, murders, rape etc make news but positive developments are also news. Life is blend of both good and bad. Steps to improve lifestyles, eradicate poverty and writing against pollution is also news.

4. News is something revealed: Unless facts are revealed and information broken, the story will remain hidden and it will never be news.

5. **Novelty.** Based on the idea that news is something you didn't know before which is significant or interesting to a group of readers, news items are basically timely or immediate. In other words, items are fresh and new as usually indicated in the news by the use of words "today" or "yesterday" or "at present time" and the use of the present tense in news headline as one principle in journalism. Although news is basically timely, it may not be always new or fresh, for it can be the development of an old event. There is news that is drawn from the historic past and is made to come alive by playing on or reporting the newest angle or latest development of the story.

6. **Famous people:** The lives of famous people make news. A famous film star getting married, getting into relationship would always make news in which people would be interested. Popular or prominent persons, places, or events make news persons become popular due to their position, rank, wealth, intellect, talent, skill, personality, and achievement. Well-known places make news due to their tourism value, historical, political, economical, and social significance. Popular events are usually those that involve a multitude of people or some well-known personalities as in the case of the NBA games, Miss Universe Pageant, and film festivals. Most of the events or activities or any gathering that involves the president of the country is newsworthy. Besides, the president of a country is a significant figure and is undoubtedly a popular person. So even if the incident is routine like the raising of the flag, if the president of a country does it on a certain occasion, it is a page one story.

7. **Proximity:** Proximity or nearness has given rise to city newspapers.

8. **Press releases make news:** Press releases also make news. On many occasions, the organizations or individuals issue press releases on vital subjects so that information is not distorted. It is also information received

from the region or concerning that particular region. For national dailies, some regional events may not be news to find place in the newspapers but for regional newspapers and electronic channels, such information may qualify to be big news. Regional news and regional newspapers have flourished because readers want a blend of global perspective and regional flavour. Regional news has limited national appeal. For writers interested in covering their town or city, or geographic region of the country, consider writing for media outlets that are regionally set.

9. **Entertainment News:** The purpose of a journalist is threefold-to inform, to instruct and to entertain. So entertainment section is often a very widely read section of a newspaper. If you are seeking to write entertainment, and base articles around celebrity and entertainment new, you will have a lot of company. Entertainment news is a popular area for news writers. Fortunately, there is also a huge demand for it.? Entertainment news writing is best suited to anyone who has connections or lives in an entertainment-rich area. Entertainment news is also for any news writer who likes to write features, profiles and interview celebrities.

Any writer who can bring a fresh perspective to entertainment news will find a following. Choose an entertainment topic that interests you and become and expert.

10. Honesty and Hardwork: In these days of corruption, an honest deed becomes an interesting story. A poor man returning a bag full of currency touches human heart. Similarly hardwork, achievers, the first generation entrepreneurs making big in life makes news.

11. **Niche subjects:** Niche news includes many topics. Popular niche news topics: health, science, technology, women's, children's and travel. Each of those topics has its own sub-topics. Writers in these and other topics will need to become masters of their domain, and have a solid background in their topic.

12. **Sex and Crime:** Crime reporting is not the type of news that should be taken on lightly. Crime reporting should be written using good taste, ethics, a sense of respect for the crime victims and their families. Crime reporting should not be gory, or gross. Unseasoned news writers who attempt to write about crimes often end up in a bad place called Sensationalism.

In the West, many tabloids survive only because of stories relating to sex lives of important people or stories relating to crime. However, there often is the lurking fear of such Reporters falling into the trap of Sensationalism or yellow journalism. There is a definite line between some crime news and sensationalism that has become increasingly blurred in the last decade, thanks to TV news magazines, the tabloid press and the Internet. Another type of information dissemination posing as news is more aptly called sensationalism. Sensationalism is those stories that go viral, because they are unbelievable or sensational in some way. They often involve extreme acts of violence of bizarre behaviour. They are humanity at their worst. Sensationalism has obviously found its seat comfortably among the other news outlets. Sensationalism is appropriate for tabloid style press, in print, and online. TV news likes to toss in some sensationalism into their nightly news.

13. **In-depth news:** This involves lot of hard work by the Reporters to dig out information, analyse the same with background of the issue. In fact such in-depth news can prove to be the saviour of print media which is facing a huge challenge from television channels and online media

14. **News is Five Ws and one H. Who, What, When, Where and Why.** These 5 W's are the essential building blocks of news writing.

15. Art, plays, musical programmes: Live shows generate interest and become news.

16. Tension: Tension at the borders, rift between various constituents of an alliance, religious tensions between communities is news.

17. Follow-up: Follow-up of a story or news or an event leading to logical aftermath of a story is news.

18. Curtain raiser: News about an impending event or what is to happen is eagerly looked for by the people. Similarly miracles, humour stories, change in fashion make news.

Chapter III

NEWS REPORTING

Reporting

Who is a reporter and what are the rules for reporters? This question has been debated for decades without any concrete answer which is acceptable to all. A reporter is a person who gathers news. He or she is the heartbeat of a newspaper which the person represents. Reporter is the face of the media house that public sees. There are no ground rules that are written for journalists or reporters but there are some rules that are universally acceptable. These rules actually exist in the minds of reporters.

Qualifications of a good reporter:

1. Hardworking: The basis of all good reporting is hard work. Much of reporting is based on dull, routine, mundane details. However, sometime these may lead to major stories.
2. Well read: The reporter should be well read with good expression and crisp writing. Though it is said that a reporter is only a carrier of information and the stories filed are edited and polished by the news desk, yet it helps if the reporter can comprehend the subject well and convey through lucid language.
3. Knowledge of law: The reporter must be conversant with law of land otherwise he or she would land himself or herself in legal trouble.

There are laws relating to Defamation-both civil and criminal that can be tried against reporters if they don't learn to write without prejudice and intend to hurt other's reputation in public eye. Then while covering Courts, when has to take guard against reporting that can lead reporters to Contempt of Court.

4. Analytical mind: The reporter has to interpret and analyse a situation and write the analysis for the benefit of readers/viewers. Unless the reporter has an analytical mind, the reporter would find himself or herself misfit for the job.

5. Generalist: It is said that a reporter is a generalist who knows something about everything. The reporter may not be master of everything but he should at least conversant with day to day happenings. The reporter should have sound knowledge of current affairs and trends.

6. Team leader: A reporter must be a team leader because in a media house, the reporter has to be the member of a team. When he grows as a reporter, he has to discharge the duties of a team leader as Reporting Chief or Chief of Bureau. The reporter should be a go getter who can have his way with anyone. The reporter must also be able to nurse his sources.

7. Meeting deadlines: A newspaper or a television channel works like a war room because delays are a total taboo. One has to meet the deadlines of a bulletin or newspaper edition. During breaking news, there could be some delays but on normal days, deadline for filing of stories, editing, page layout and printing is scrupulously laid out in advance.

8. Asking questions: The reporter must be an extrovert person and not shy of asking questions, supplementary questions and dig out the required information. The cardinal principle of journalism and reporting is asking questions after questions. He or she should be good in communication so that right kind of question is coined and posed in a flawless language.

9. Physically fit: That is a key to reporting. Reporters have to do a lot of leg work to chase stories and find out the information. In addition, one has to remain ahead of others to work on exclusives, scoops and file these on time. For a reporter, key is survival of fittest in journalism. Speed matters a lot in reporting.

10. Off the record: A good reporter is one who can protest his sources and keep off the record information as such. Often reporters are privy to lot of information. It is expected of him to keep such information guarded and not to expose the source who had revealed the information in good faith.

11. Accuracy: Reporter must be accurate with facts. No deviation from facts is permitted. A reporter has to ensure that credibility of the media house and his own credibility is of utmost importance. Readers want from him accurate report which is property documented and not a story based on hearsay.

12. Answer all questions: A good reporter must answer all the questions that may arise in the mind of his readers or viewers upon scrutiny of a story. Five Ws and one H must be answered by the reporter in the story. The reporter must understand the needs of his organisation and of public.

13. Avoid repetition: Reporter must never be repetitive. The job of a good reporter is to provide information at the very outset and not in a roundabout manner on by being repetitive. Repetitive information becomes redundant and is a waste of precious newspaper space and time on broadcast and television journalism.

14. Always on the move: A reporter must always be mobile because small information may lead to a major story. He should reach the spot of happening of any event because that allows him access to new sources that would be useful for future stories.

15. Inquisitive by nature: The reporter should be inquisitive and curious like a cat. He should have nose for the news so that he can smell news. The good reporter should be alert.

16. Punctuality: A good reporter should be punctual or otherwise he would miss on vital details. Interviews, time and tide wait for none. Timeliness is most important for a reporter.

17. True to his organisation: A good reporter should be true to his or her organisation. He should only be dictated by his Editor or boss and not by anyone else. Nobody should take a reporter for guaranteed and at the same time, the reporter should not take anyone for guaranteed.

18. Always objective: Subjectivity is not permitted in journalism. Except editorials or opinion pieces, subjectivity or use of "I" is not permitted.

Readers and viewers want an objective assessment and not the personal opinion of the reporter. The reporter should not be vagu but clear on all issues.

19. Truthful and tactful: A reporter should always be truthful to himself or herself and also to readers and viewers. Journalism is all about truth, honesty and will to call a spade a spade. At the same time the reporter should be tactful so that he can dig out information and do the story before others.

20. Fearless: The reporter should be fearless and not in awe of anyone except his editor. At the same time he should have lots of patience and keep a tab on upcoming events. He should be organised and maintain a file on updates.

21. Tech Savvy: The reporter should be computer savvy. He should explore information about breaking news and about background of a story on the internet and should be well conversant about various search engines. He should upon getting up in the morning think himself to be a student and must go through the newspapers and television news etc to keep himself abreast of newer happenings. He should have good knowledge of history and a grasp over current affairs.

22. Friendly: The reporter should be friendly in disposition. He should be faithful to his sources as well to his organisation. He should have a genuine aptitude for journalism. He should be polite and aggressive at the same time.

23. Qualities of a detective: The reporter should have the qualities of a detective for investigative stories. It is not that the reporter can smell a story like a detective but he should have basic urge to uncover what is being kept under wraps. The more an attempt is being made to hide something, the more is the change that there is a story hidden in it.

24. Good listener: The reporter needs to be a good listener. While interviewing an important personality or a celebrity, it is essential that the reporter is all ears to the person. Looking disinterested would put off the person being interviewed. At times the reporter should nod in agreement or should his rejection for a fact. Idea is to keep interviewer hooked to him and nothing interests the person most than the fact that you are showing interest and are listening to him with rapt attention.

25. Immediacy: Timeliness is most important for reporters. The reporters should reach the spot or the source of the story without any waste of time. The lazy reporters, the reporters who show up late will never do well in life as a journalist. The golden rule for reporters is keep moving all the time. For certain stories like the story about accident, fire, disaster or some other crime, the reporter must try to reach the spot soon so that he can see for himself what had actually happened and before evidence is gone. The reporter can see what police was doing, what non government organisations were doing, what political leaders had done and mental state of relatives, friends and eye witness account. The reporter who reaches late will get only the second version. This applies to photo journalists as well as because they may not be able to take pictures if they reach late.

26. Check both sides: The reporter must get version of both sides. Even a murder accused is given an opportunity to defend himself by the Court. You cannot hang a person or tarnish his image without giving him an opportunity to give his side of story or defend himself. The reporter should inquire into the background of the story and check both sides.

27. Never take anything for granted: The reporter should remember this rule to never take anything for granted. Appearances may be deceptive.

28. Basic approach: Reporter should not generally adopt tricks or disguise without the consent of their superiors. Many reporters have made praise worthy contribution by doing first hand stories but office should be kept informed in advance. Then there are reporters who try to get information by posing as someone else. However, generally one should try to get information from the front door.

29. Avoid stories being planted: Reporters should never accept the version of a top official, political figure or any important person as gospel truth. The source may have some vested interest and may be trying to mislead the reporter to plant a story in the publication. The reporter should try to check that whatever has been provided to him is a fact or a planted story. No doubt the reporter is supposed to give official version but he must make independent enquires into the facts. Similarly a reporter should never trust a second hand information as it might be exaggerated or based on a rumour. Reporters have to apply their own checks and breaks.

30. Pool reporting: When reporters share some information, it is called pool reporting. It is a fact that all reporters can't reach every spot or be present everywhere at the same time. In such a situation, pool reporting comes handy. Say at some event only handpicked reporters are invited due to security reasons or otherwise. In such a case, there is a tacit understanding between reporters to share the information. It is presumed that reporters concerned are duty bound to share information with other colleagues. If the reporter does not share the entire information, then he or she could be thrown out of pool. At times pool reporting is helpful particularly in a situation where number of reporters is too small. Readers are benefitted because of pool reporting. However, if the media house where a reporter works does not believe in sharing information with others, then said reporter must let others know of this.

31. Embargo: Embargo is an order forbidding story to be filed before a particular day or time. It is a mandatory deadline to a story. The story must be held back till that time. For example, if the text of the speech is provided to a reporter before the meeting, it is presumed that the reporter will observe the embargo. Embargo comes from the practice in shipping industry when a government orders forbids ships to enter or leave its ports. Coming back to journalism, in certain cases when extra-ordinary significance is given to news, it may be embargoed several days in advance. At times reporters themselves embargo a story. Except special occasions, reporters should avoid embargo and not fall into this trap which forbids them to share information with readers.

32. Off the record: No reporter is fully privileged to write all that he knows. He is supposed to write only that is on the record. The information which the reporter is asked to not to share is called off the record. The purpose is twofold-the official cannot be held guilty of withholding the information. While the reporter is prohibited from using this information. At times, clever officials and politicians use this ploy to involve reporters in an act where he is in a no win situation. On other occasions, officials provide information with details about criminals, terrorists and other social elements asking reporters to keep the information off the record. As it is in public interest, it is expected of reporters to keep this information off the record.

33. Handouts: Reporters should know that handouts are favourable reports concerning a company or organisation which forbids reporters from making further enquires. However, good reporters should try to go beyond the handouts and provide more relevant information to readers/viewers.

34. Gifts and junkets: Good reporters should apply their own breaks when it comes to temptations like accepting gifts and going in for junkets. These could be in the form of a cocktail party, a trip abroad of some expensive gifts. They should know that there are no free lunches and the offer of a party or cocktail has a method behind it.

35. Depth reporting: While engaged in depth reporting, the reporter should know that depth reporting is much more than general routine reporting. It is about digging up of facts. It going beyond the surface to bring out the facts. It involves hard work and the end result should be such that no questions are left unanswered. It is not a 200-300 word story, but a complete article with backgrounder, new developments and facts. It is not an explanatory opinion but explanatory fact.

36. Sports reporting: The reporters on sports beat should observe some rules like they must mention the name of the stadium, write about the atmosphere inside the stadium, exact names and details of members of teams, interview some players who achieve laurels. The reporter writing for print should know that the readers may have already watched the contest live on television channels; as such he needs to give some more details using racy and crisp language. Write about the form of players, records made, mood at the stadium and give his analysis which is permitted in sports and arts.

37. Developmental reporting: A reporter on the developmental journalism beat should know that it involves social and economic aspects. It is about new projects for betterment of people to raise their standards of living. The reporters can write about castism, red-tapism, corruption, agriculture, horticulture, government policies and programmes if these are bringing about a change in the lives of common people. Success stories are a part of it. The reporters should keep a desk diary and reference material handy while doing developmental stories.

38. Political reporting: Reporters on this specialised beat should be familiar with the constitution of the country, with the political scene and

should have good knowledge of election coverage. They should know about State Assemblies and Parliament working. Political reporters should have good knowledge of all fields like history, sociology, political science, psychology and economics. Politics is a dirty game where parties and individuals work for self aggrandisement and self empowerment, misusing, caste, religions and ideologies as these suit them. One should avoid praising criminals in politics. It is reporter's duty to expose horse trading, power hungry politicians and lobbying for power. Political reporters should be able to separate grain from chaff.

39. Investigative reporting: Investigative reporters should make readers aware of all aspects of an issue. It is not to sniff around to search for a trail. The reporters must protect themselves from legal action.

40. Some liabilities of a reporter include functioning as a watchdog, a bridge between the government and people, a guardian of fundamental rights, building opinion, enlightening people, to set role models for people but not to misuse liberty and freedom.

41. Sins to be avoided: These are called seven sins that include error, distortion, dullness, bias, insinuation. Confusion and superficiality.

Qualities of a good reporter:

1. **Accuracy:** The story should be based on facts. A reporter should strive to make the story as precise as possible. A good reporter should be able to gather facts in a very careful and accurate way. The reporter must report the news accurately and fairly without prejudice and personal opinion. Newspaper journalism is still a vital form of communication, even in the digital age. Investigative reporting and in-depth stories are integral parts of newspaper journalism. The reporter needs to have certain qualities to do a flawless job. Accuracy is vital. A good journalist verifies all the major details of his story, including addresses, numbers and the spelling of names. For a controversial story, he talks with people on all sides of the issue to make sure he is not presenting a slanted view of the issue. He does not let his own opinions cloud his reporting. He double checks his work before he submits it to the editor. A good journalist is one who double- and even triple-checks

the spelling of names and gives the correct details of the events that took place. Journalists need to have an eye for detail and not be afraid to ask questions again and again to ensure accuracy.

2. **Nose for the news or curiosity:** A reporter must absolutely be a very curious person. This is by far the number one thing and it outweighs all of them. Interested in how things work, and why people are they way they are. A good journalist is one who is nosey. Where did the money for the project come from? Why is this politician supporting this policy? Why are these construction workers not wearing their head gear? A good journalist is one who is curious and burns with the desire to know what is going on in the world. Curiosity is another very important quality of any good reporter. There is the need to be curious all the time. The spirit of curiosity helps the reporter get good stories. A journalist should have a healthy scepticism. This means checking and rechecking information which is very important because every story is based on facts and evidence. Curiosity is present in every person but real thing is its correct use. Curiosity is very necessary for a journalist because it helps him/her to know different sides of a news. Even a tiny incident can help a journalist to fetch a big story behind it only because of curiosity about that incident. This quality is compulsory for those who are working crime report department or investigation department

3. **Meeting deadlines:** The reporter has to meet deadlines fixed by a publication or else the story may be detailed and become stale the next day. In this jet age, the reporter has to run against time to meet the deadlines.

4. **Knowledge of current events:** Maintain knowledge on latest events and news to obtain news coverage of important and pertinent issues.

5. **Good legs:** The reporter has always to be on his toes so he needs to have liking for lot of leg work. The work is often fast paced, with constant demands to meet deadlines and to be the first reporter to publish a news story on a subject. A reporter should have strong determination for what he is going. In other side, punctuality gives the chance to present the report in time. A good reporter must have determination and punctuality.

6. **Attribution:** Attribution should be made clear and should be placed before what the person said. Failure to do so, makes a reporter's story

suspect. Attribution refers to a source. If you write in a story that Michel said it, it is wrong because reader would like to know who is Michel. Also the attribution of source should be a well known personality or source.

7. **Fairness:** Recognition of the importance of fair and balanced reporting, in which opinions that differ from those of the writer, or the newspaper or a government official is one of the important principle of good reporting. It does not suit a Journalist to be one-sided. This is totally against the respect of that profession. One should only provide the fact without his personal views about any issue. It is one of the basic rules of Journalism. A reporter's report should not reflect his/her support to any regional, political or religious party.

 Either way, a journalist must be fair all the time and maintain a level of objectivity in what they report. The Media Alliance Code of Ethics (new window) is a great starting point for journalists, outlining some essential ethical requirements. News is a factual report of an event, not a report as seen by a biased person or seen as a reporter might wish it to be seen. The reporter should be as impartial and honest as possible. Reporters should have a neutral point of view. They should report what "both sides" of an issue tell them. The tenets of objectivity are violated to the degree to which the story appears to favour one pole over the other.

8. **Objectivity:** Objectivity is a significant principle of journalistic A good journalist is one who is able to take personal responsibility for what they write. They must keep in mind that there will be people who will be upset because they disagree with the angle of the story or because they wanted their story to be

9. **Communication Skills:** The reporter must be a good communicator. After all you have to be able to communicate with people, interpret what information they give you, and present it to others. A good reporter should be skilled at taking notes.

10. **Integrity:** This goes without explanation because a reporter is responsible to the society and he needs to be always above board. No doubt the Press is called Fourth Estate after Judiciary, Executive and Legislature. Without integrity, it doesn't matter how good of a writer the journalist is or how wonderful his sources. Once a reporter is caught

plagiarizing or twisting the facts, no one will find him credible as a journalist. Integrity means more than just not plagiarizing or fudging the facts, though; integrity means being committed to uncovering the truth regardless of the difficulties involved and reporting it in a fair, respectful manner.

11. **Ability to be neutral and unbiased:** A person who takes sides and has a prejudiced mind cannot be a good reporter. The reporter has to be a no party man. Idea is to ensure that his reporting is fair, accurate and without any bias.

12. **People skills:** A lot of hard news/beat reporters don't have great people skills, but the best reporters do. If you love meeting people, interacting with cross section of society to dig out information, you are a good reporter. But if you are an introvert, you may be a good writer of books but not a reporter who is like a public man. Studies polish the attitude of a person. Study enhances the speaking power and good behaviour of a person. Study of different books also increase your vocabulary and gives many options of words about any condition. Therefore, a Journalist must study the language and literature deeply.

13. **Face of the newspaper:** A reporter is the only representative of a newspaper whom public sees. Others like Copy Editors, Sub Editors at different levels, though performing equally responsible jobs are rarely seen by the public at large. In view of this, the reporter has to be the role model.

14. **Writing Skills:** Though reporter is simply a carrier of information yet a reporter who can write flawlessly would be worth his weight in gold. The publications benefit if they have reporters with good writing skills. Journalists need to be able to write clearly and using few words. Wherever a journalist may work, whether in print, radio, TV or online, they have to write. Depending on the time constraints, a good journalist is one who writes articulately, succinctly and quickly in an interesting and relevant way that appeals to readers.

By writing very well means writing clear and well-focused stories that is easy to understand by everyone. Good spellings, punctuations and grammar are also requirements. Reporters should be able to write very good leads for their news stories and features. Everyone knows how to write but writing according to the demand of department is little

bit difficult. So, a journalist must have extraordinary writing skills which come via experience. One should how to write a news, article or column. Being a journalist, you should not wait for the mood to write.

15. **Persistence:** To get information is not easy. Some top officials and sources may not be willing to part with information or may be media shy. You have to be able to call them over and over and over and follow them persistently to get the information you need.

16. **Guts:** You need to be brave enough to write the truth, no matter what the consequences. Sometimes it's not easy. You end up almost becoming friends with your sources over time, and then one day you may be forced to write something negative about someone who thought they were your friend. That's just the nature of the business. A good reporter should be courageous and confident. Without courage and confidence it is difficult for a person to be a good reporter. Timidity on the part of any reporter will get them nowhere.

17. **Knowledge of law of the land:** A reporter who knows about the law of the land and about country's constitution would be more successful than those who lack this knowledge. The knowledge of law would mean that you can be aware of various laws like the Contempt of Court while doing Court reporting. Similarly, when writing investigating stories, you need to guard against libel and defamation. A reporter must be qualified because drafting of report is a complex and specialized task. He must know what to report, how to report, and to whom to report and how to focus on real fact.

18. **Specialization:** It helps a lot if you have a skill or interest in something else. For instance journalists that know a lot and have a lot of interest in a certain subject are usually valuable. Another additional advantage is if the reporter has translation skills to translate the content in required language. He/she can write and understand the concerned language. For example being a Pakistani he/she can translate the news from national language Urdu to English. If you are journalist of any international News Agency than good grip on English is necessary. Learning other different languages is also very helpful for a Journalist to gather more and more views about any issue. A reporter must know in details regarding the subject matter to be addressed and he must report on that topic in due time. Otherwise, the object of a

report would go in vain. So, knowledge and timeliness is also essential qualities of a good reporter.

19. **Competitive Spirit:** Journalism is a competitive business. Jobs are few and far between. Also, once you get a job, you have to be competitive to beat your opponents to the story. A reporter should be able to work fast and enthusiastically on any given story. News writing especially has a lot to do with deadlines. This therefore means that a good reporter should be able to work under pressure and meet deadlines. If you can't soak the pressure then it is going to be hard to work as a reporter.

20. **Industrious:** The reporter's job entails lot of hard work. Before a reporter interviews any sources, he needs to do the background work. He finds information online from reputable websites, from print articles and from other reporters. He prepares his questions carefully and checks with his subject to make sure he correctly understand what the person is saying. He talks to other people to clarify and validate what the source has said, and he follows up on any contradictions. He reads any pertinent documents, such as public records, and follows where the trail leads him. It is not going to be easy. It requires a lot of hard work and effort. It is achievable, thought. Just don't give up, and take advantage of any opportunity that comes your way.

21. **Observant:** A good newspaper journalist is observant. He notices the details that give richness to a story: the expressions on the face of the subjects, the clothes they are wearing or the style of music playing in the background. He notices the amount of traffic in the neighbourhood, the types of shops and houses, whether it's crowded or quiet. In short, he notices everything. Not every detail will make its way into the story, but observing the details will help him write a fuller, more compelling story. Data obtained from various sources are required to be analyzed through various tools such as statistical or mathematical tools and functions. proper analyzing in proper way helps to draw findings and reach conclusion.

22. **Empathetic:** A newspaper journalist remembers he is dealing with real people, sometimes when they are at a difficult point in their lives. He is respectful of their feelings even when he must ask them hard questions. Journalism can be a tool to right social injustices by

revealing them to the public, and a reporter's empathy can help him relate to the downtrodden.

23. **Thick-skinned:** Whether it is a quality of a journalist or a flaw in his profession, but reporters at times need to be thick skinned. Journalists are usually not a popular group. By reporting the facts, they are bound to offend some of the people almost all the time. A journalist needs to be tough enough to get the story even when people are giving him a hard time, and he needs to be tough enough to deal with the complaints that will inevitably come his way from time to time if he's doing his job correctly.

24. **Be sceptic:** A good journalist is one who doesn't take things on face value. Press releases or information given to them from people pushing for a certain agenda is only a starting point for a good journalist. Good journalists question sources and are always prepared to dig around until they get facts they are satisfied with. A good reporter should have the habit of self-editing their copy before submitting it to their editors. A good reporter must be able to analyze and interpret information. A good reporter should be ready to do deep analysis which means observing the different issues with full concentration. Not only observing but also saving it in our memories. A good observer can be a good journalist. Writing news is like making a sketch of the incident. This skill gives you the power to better understand different skills of your surroundings.

25. **Be determined and steadfast:** A journalist knows the difficulty in finding information, especially when certain people won't agree to be interviewed. Nevertheless, they are determined to get over the toughest hurdle and bring a difficult story out into the open. What may start off seeming to be a simple news story can require hard work and determination? An ideal journalist is determined and strong willed. Actually it is the basic rule of success in every field of life. You can't achieve your goal without determination. When you lose it you fail. Above are the few qualities of a good journalist. So, if want to be a good journalist than you must have the above given qualities in your character.

26. **Good grasp of general knowledge and current affairs:** A good journalist is one who knows something about everything. They are

well-informed news junkies especially in the area of politics, current affairs and law. There are plenty of ways to improve your general knowledge, from watching TV quiz shows and doing the newspaper quizzes to online searches, playing board games or even using your local or school library to access things like atlases, dictionaries and encyclopaedias. In present time, Life is so much complex so one should have complete information and awareness about his/her surrounding issues. Lack of information can put you on back in this field. He/should should have awareness about his region, country, culture, geography and must have good interest in National and International affairs of his/her country.

27. **Be trustworthy:** People and sources repose confidence in reporters and provide them information sometime on privileged subjects. The reporter needs to be worth their trust and even keep off-the record information as off the record and never disclose the source. Journalists interact with people from all walks of life who are often faced with an extreme crisis in their lives. It is a good journalist's duty to know what to ask and when in the most appropriate manner.

 When people trust you enough to give you confidential or private information, it is your duty as a journalist to not make that information publicly available. The best journalist is one who has strong ethical and moral codes of conduct that help them determine what information to write and what to leave out. Report must be free from biased information. The information provided in the report must be reliable and valid. False, invalid and biased information are supposed to hamper the decision and would outcome in wrong decision.

 Credibility is something that every good reporter should have. In other words, a reporter must exhibit characters and behaviours that make him or her to be believed and trusted by people.

28. **Be motivated and enthusiastic:** A good journalist is one who does not give up easily and one who has thick skin. There will be times when a journalist won't be able to find interesting stories to write up, or people who are willing to talk to them. Regardless, a good journalist maintains a high level of motivation whatever the situation may be.

29. **Be competitive:** It is difficult to get a job in mainstream media as a journalist. The industry is highly competitive and only few get selected.

Nevertheless, there are many other opportunities for journalists as long as they are determined, competitive and have the skills noted above. Just make sure you get your foot in the media door.

30. **Ask Ask Ask:** Reporters must be adept at asking questions. The reporter must also be good at asking the right questions at the right time. After you have asked questions at an interview and a press conference, you must know how to write down all relevant and necessary information maintaining a proper structure should be known to a good reporter. He must know how to present the facts and information in a simple but effective way. So, Knowledge of structure and presentation are necessary qualities to be possessed by a reporter.

31. **Willing to work at odd hours:** The work of news gathering is quite an unpredictable one. One might never know when news will break or where it will happen. It is for this reason that a reporter should be able and willing to work at irregular hours. The reporter should also be willing to take on stress. Reporter is also required to collect information from primary or secondary source of information as the situation demands. He must have the capacity to identify the source of information and collect data required for report.

32. **Good team leader:** A reporter should be a good team player and be capable of working with other reporters, photographers and even editors. A good reporter should be able to take corrections and criticisms in the course of performing their job. Making a good and perfect report is a complicated task. It may need time and labor. A good reporter should have such patience for completing the task properly and timely and to deal with a team.

33. **Presentation:** Reporter must have some knowledge about the desk, the requirement of news desk and write story keeping in mind the space constraint. Information or data received from various primary or secondary sources are required to be organized in a acceptable processing way to create a meaningful picture. Haphazard presentation of data makes no impression rather wastage of time, money and effort.

34. **Jack of all trades:** It is said that a journalist is a generalist who knows something about everything because he or she may be asked to work on any beat, interview any personality or celebrity from any field. So to sum up we can say that a reporter must also be a good public relations

person: A good reporter should know and make good relations with all the famous personalities of his or her defined area. A good reporter should be well educated, and have interest in history, geography, politics, sports, and other human activities. He or she should have an ability to write in a style which is easy to understand. Good spellings, grammar, and punctuation are also required.

The news business is highly unpredictable, and the person who refuses to work nights, weekends, or holidays usually won't get far. That is why reporter should accept to work irregular hours. The reporter should have an ability to work under pressure to meet deadlines. Should have an ability to ask critical questions to the source and look for exclusive information. eporters have to have an eye for what is newsworthy, what the hook is in a story. Editors are there to help reporters develop good news judgment, but there are times when reporter will have to make snap decisions on their own and find the proper focus for a story. Resourcefulness is the "where there's a will, there's a way" person. When a reporter hits a brick wall when chasing down a story, he or she needs to have the kind of mind that can quickly come up with new avenues to try.

Chapter IV

FEATURES AND MIDDLE WRITING

Dictionary defines feature as a newspaper or magazine article or a broadcast programme devoted to the treatment of a particular topic, typically at length. It goes on to give synonyms for feature as an article, a piece, an item, a report, a story, a column, a review, a commentary, a write up etc.

However, for a journalist, it is essential to differentiate feature or middle from a hard news story. A major point that differentiates a feature from a hard news story is the timeliness of the subject. At times, it begins with the subject where the news story ends. It gives complete information with backgrounder to the reader. The information with the reader may be sketchy. To ensure that the reader reads the feature and enjoys it, it must be written in an interesting manner, one may take the liberty to use flowery language.

Example: Recently, there was a week there was a story about a young handicapped girl scaling Mount Everest. The story talked about how she had become the first handicapped girl in the world to scale this peak.

The feature that appeared subsequently talked about her grit, her resolve, her falling spirits when she lost her leg in an accident, the friends who showed only pity on her condition and how she overcame that, worked hard to earn enough money and with determination learnt mountaineering and made it to the Mount Everest.

A feature can thus be on any topic. If adventure feature, sports feature, a rags to riches feature, a unusual success story feature, a feature on a dying art, a feature on changing life styles, on changing fashions etc.

A Middle is akin to a Feature except that it appears usually in the middle of Editorial page or on OPED-opposite editorial page. As such it is called Middle because of its placement on the page.

The purpose of Middle is to provide relief to a reader because most of other matter on Editorial Page or on OPED is of serious nature. It is generally humorous and entertaining. At times it may touch a serious subject but the tone is mostly light. Many newspapers have stopped using Middles these days but some prominent dailies still continue with the practice. Another advantage of Middles is that it links many people including free lance reporters, fresher's, authors, prominent people and experts to write on any subject in a light vein.

The middle writing is akin to feature writing except that a feature may be a story is a piece of news item written with a particular intention that is either to make audience aware of a particular matter, to instruct or to entertain. Unlike a general news story, the feature might be prejudiced and sometimes can be used to express the emotion of the writer. An ordinary news story on the other hand is written to convey information and lacks the opinions and conclusions of the reporter. Hence the feature writer has more freedom to express himself and feature comparatively is less time sensitive than an ordinary news story. Any ordinary news story is highly time sensitive. The earlier updating of news is important. But a feature need not be on a topic of current discussion but can be a general topic. A feature story is normally slightly bigger than an ordinary news story.

E.M.Foster defines in his masterpiece Aspects of Novel that a novel requires a story, a plot and a pattern of writing. This applies to Middle writing and to Feature writing. The feature and the middle must have the following aspects:

Headline	Headline should be as catchy as possible. The reader decides to read the news only if the headline is attractive.
The introduction	The introduction should be attractive and should persuade the reader to read further. It can have quotations, anecdotes and can be made dramatic and sensitive.
The body	Of the feature should present the details of the story. The various and opposing ideas regarding the story are presented in the body. The story should maintain its rhythm and tempo throughout.

Conclusion The conclusion should be able to convince audiences of a particular perspective and should end with a punch line so that the reader will be reminded of the story when it is mentioned again.

However, the writer must keep in mind:

1. Focus should be on the topic and the topic should appeal to the audience. The feel and emotion that the writer creates determine the success of the feature.
2. Be clear what the feature should do. Is it to inform, persuade, evaluate, evoke emotion, observe, analyze?
3. Accuracy is important. Make sure that the details are correct.
4. Write for the audience. Know the audience's taste and write.
5. Interviews should be detailed and it would be better if the writer can meet the interviewed rather than talk on the phone so that the interview can be flavoured and detailed.
6. Use Anecdotes, quotations and stories to make the feature attractive.
7. Use the same tense form of the verb throughout the feature unless the situation demands so that the language will be stable for the audience.
8. Write in active voice. Avoid lengthy, complex sentences and paragraphs. Use Active Voice of the sentence. (The person who does an action is mentioned at the beginning of the sentence).
9. Collect details from various sources before writing a feature. Update information and talk to experts on the topic before writing.
10. Check the grammar and spelling before sending for publication.
11. The feature must give information
12. Interpret a recent trend
13. Analyse a current situation
14. Attempt to predict the future of a particular issue.
15. Feature or Middle is a piece written when the news is still hot.
16. Features or Middles are mostly written by free lancers while news stories are from staffers of the newspaper.

While Middle is a short piece that appears on Edit or OPED page, a feature can be defined as a story that stresses the human interest angle. A good

feature is about the people in your community and their struggles, victories and defeats. A feature takes a certain angle and explores it by interviewing the people involved and drawing conclusion from that information. The writer takes an important issue of the day and explains it to the reader through comments from people involved in the story.

A feature takes an in-depth look at what's going on behind the news

- Its gets into the lives of people.
- It tries to explain why and how a trend developed.
- Unlike news, a feature does not have to be tied to a current event or a breaking story. But it can grow out of something that's reported in the news. The feature is the journalistic equivalent of an essay and follows these guidelines:
- Starts with an idea or theme.
- Present information and opinions that back your point.
- Bring the reader to a conclusion.

Features can be classified according to purpose-expository, explaining things or timely topics; descriptive, giving verbal picture of persons, things and places of interest; and narratives which narrates events with plots, settings and characters.

Editorial

Editorial is the mirror of the newspapers opinion. It often defines the Editorial Policy of the newspaper. It is the conscience of the paper. Editorial is also called Leader in many newspapers. There may be on or more editorials in a newspaper on a single day on one or different issues. It projects the viewpoint of the paper on a particular policy, programme or event. It can inspire, motivate, excite, appeal, criticise or reject certain idea or policy. The expression of opinion is intended to lead the public opinion, and convert the readers to its point of view.

Editorials are written with reason and conviction. The writer should have his heart in the subject on which he is writing. The editorial should not be repetitive of facts stated in the news story. It should give a digest of facts, evaluate them, and arrive at logical conclusion step by step. The structure of editorial should be simple, so that the readers can easily follow it.

Interviews

The cardinal principle for Reporters going out for an interview is to never to forget to Ask, Ask and Ask. Idea is to bring out information. Here one must remember that during interview, he or she is not supposed to argue with the personality being interviewed. The person who is being interviewed has right to his views. Reporters interview other people to learn their opinions and to obtain factual information about events in the news. Reporters like interviews because they provide a fast, easy way to obtain news. Often there is no alternative to an interview.

Though interview stories are of many kinds, they can be broadly classified into three categories:

1) Interview for getting facts or news interviews.
2) Interview for opinions or symposium or group interview.
3) Personality interview

In some stories different types of interviews are combined together.

Preparation

Advance preparation or homework of the reporter can be in two parts- reading about the subject concerned and preparing questions to be asked.

Once the reporter has decided the general subject to be covered he must decide what information he wants to get. The more specific his objectives the better will be the preparation.

Obviously, he must know the person to be interviewed. If he has written any books, articles or made any speeches about the subject of interview, the reporter should read them. Such materials will reduce the time and effort for preparation and help him in framing better and more precise questions.

Reporters who do not prepare questions usually run out of questions. It is always good to tape the interview if the interview is pre-planned. It is also good to take notes while asking questions for it will help if the machine fails. While taking notes one should always note important sentences or phrases which will be useful in assessing the interview and writing the story. Closing of an interview is also as important as the beginning. The end should be smooth and meaningful. The interviewer should not publish off the record comments of the interviewee.

Most interviews are presented in the question and answer structure. A brief biographical sketch is given at the beginning and then the entire interview is reproduced or its excerpts. Another structure of interview is in the form of a speech story giving important facts and quotes.

Columns

The personal opinion of a column writer is expressed on a subject in a column. The writer has a fixed style of writing, and he generally writes on fixed subjects and has fixed point of view.

However, there are columns in a newspaper where other persons also contribute. There are also columns where the columnist writes on a variety of subjects. Columns are on political, economics, or cultural subjects or on sports, radio, films, books, humour etc. Generally, columnists write once a week though there is no fixed rule about its frequency.

Photojournalism

A photographer has been defined as equal to 1000 words and so photojournalism is a specialised avocation. Photojournalism is a particular form of journalism (the collecting, editing and presentation of news materials for publication or broadcast) that creates images in order to tell a news story. It is now usually understood to refer only to still images, and in some cases to video used in broadcast

Photojournalism can fall under all subjects of photography but the image needs to be newsworthy to end up being published.

The job of a photojournalist involves immense responsibility. The photojournalists face great difficulties when reporting news. He should have a lot of common sense, a desire to work hard and an eye for a good picture story. Speed, accuracy and imaginative powers are necessary.

No other medium can bring life and reality as close as photography and it is in the field of reportage and documentation that photography's most important contribution lies in modern times.

Not the least of its achievements, photography and photojournalism has proved powerful agents in the awakening of social conscience.

News as Entertainment

News is fast becoming entertainment to raise TRP with editors and reporters claiming that readers and viewers want news that entertains like soap operas. There are countless stories across the world over -- good and bad -- that need to be in a news line up. Yes, they will cost money and physical effort to go cover, and you might need to leave an AC office to do so. But they are important to the world.

Media should act as the soldier of truth because it is not only that truth involves us all but also because media stands on the side of millions of people who rely on it. Time has come for media to seriously introspect on its role on how it could improve its performance in betterment of the welfare of the people and what was best in National Interest.

There is need for a thorough debate on the conflict of interests between freedom of speech and social responsibility. Media needs to realize that it cannot claim to have the role of agenda building but play a role in contributing to the debate on the agenda set by society. The main role of the media is not only to ensure deliverance of credible information but also provide full background of the information.

The media, no doubt, bridges the gap between the event and the people, but in most cases they blow some events out of proportion. Instead of just reporting the event, journalists have developed a tendency to become part of the event that to report objectively.

We must realize that we are living amidst the fallout of the most controversial conflict of our times, where media plays a vital role with greater responsibility and can affect the public discourse on politics, economy and society at large.

Media with its intellectual vigour, analytical attitude and firm fore-sightedness can address, safeguard and resolve conflict between states, communities within the states in a multi-cultural society with ethnic diverse people, being a catalyst agent. The trivialisation of news, the trivialisation of editors and dilution of their role must stop for now in larger National Interest.

Media in this contemporary world is being used for political marketing purpose and today it has assumed tremendous importance. Every bit of our activity is not only reflected but also regulated and governed through media. This medium is for the protection and well-being of the people and it is its moral responsibility to foster liberty, justice, fraternity, peace and human

rights in the society. But media has been facing a perennial dilemma while discharging its rights, duties and obligation to continue that degree of liberty without which law is tyranny and with that degree of law without which liberty becomes license. Little doubt historically we have seen that media has been used by Hitler and Goebbels to propagate doctrines of one race, one nation and one leader.

Media can do miracles by fostering global security, addressing international arm trades, balance of power, nuclear weapons and non-military threats: such as terrorism, extremism, militia conspiracy and movements, strategic relationship of states and their foreign policy, etc.

Media with its new information and communication technology can analyse the minds of political parties, pressure groups, new social movements, contemporary problems of citizen and states for public information and opinion construction. It has to provide people with every tiny detail of what is going on in the world or any other particular place. It has to work for the formation of public opinion, to throw light on issues, do something for the solution of issues by presenting the opinion of experts, work for culture, provide guidelines to the youth and condemn criminal activities.

Chapter V

WRITING OF HEADLINES
AND INTRO OR LEAD

John Keats once wrote that "if poetry comes not as naturally as the leaves to a tree, it had better not come at all". This applies in equal measure to any kind of writing even to journalism and journalistic writing.

Parts of a Newspaper Article

Any news story would have a headline, body or middle and an end. To be a good story, there should be continuity and uniformity of these three parts. The headline should not be far-fetched but must contain the central point of the story. The lead should lead the story or give an introduction to the contents of the story and finally it should lead to a conclusion or an end.

Headline writing:

The headline is the crux of the story that is given at the top. A news story comprises of a headline, the lead or intro, middle and the end. All parts are equally important but it is the headline that serves as a window to the story. It is the first part of a news story that catches the attention of the reader first. It should be catchy and to the point. You should punctuate your title using AP style guidelines, which means a few things: the first word is capitalized.

The headline is the window to the story. We must remember that not everyone spends equal time on reading a newspaper. For a reader in a hurry,

the headlines serve the purpose to inform him of major stories. However, for a reader who is disinterested in a newspaper, the headline serves the purpose of attracting him to read the entire story.

Little doubt headlines need to be very catchy and clear, sometime very straight. Apply the following rules when writing headlines. The best way to write a good headline is to keep it simple and direct. Be clever only when being clever is called for. Puns are good, but only on "punny" stories. Effective headlines usually involve logical sentence structure, active voice and strong present-tense verbs. They do not include "headlines." As with any good writing, good headlines are driven by good verbs. Normally numbers should be avoided in the beginning of the headline like "3 die in crash". Then all head should be written to the left. The headlines should always be written in present tense like "Accident kills 3" and not "Accident killed 3". The cardinal principle is that news reports are history in the making and not a history which is always in the past tense. Use present tense for immediate past information. Use single quotes like Obama: 'Economy bounces back' or Modi: 'Make in India brings FDI'.

Avoid ambiguity in the headline. Headlines like 'Massive crowds greet Obama' are wrong because there is no clarity on what massive here means. Is one million massive or ten million qualifies to be called massive. Similarly don't use words like elderly. If a headline says elderly man saved from drowning. What does that mean? Elderly may refer to a man between the age of say 60 years to 100 or more. Be careful about headlines that convey a double meaning or hidden meaning like Need I say more?.

As far as possible we should use straight headlines which relate the main topic of the story. They are the most common types of headlines and are the easiest to understand.

There are headlines that ask a question. Like "To be or not to be", that comes from famous soliloquy of Hamlet in Shakespeare's Hamlet. One can use quotation headline effectively like "smile and smile and be a villain". Headlines for some unusual or amusing stories don't give a complete meaning. It's often necessary to read the story to understand the headline.

While working on the Desk we found that for a sub editor it is easy to edit the entire story but often difficult to give a suitable and most befitting headline. Often when it comes to giving a headline, the sub editor would order a cup of tea or coffee, think deeply and then could out with some of

the outstanding headlines. Indeed headline is art of selling the story. A good headline brightens even a dull newspaper or the story.

Broadly the headline should:

Fit into the space
Should tell the story
Should be eye catching
Should conform to the policy of the newspaper
Should not sensationalise the story
Should not editorialize

Lead or Intro:

The lead or intro is the first paragraph, but it is written to provide a detailed preview of the entire story. It summarizes the story and includes all of the basic facts. The lead will help readers decide if they want to read the rest of the story, or if they are satisfied knowing these details. There is another reason to pump in most of the points of the story in the lead itself because a reader who is in hurry or who spends very little time on newspaper would read only the headline and the lead to get required information.

One may use any kind of intro or lead but it should always be kept in mind that

The lead should be befitting the story or appropriate to the content of the story.

It should be succinct as far as possible

It should be the crux of the story and contain key point or key points of the story

The lead should lead the reader to the story as such it should be interesting enough to make a reader read the entire story.

Type of Intros or Leads

Basic elements of a news story can be found by asking and trying to find answers to six basic questions popularly known as the five Ws and one H. The five Ws are- What? When? Where? Who? and Why?. And the H is how?

There was a time when journalists were supposed to answer all the questions in the intro. But slowly it was discovered that it resulted in over-crowding of

the opening para, loss of clarity which at times confused and irritated the reader.

There are innumerable ways of writing intro or lead. The first paragraph of the story is called the intro or lead. There are various ways to classify the intro or lead depending on different criteria. Broadly the leads are of following types:

1. **Bullet lead:** It is like a bullet and hits straight on the head. It is used for exceptional events and can be used without giving details because either the place or personality is fairly well know.
 Example: *Prime Minister, Indira Gandhi was assassinated by her bodyguards at her residence here today.*
 You need not give more details in such type of lead because the personality is well know to the world.

2. **Simple lead:** Such type of lead involves a single incident. Even if the event may have several different incidents, the intro takes account of a single incident. Simple lead is very common in newspapers and should normally be favoured as it is easy to write it clearly.
 Example: *The Prime Minister announced a special package for flood hit farmers after an aerial survey of the countryside here today.*

3. **Complex lead:** It involves more than one incident in the intro. It is normally used when similar or related incidents are clubbed together in one story. One has to be careful with this kind of intro as it is normally long and at times confusing.
 Example: *While Ronaldo won the World Cup final almost single handily, in Tennis, William sisters caused a major upset by edging past the World champion today.*

4. **Astonisher:** This intro is of moderate length from twenty five to thirty five words and tries to arrest the reader's attention by presenting the unexpected but not of world rocking importance.
 Example: *It was like a shocker when the lone young girl caught hold of the sturdy thief and prevented the robbery attempt at the shop here today*

5. **Cartridge or Capsule:** This lead is brief and goes right to the point and present news with high concentration of news values. Such lead is short and crisp without any superficial details.

6. **Descriptive lead:** Also known as situation or picture lead, it tries to paint a word picture of an interesting person, place or thing to help create mood for the story. It gives all details in the lead itself.

7. **Staccato intro:** It consists of short clipped words, jerky, disjoined phrases, sentences, sometimes separated by dots or dashes. It is casually disruptive and should not be used if the facts of the story do not justify it. It is rarely used these days.

8. **Freak lead:** This type of intro has a novel approach in sentence structure and presentation, in order to catch the reader's attention.

9. **Summary Lead:** This lead gives the story in the first sentence. In fact it is a summary of the story. Such lead summarises the key points.
 Example: *At least 12 persons were killed and 40 injured when a truck and bus coming from opposite directions collided head-on today.*

10. **Interpretative lead:** With interpretative news stories becoming more and more prominent in journalism interpretative leads are also becoming common in newspapers. But reporters normally do not quote anybody and begin with a statement from the writer of the story. The interpretative lead gives the assessment of the reporter or special correspondents based on facts of the situation.

11. **Quotation lead:** The lead can begin with a quotation and then give details subsequently in next sentence or next sentences. Such lead can be very effective if quotation is relevant and well chosen.
 Example: *"To be or not to be that is the question". Whether the leader should accept the offer from the premier to accept a new responsibility for a new apolitical assignment or continue in active politics. The reporter can begin the story with a lead like this "A thing of beauty is a joy forever". This was what one would feel after attending the flower fair organised by the Horticulture Department at the City Rose garden here today.*

12. **Suspended interest lead:** The lead does not give a clue about the story that follows. That is why it is called suspended interest lead.
 Example: *The young man was carrying a knife in his hand. It was midnight. What was he upto? Such type of lead keeps the interest of readers in the story till the end.*

13. **Question lead:** Such lead begins with a question. Normally such a lead is used when you want to involve large number of people in the story. However, most Editors do not like to use question lead these days on the argument that readers want answers and not questions from a story.
 Example: *Who is responsible for the turnaround in the fortunes of the company?. That was the question uppermost on the minds of all those who were present at the meeting.*

14. **Oddity lead:** This lead begins with an odd equation. It may be an odd comparison.
 Example: *Cricket and religion are two separate things but in India cricket is religion for many people.*
 Example: *For sale an elephant.*
 Example: *Wanted supporters for the President.*

15. **What lead:** Such lead begins with What.
 What lead to tsunami and subsequent destruction in the coastal belt across the globe?

16. **When lead:** This lead begins with When.
 Example: *When would the World Earth Day be celebrated? According to UNESCO, it would be celebrated on April 22.*

17. **Why lead:** As the name suggests, the Why lead begins with Why.
 Example: *Why Commonwealth games have been postponed? Then rest of the story gives the detailed content.*

18. **Where lead:** This type of lead begins with Where and then goes on to elaborate the story in the body of the story.
 Example: *Where was the police when a mob attacked the religious place to foment trouble?*

19. **Who lead:** This type of lead raises an important question and begins with Who.
 Example: *Who was the mastermind of the massacre? That is still a mystery for the police and intelligence agencies.*

20. **How lead:** *Such a lead tries to involve readers by raising a question mark with its How.*

Example: *How could the prisoners scale such a high wall and escape? Then answers was it with the help of police and jail authorities that such a sensational jail break plan was executed.*

21. **Contrast lead:** Such lead gives comparison and contrast between two different things and situations to catch reader's attention. Contrast could be between big and small, ugly and beautiful, old and new, past and present, simple and complex, comedy with tragedy and so on.

22. **Figurative lead:** The Figurative or Colour lead begins with figures of speech and uses metaphors. Like the athlete bounced like a lion to race ahead in marathon to lift the title.

23. **Direct address lead:** Such lead directly establishes contact with the readers with the word You.
 Example: *You may believe it or not but ants can make an elephant mad.*

24. **Parody lead:** This lead begins with parody of a song, a phrase or a quotation. The pun in such a lead is intended to introduce a serious subject to the reader in the form of a parody.

25. **Dialogue Intro:** Such an intro begins with a dialogue. "People, mostly sycophants have formed a coterie around you and your self fixation is not allowing getting real feedback from people" said an opponent to the President. The President retorted "We have called this meeting to discuss issues concerning the country and not to discuss persons or personalities. I will not allow this and if you still insist, I will move out." The story then elaborates that the threat worked and the opponents within the party kept silent during further proceedings.

26. **Narrative lead:** This lead is like narration of a story. The narration could be from the middle of the story and then come to the central point.
 Example: *He kneeled down, found blood everywhere and cried his heart out. That was famous Hollywood actor enacting a tragic scene when the Director announced "cut".*

Chapter VI

ART OF WRITING A NEWS STORY

Inverted pyramid style of writing

Once you have set the stage with a catchy headline and a good lead, you follow up with a well-written story that contains facts from your research and quotes from people you've interviewed. There are many ways of organizing news stories, or in other words, there are many basic structures on which the content of news stories is based.

After headline which is usually given by the sub editor, what follow are the intro or lead and then the detailed story. It should be written in a manner that there is continuity throughout the story.

You must have noticed when you enter a movie hall, little late when the movie is already being screened. You are unable to reach your seat in view of darkness around. The torch man comes, holds you by your hands or otherwise directs you to the seat. It is the same way a reporter holds the reader by the hand and takes him through the story from beginning to end.

Ideally never use the same key word in the story again. If it is absolutely necessary then you should ensure that it is not used again in the same paragraph. Still not finding the equivalent of that word, at least make sure that same word is not used in the same sentence in any way. Try to use simple words and avoid verbosity because lucidity is the hallmark of journalism. Always use small sentences. Do not try to explain everything and every detail in a single sentence.

Stories could be about the man in the street or a common man, on the basis of personal interviews, telephonic interviews or through email, about people who matter and on the basis of press conferences. But always remember some cardinal principles. Never be afraid to ask

What Shakespeare wrote in the 16th century Elizabethan era is relevant even today. He penned that "when beggars die, no comets are seen, heavens themselves blaze forth at the death of princes" which simply means that important personalities matter more than common people. The President catching bad cold or a top film star having fever will make news than the suffering of an ordinary mortal. In such a scenario, the reporter has to find out that extraordinary trait about the man in street that would interest readers.

There are many different styles to write a story like holding the interest of the reader till the last sentence by using suspended interest method. In such a style mystery is kept till the end.

How to write well:

The story would be informative if the Reporter makes it a point to learn that his job is to ask questions to gather information. As such the reporter should never be shy or afraid of asking questions either if it is a Press Conference or an interview or otherwise. At the same time, the reporter should not break confidence. If some information has been given "öff the record", the reporter should not expose the source. When working on an exclusive story, it should not be discussed with anyone else except the Editor of the newspaper. The friends or readers should know about the story only when it is published the next day. One should cross check facts and not take things for granted. Similarly people should not take you for granted. Remember that the only person who can dictate you is your Editor or Chief Reporter. Never be dictated by a Corporate biggie or a political figure.

Long ago, Christian Science Monitor put together a set of rules for beginners to write well. These are still relevant. Following are the ways to write well, without ambiguity and clearly:

1. Use short simple words
2. Use one syllable words
3. Use familiar words
4. Use personal words

5. Use concrete words
6. Make every word work
7. Avoid technical words
8. Get rid of rubber stamp phrases
9. Put sparkle and freshness into simple phrases
10. Create figures of speech
11. Use intimate phrases
12. Use short sentences
13. Make frequent use of short sentences
14. Use short sentences as an aid to clear thinking
15. Make sentences active
16. Use short simple paragraphs
17. Use very short paragraphs for variety and emphasis
18. Use one-idea paragraphs
19. Use paragraphs for action, impact and result
20. Write for a specific purpose
21. Write to one person-one human being
22. Talk to that person right where that person is
23. Talk to that person in his own field of knowledge
24. Work with one basic idea
25. Write with one view point

Common faults in a news story:

1. Headline is not in conformity with the story
2. Headline lacks clarity
3. Lead or Intro does not lead to the body of the story
4. Verbosity because of unnecessary use of difficult words
5. Too long sentences
6. Same word or words have been used again and again
7. Does not meet the style of the newspaper
8. Words used are vague or equivocal
9. No single style has been followed by the reporter
10. Story does not maintain interest of the reader
11. Use of unknown sources like William said. Who is William?
12. The story fails to transport reader to the spot of happening

13. The story lacks colour-the relevant details and information is too sketchy
14. Story contains no information at all
15. The news story contains information that is stale.
16. The story is too sensational or amounts to yellow journalism
17. The story is defamatory in nature and can land Reporter in Court
18. The story is based on information that is one sided
19. It is a planted story and not based on the investigations of the Reporter
20. The story is promotional in nature like promoting the shares and stocks of a company
21. Source has either not been identified or the source is too weak to be relied
22. The story is against the ethics of journalism and public life
23. The story could inflame tensions in society
24. The story passes on vital information about a nation's plans to enemy countries
25. Information is incoherent and not in chronological order
26. Editorialises the story or it is too subjective
27. Story reads like an opinion piece

Inverted Pyramid style of writing a news story:

Now when we know about the common faults in a news story and how to write well, the next question is the style of writing. We find that in today's fast paced life when people are hard pressed for time, it is essential to give readers information in the intro itself. Other details can come in subsequent paragraphs in diminishing utility style.

It is this reason that the most prominent or the most commonly used style of writing news is based on the Inverted Pyramid structure.

Further, a news story is normally written in inverted pyramid style, that is, the most important facts come first followed by other facts in order of significance. The inverted pyramid style has developed in journalism over the years. Detail any events in chronological order. Use active voice—avoid passive voice when possible.

In a news article, you would typically put the most critical information in the early paragraphs and follow with supporting information, background

information, and related information. You do not put a list of sources at the end of a news story.

This way of writing a news story, with the main news at the start and the rest of the detail following in decreasing order of importance, is known as the inverted pyramid. A pyramid has a broad base and tapers towards its top; the news story is just the opposite, with a broad top and tapering towards the base. It is therefore called an inverted (or upside-down) pyramid.

This "shape" of the news story, with a "broad" top and a "narrow" base, is in the weight of the news itself.

Examples of the inverted pyramid form can be found in writing before the mid 19th century, but most journalism historians say that the concept was developed during the American Civil War.

Newspaper correspondents in the field sent their dispatches by telegraph. As they were afraid that the system would malfunction or the enemy would cut the wires, the correspondents squeezed the most important information into the first few sentences.

Reporters using the inverted pyramid style of writing normally summarize a story in the lead and present the facts in descending order of importance. Consequently they place the story's most important details in the second paragraph. They continue to add details in decreasing order of importance. Each paragraph presents additional information: names, descriptions, quotations, conflicting viewpoints, explanations and background data.

According to this structure, news stories are organised in such a way that the most important or most interesting part of the news is told first. This usually refers to that kind of information which is important to the reader, and he/she would want to know about it first. All questions of who, what, when, where, why and how are answered here.

After this, usually the details are given. This part of a news story usually reflects that information which is used to substantiate the beginning part. And then this is followed by some conclusion, or the least important bit of information, that winds up or ends the news story.

Thus, the inverted pyramid structure basically organizes the information in an order of diminishing importance, with the most important information first, and the least important information at the end.

In other words we can say that the inverted pyramid is a metaphor used by journalists and other writers to illustrate the placing of the most important

information first within a text. It is a common method for writing news stories and is widely taught to journalism students. The "inverted" or upside-down "pyramid" can be thought of as a simple triangle with one side drawn horizontally at the top and the body pointing down. The widest part at the top represents the most substantial, interesting, and important information the writer means to convey, illustrating that this kind of material should head the article, while the tapering lower portion illustrates that other material should follow in order of diminishing importance. It is sometimes called a "summary news lead" style or "Bottom Line Up Front" or BLUF.

The format is valued because readers can leave the story at any point and understand it, even if they don't have all the details. It also allows less important information at the end, where it can be removed by editors so the article can fit a fixed size - that is, it can be "cut from the bottom". Rather than petering out, a story may end with a "kicker" – a conclusion, perhaps call to action – which comes after the pyramid. This is particularly common in feature style.

However, this style also has several disadvantages. Just because the lead summarizes facts that later paragraphs discuss in greater detail some of those facts may be repeated. Second a story that follows the inverted pyramid style rarely contains any surprises; the lead immediately reveals every major details. Third, the style makes some stories more complex and more difficult to write. Despite these problems, reporters use the inverted pyramid style for most news stories.

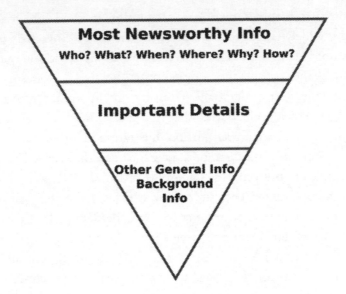

Thus, the inverted pyramid structure basically organizes the information in an order of diminishing importance, with the most important information first, and the least important information at the end.

1. **Address the 5 W's.** Writers like to start out with who, what, when, where and why using the inverted pyramid form.

The reader knows the outcome of the drama in the first sentence of the news story. The background information about how it happened, and why it happened, are filled in later in the story.

Top priority

News stories are written in a way which sets out clearly what is the top priority news, what is the next most newsworthy, and so on. This makes it easier for readers and listeners to understand.

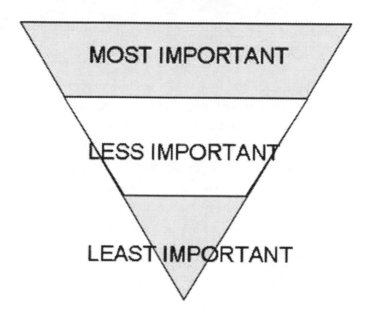

In many societies, people read newspapers and web pages in a hurry. They probably do not read every word, but skim quickly through, reading headlines and intros to see which stories interest them. Some which seem at first glance to be interesting may seem less interesting after a few paragraphs, and so the reader moves on.

In other societies, people may find reading a newspaper hard work. This may be because it is written in a language which is not their first language; or it may be because they are not good at reading. They, too, will look at headlines and intros to decide which stories are interesting enough to be worth the effort of reading them.

In either case, the readers will generally read less than half of most stories; there are very few stories indeed of which they will read every word.

Similarly, people do not listen intently to every word of a radio or television news bulletin. Unless the first sentence of each item interests them, they allow their minds to wander until they hear something that interests them.

The way a news story is written therefore has to do two things:

- It has to sell the story to the casual reader or listener.
- It has to give the main point of the story very quickly, so that even if the reader moves on after one or two paragraphs, or if the listener stops

listening after the first sentence or two, they will still have a fair idea of what the story was about.

This way of writing a news story, with the main news at the start and the rest of the detail following in decreasing order of importance, is known as the inverted pyramid. A pyramid has a broad base and tapers towards its top; the news story is just the opposite, with a broad top and tapering towards the base. It is therefore called an inverted (or upside-down) pyramid.

The first paragraph, which is called the intro, contains the most newsworthy part of the story - the newest, most unusual, most interesting and most significant - told clearly and simply. This is followed by a full explanation and all the details. The most newsworthy parts of the story will be written nearest to the top of the story.

The later part of the story - the tapering point of the inverted pyramid - contains detail which is helpful, but not essential.

Advantages of Inverted Style:

Journalism has a love-hate relationship. Historians argue over when the form was created. But they agree that the invention of the telegraph sparked its development so that it had entered into common use by newspapers and the newly-formed wire service organizations by the beginning of the 20th century. But the fact that it is used even today and even online media uses it shows how useful this type of style is.

1. **Useful for reader in a hurry**

The primary advantage of the inverted pyramid style is that if someone stops reading a story after only one or two paragraphs, that person will learn the story's most important details.

2. **Easy to edit and crop.**

Moreover if a story is long editors can easily shorten it by deleting one or more paragraphs from the bottom. If it is necessary to cut a number of lines, to fit the story into the available space on a page or into the available time in a news bulletin, it is best if the least important facts are at the end. They can then be cut without harming the story.

3. **Readers can identify with the story**

News stories put the main point first, with other information following in order of importance, finishing with the least important. This helps readers and listeners by identifying the main news and saving them time and effort.

Some other tips on writing news reports

What noted writer E. M. Forster suggests for a successful story teller equally applies to a journalist to learn about the craft of perfect writing. According to Forster, there are seven elements vital to a novel: story, people, plot, fantasy, prophecy, pattern, and rhythm.

The famous poet William Wordsworth defined poetry as spontaneous overflow of powerful feelings, emotions recollected in tranquillity.

Similarly, the news story writing is a craft. If you need writing a news story, you need to concentrate on the four important parts of a new story - the news, context, impact and emotion. The way you combine these four elements will determine the success of your news story. Because you have to make reader read the entire story which must have a beginning, middle and an end.

Holding reader's interest

The news story must answer all the questions that arise in the mind of a reader when he or she is reading that story. Readers need to know the facts and who or what may be affected by them. Related stories and background information make up the context and the emotional parts of the story show the human side of it. In depth stories provide all the relevant information along with backgrounder.

Following are tips on writing a compelling and gripping news report.

* Facts: Always remember that for a news story, the most important aspect is the facts. The facts will answer the: who, what, when, where, why, and how of the news event. A writer has a responsibility to make sure his facts are accurate. If you have to write a report before you get all the facts and then say that in the report otherwise the readers will take the story at its face value and would only curse you for lack of clarity and lack of complete information.
* Style: There is a famous saying that style is the man and writing distinguishes one writer from another because everyone has a distinct

style of his own. When writing a news report, use the active voice. The active voice is more understandable and has more impact.

- Is it new? News must have an element of novelty because no one is interested in stale news. Even for news magazines or periodicals that use old news, you have to give an analysis of an event or situation to provide an element of novelty.
- Is it unusual? Because no reader is interested in hackneyed information. The information must be unusual to make it an interesting copy.
- Is it interesting or significant? Today news has become more of entertainment. As such it must be written in an interesting fashion with interesting details.
- Is it about people? Readers are interested in news because it concerns people. The more the people that are affected the more would be the news value of the story.
- Lucidity: Make short, concise sentences with action verbs. Your language needs to be simple and not have extra words that don't really contribute to the focus of the story. For example, the weather or how someone is dressed doesn't need to be included unless it has a bearing on the overall story. While you are writing, try to anticipate any questions a reader might have while reading your story.
- Writing a Good Lead

The lead is the first few sentences of the story which must be catch and crisp to attract readers to the story. It needs to be strong so it will grab the readers and make them want to read more. First as we know comes the headline that catches the attention of the readers, then comes the lead or intro which must maintain the interest of the readers and take him to middle and then finally to the end of the story.

- If it is a hard hitting news story, which is the breaking news or up-to-the-minute news, then you include as many facts as you can in the summary of the story. It should be purely written in an objective fashion avoiding subjectivity or use of word "I".
- If it is a soft news story or a featurized news story or a human interest story or background information, then you put the facts in the body of the story.

- Leads need to tell the reader what the story is about and why it is important. The lead tells the reader why he should read the story. It needs to sound like you are having a conversation; that you are telling a friend about the latest news. Lead must lead meaning thereby that it should lead to rest of the story.

- Errors in a lead: If lead is inconsistent with the story or some errors that are found in leads include the lead having more than one main idea. When this happens, the reader is unclear as to what the story is about. You have to help out the reader and not to confuse him.

- Some leads are lifeless and innate. Such leads are dull and predictable. It's good to make the reader smile or be surprised sometimes.

- Leads should not be full of jargon, bombastic words or only technical of scientific words. Make sure the news report is suitable for everyone to read. Don't presume that your reader knows everything and is well read.

- If you follow a step-by-step approach to the rest of the story you will make your task simpler and easier. The amount of detail which you include will be different for print and broadcasting. If you are writing for a newspaper, you will need to include as much relevant detail as possible. If you are writing for radio or television you will give much less detail because its copy is crisper with more space for visuals. For example, a newspaper report should certainly include the names and other details of the dead and injured people, if those details are available.

- Include only those details that are newsworthy. One reason for this is that newspaper readers can jump over details which they do not want, and carry on reading at a later part of the story. Radio listeners and television viewers cannot do this, so you must make sure that you do not give details which most of your listeners will not want. It is also true, of course, that you can fit much more news into a newspaper than into a radio or television bulletin. Radio reports or reports for the television have to be short so that there is room for other reports in the bulletin. There is an exception of relative importance of the story.

The four criteria for news:

The intro

By filling in just enough of the Who? What? Where? When? Why? How? To allow the intro to stand alone if necessary, we finally wrote the intro: We have different options at this point for writing the rest of the story. We could tell it chronologically or achronologically- that means in the time order in which the events happened or just opposite to that. Or we can tell it in descending order of importance of the key points, all the way down to the least newsworthy at the end. Or we can use a combination of these two approaches. Like we can begin by giving the key points in descending order and then fill in the less important details in chronological order. Either way the story must hold reader's attention till the end.

Whichever option we choose, there must be a clear logic behind the way the story is told. This will make it easy for the reader to follow and understand it.

So it is with writing the news story. You must choose a clear and simple sequence for telling the facts and giving relevant opinions. In this way your readers or listeners will not become confused. Give the main key points in descending order of importance and then to tell the story in chronological order to give the minor details. This will demonstrate both of the other approaches.

Telling the rest of the story

We have so far used five of our key points in the first four paragraphs of our news story. The remaining two key points are facts about the cyclone itself - how it was spotted and how people were warned. There are clearly lots of details which can be given here.

It would be possible to write the rest of the story by choosing more key points from the information left, ranking them according to newsworthiness then writing them in order. This is, however, very complicated and may confuse your reader or listener. A much simpler alternative is to now go back to the beginning of the event and tell it in chronological order, as things happened.

Checking the story

Before we hand this story in to our chief of staff or news editor, there are two more things we have to do to make sure that it is accurate; we must check for mistakes and we must check for missing details.

Inexperienced journalists are often so relieved that they have actually written a story that they forget to check it properly. You should make it a firm rule to read your story through several times before handing it in.

If you should find another mistake on any reading, correct it and then, because your reading has been interrupted by the correction, you should read the whole story through again from the beginning. Keep doing this until you can read it through from beginning to end without finding any errors. Only then can you hand it in.

Mistakes

We have to check back through our story to make sure that we have all the facts correct, the right spellings, the correct order of events, the proper punctuation. In short, is this how you want to see the story in your newspaper or hear it read out on air?

Missing details

We have to ask ourselves whether there are still any outstanding Who? What? Where? When? Why? or How? questions still to be answered.

The amount of detail which we include in the story will depend on how much we feel our readers or listeners will want.

Newspapers will give more details than radio or television bulletins. In particular, we shall want the names of the six people who have been killed to publish in a newspaper report; but not in a broadcast report.

The final version

For final version of the story, one must check for mistakes, missing details. Remember to read your story through thoroughly before handing it in. If you find any errors, correct them - *then read it through again.*

Ask yourself the following questions:

- Does your intro meet all the requirements?
- Have you chosen the key points? Have you ranked them in order when writing your story?
- Has your story answered the six questions **Who? What? Where? When? Why?** and **How?**

- Have you presented the facts in an orderly manner and provided links between different segments?
- Have you read it through again?

Writing news stories isn't particularly difficult. It does take practice and not everyone will be an expert but if you follow the guidelines below you should be able to create effective news items without too much stress.

Avoiding faults in a news story

An average reader reads about 200-250 words a minute or say four words a second. Any writing that is pompous and verbose hinders this smooth flow of reading. Such a story which has more difficult words which an average reader understands only creates problems in communication. These are problems that a reader faces to comprehend and grasp the gist of the story. In view of this, lucidity or clarity in writing is of utmost importance in journalism. The common faults with any news stories can be summarised thus:

- Lack of clarity: Writing simple, direct and clear sentences is the most difficult task. It comes with more and more practice. A good news story should have the language that the common people understand. Sentences should be as short as possible say about 20 words at the maximum. Though in exceptional cases, the sentences may exceed this limit. The lead sentence should preferably have single idea. Multiple ideas in lead sentence may confuse the reader.

You must use language of people and words that are understood by the people. To give you an example, the word table has different connotations in different countries. In USA, 'to table a resolution' would mean to drop it, shelve it, pigeon hole it or prevent action on it. The resolutions are tabled which means presented, asking for a vote on it. In India, 'under the table' is mostly used to explain underhand deals.

Till recently banana was nothing more than a fruit. But now it is 'going bananas' means to be driven out of one's mind. Similarly creep earlier meant movement but not it means an objectionable person.

- Tired words: Tired words or obsolete phrases should be avoided like 'busy as a bee' 'cool as a cucumber', 'blushing bride', 'meets the eye', 'last but not the least' or 'green with envy. Use of 'dead body' is wrong as also 'repeat again'.

Easier reading also requires small paragraphs, use of non-technical words and use of intimate phrases and writing as people speak.

- All questions not answered: A story that does not provide replies to the five W's and one H, leaves the reader perplexed. It confuses the reader and leaves many strings hanging. The news stories should be written in such a way that they satisfy the reader's curiosity.
- Lack of attribution: Attribution is the practice of attributing news to the proper sources. The best attribution is to name the source. The second best attribution is to name the organisation and the third one is to attribute the news to the informed sources.

The rule is that every news story must have a source. Even if the source is not identified, some indication or hint must be given so that readers could evaluate the source. If origin of source is to be kept confidential, the news story should be left to a very senior journalist who may who may involve top editorial people on the plea that information must be passed on in public interest.

- Use of unknown characters: A news story that uses unknown characters like Ram Singh said or John said that thing. Who is Ram Singh or who is john? Don't take your readers for granted that they would know the person you have named in the story. Identify the person quoted like Prime Minister, Narendera Modi or former Chief Minister of Punjab, Capt Amarinder Singh.
- Comments in a story: News and views are two different things and should never be mixed up. A news story can give backgrounder but not comments. This is the job of the Editor to give views in the editorials or pieces on edit page or opposite edit page (OPED). Reporters are not supposed to give their point of view in the story.
- Lead & body differ in substance: Lead must agree with the body of the story. If the story is light or has a humours touch, one can use oddity lead or gag lead. The tone of the lead must be in keeping with the story.

Similarly if the lead says that at least 1000 persons had died in the tsunami or earthquake, the body of the story must justify the number.

- Use of past tense: It is a tradition that news story is written in past tense for newspapers. However, headline is given in the present tense. Radio uses one tense for the entire story. When the newspaper story is written, the event is recorded. It becomes part of the history. History is always in the past tense. However, headlines are for hurried readers conveying urgency and immediacy and hence use is in present tense. Any variation in it would be a fault with the news story. Newspapers have an air of permanence.

- Distortion: Sometime newspapers and reporters take sides and become parties to an issue. The news in this case becomes faulty as it appears in the newspapers. Some reporters emphasis a fact or attain striking effect and resort to hard words and inadvertent comments.

For example, how can you describe a meeting as 'massive'? How many people make a meeting massive-10,000 or 10 lakh people? At the best you can say that the hall which has a capacity to accommodate one lakh people was full. You should be specific. Then how can you describe a woman tall 6 feet or 6.5 feet. Instead of generalising that the elderly woman was performing aerobatic say the women in her sixties. Even otherwise no woman would like to be referred as elderly at any age. When using an abbreviated form, first explain the full form. Give meaning to news like never write simply that the Parliament Speaker was nervous. Better say that the Parliament Speaker threw papers on the table.

- Writing in good taste: Avid morbid style of writing. No good reporter should intentionally try to harm individuals in the news. Avoid arousing morbid public interest and good taste must be following in making reporters. Using hard words in the name of straight reporting or making an excuse that so and so said it is not a sufficient ground for using harsh words.

- Sadism: Never draw a sadistic pleasure out of the stories you write. Sadism is driving pleasure from inflicting pain or injury on others. It is a form of sexual perversion. Its opposite is masochism a condition in which the subject delights in being hurt of humiliated especially as

a form of sexual perversion. A reporter should never poke a crippled person or write to embarrass women.

- Distortion by cooked up facts: Publishing pictures of a prominent personality, a religious figure, carrying a bottle in hand to wrongly show that it was a bottle of liquor though it was plain water is wrong. It is unethical. Rumours used as news reports are not acceptable in journalism. Rumours are unverified gossips in most cases.

- Adhering to a style: There is a style book of every newspaper or television channels. Many newspapers use Mr. Miss or Mrs with the names. However, some newspapers consider it a waste of precious news space while there are others that use these prefixes but don't use these for criminals and in sports. This creates problems and confusion galore. For instance when a reporter is not sure of the status of woman, whether she is married or unmarried? It is always better to use Ms in all such cases. The cardinal principle is to conform to a style so that there is uniformity.

- Omission of necessary details: For the sake of brevity or being succinct, a reporter can't do away with necessary details. The reports filed by a reporter must give details that a reader would like to know. If necessary details are missing, that is a major fault with a news story and as such no reporter should commit this follow for the sake of brevity.

Chapter VII

WHY DEVELOPMENTAL JOURNALISM?

It is somewhat ironic and unfortunate to talk about the need and the possibilities of development journalism in an era that is being characterized as the era of communication revolution.

Development Journalism is the new, upcoming entrant into the field of journalism that has carved an identity by delving into the grave and unpleasant issues of the socio-economic segment of the society and world. The social and economic concerns, issues and crimes form the basis of this form of journalism.

I got my first lesson in developmental journalism when I was posted with the Indian Express at Dehradun covering Garhwal and Kumaon that were mostly untapped. Doing a series of write ups on Gujjars-the forest dwellers of Rajaji National Park provided me an opportunity to understand the nuisances of developmental journalism. The question was whether the these forest dwellers who were staying in forests for centuries were the rightful owners of forests or the officials who wanted to get them out of forests that had been declared a national property? I learnt all these while working in tandem with Professor Avdhash Kaushal, a highly respected philanthropic on which Padma Shri was conferred by the President of India for taking up environmental issues.

Interestingly I found that Gujjars are vegetarians, lived in close harmony with nature as there never had been a case that wild beasts had killed any Gujjar and they were one's who did not allow forest mafias to run a reign of terror in forests. Little doubt elephant population had surged in Rajaji National Park. Ditto for Valley of Flower which was declared a National Park and banned for locals. Soon the number of flower types came down from 1500 types to less

than 500 as tall grass and weed overtook flower plants. Before declaration of Valley of Flower as a National Park, locals used to enter with their herd for grazing the succulent grass allowing flowers to grow.

The reward in the form of "National Award for Developmental Journalism" came my way later when doing a series of developmental stories from Himachal Pradesh on empowerment of women, marginalized people, I did a story on How Panchayati Raj system was changing the lives of people of the hill state. The Award was conferred on May 4, 2011 at Shimla.

One finds that during last several decades means of communication have really been revolutionized and the process still continues, but at the same time the gap between communication media and human aspects of information that relate to common people has also widened in a similar proportion.

Developmental journalism is when media takes up social and economic concerns of people that is the basis of developmental journalism. It is much more than filling space in media because it provides media persons a motive to work. It is not the remuneration but the immense satisfaction that one gets on being involved in the development of the society.

The term 'development journalism' was coined very recently in 1968, at the conference of the Press Foundation of Asia in Philippines. Since then it has become quite popular with devoted and dedicated journalists and professionals dealing with the intricacies of it. Though the western nations are sceptical about this process, but the growing significance and requirement of such form of journalism, is only making their stand weaker.

Development journalism centres on development issues- issues that determine, hinder, contradict and intervene development of a nation. Some of the most talked about and frequented concerns are poverty, unemployment, sanitation, health, environment, infrastructure, agriculture, gender issues, road and safety, education, human rights, and labor issues.

Such journalists have a motive to work. Guaranteeing, augmenting, forwarding and causing socio-economic development is the prime mover and objective of development journalists. Also, this group of individuals seeks to inform the general public about the various issues that affect us, and thus awaken and enlighten us against those. They report such events of concern, and try to educate us, so that the malpractices and events can be eroded from the society.

The ultimate aim is to rationalize people, and build up a changed and better society. This I realized when doing a series on Tehri Dam and writing on

the problems of oustees who even after more than a decade of being dislocated and settled at other places were yet to find their roots.

The specific skills required to be a development journalist include excellent communication, to be able to know, understand, comprehend, and share and educate. So is the need of inter-personal skills to be able to empathize, and extract the most crucial and hidden truths. One has to have keen observation power, which does not mean only looking out for different and new events, but also exploring and exploiting those that are already present. Sometimes the most bitter of truths lie in front of us, and we tend to ignore or overlook it. And being aware of everything is necessary that is why the off quoted "journalists are generalists, they know something about everything".

The profession demands considerable amount of travel and expeditions; different projects every other day. It demands great responsibility. One has to be responsible not only to oneself, but also to the organization one is working for and that entrusts such delicate and critical work to the journalist. Responsibility should also be towards the society and people, who are either the sufferers of the crime or are unaware of the existence of such serious issues. Only a diligent human being can fit into the shoes of a development journalist. One who is not concerned about the adversities, threats and risks of the profession.

It might pain us but the truth is that our communication media have never assumed the crucial responsibility of defining and reviewing its role with regard to social concerns and people's problems. It simply means that those who claim to assess and examine everyone and everything are oblivious to assessing and examining their own selves. And this is happening at a juncture when these media are in an extremely capable position for collecting and disseminating information in the society owing to technological and communication revolution.

Despite media's vast economic resources, the frequency of allegations on them of being insensitive to people's feelings and needs are increasing considerably. The chasm between what is being told by the mainstream newspapers and what is being felt by people across the country, particularly by indigenous populations is increasingly widening every day.

Unfortunately, the Fourth Estate responsible for strengthening democracy has also not played its role adequately. Its main focus is on the legislature and the executive. Most of the space in the mainstream media is occupied by news

related to the legislature, the executive, social failures, crimes, statements of political leaders and maligning propaganda.

Media has failed to make efforts to give the society a new direction. Nor does it underline the successes of the society. If we cherish the dream of an India where there is social justice for all, there is amity and mutual trust among people, there is equal distribution of resources; we need to take the society in to a particular direction. Then, in place of statements that divide people, we'll have to publish and highlight things that create sense of unity among them. We'll have to identify and publish about efforts that promote small initiatives of the people. If media doesn't define and perform its role and social responsibility, it'll have to face people's questions and ire in the future. It'll loose its credibility as the Fourth Estate, the vigilant eye of society.

We must remember that when we talk about communication, we are not talking only about transfer of information only; we also include in it the participation of the society, the community we are communicating about. In a society, social institutions can come into existence and survive only when people participating in them are interlinked through communication. Man is the only creature who needs communication the most for all aspects of his life. What he is today and will be tomorrow is because of his ability to communicate with others. It is obvious that culture is communication and communication is culture.

Today, there are unceasing developments in the area of communication; newer kinds of communication medium are coming into existence and that is really obliterating distinctions between mass and individual communication. It is evident that the trend of communicating the same information or material to diverse communities scattered over the globe is just a passing phase. The change is indicated by the current trend of local editions being brought out by newspapers. Hopefully, in the coming days communication on demand will become crucial.

We should also keep in mind that Information Society is evolving at a fast pace. In such a situation, it might be very difficult to demarcate precisely between mass communication and interpersonal communication. It can only happen if we delimit mass communication process only to publishing or broadcasting or telecasting a chosen material or information ignoring the receptors. But in developing countries like ours, apart from interpersonal communication, mass communication is also of considerable interest.

It is true not only about carrying health campaigns like the one against aids and disseminating information about new discoveries and inventions, but also for communicating information that is important for the civil society. We'll have to accept the simple fact that a modern society characterized by democracy, social and economic justice, national integration, social discipline and economic progress can't be possible without the active and oriented help of mass media; for in a country as vast as India only mass media can communicate information to the inhabitants of the rural regions.

A communication system only can ensure that rural populations are consistently kept informed about latest and relevant information and can have a forum for articulating their views. Only it can ensure that the division of country into information rich and information poor regions is gradually eliminated.

Apart from technological progress and economic development, modernization of a society also includes development of democratic institutions by replacing pre-modern and feudal setups. It can only be done by making the poor, the marginalized sections of the society participate in the decision making processes. Development also includes the values of human dignity, equality, social justice and security. Any development that doesn't bring these values in its orbit; that doesn't provide all people equal opportunities is suspect. Mass media can play a very crucial role in it for any transitional period requires new attitudes, a new mind set and a value system in society. Media by its reach, scope and potential can do it very effectively.

For media to play its role as a watchdog, a vehicle of social change needs to be free of the control and interference of the state. It should also not be controlled by either powerful people or companies for that will make it the mouthpiece of only these forces. Freedom of press means that it should not be obstructed it in its above mentioned roles. Flow of information shouldn't be controlled.

The role of media enunciated above can be summarized in a succinct term called 'Development Journalism'. It focuses on the needs of the poor, the deprived, and the marginalized and emphasizes their effective participation in developmental planning. Or to say it slightly elaborately, this kind of journalism motivates the active participation of the affected people and advocating for their interests, in place of the views of the policy makers and the planners i.e. the government. It is for this reason; activists of mass movements and

organizations have initiated efforts for making an interface possible between mass media and such organizations.

There was a time when media would reach to grassroots level of movements for reporting it. But unfortunately now, activists have to do two things simultaneously- carry on with their movements and write news reports about them and also take those reports to newspaper offices for favor of publication. In place of our journalism becoming development journalism, it has become 'envelopment' journalism based on envelopes with press releases reaching newspaper offices.

There is a need to make bridges between peoples issues and the media. To put it more clearly, we want media's centralized power to be decentralized. The word decentralization is in vogue now a day. Power has been decentralized to the Panchayat level, but the watch dog who keeps vigil on this power is increasing getting decentralized. If power could be handed over to an illiterate rural woman, why can't a literate young man or a woman of a village be imparted media training?

From the center to the Panchayat level, power wants media with and around it and those who are in media want are with and around those who yield power and in this holy or unholy alliance it is finally people who suffer and are marginalized.

The government needs to organize training of its PR professionals in writing reports etc say for Panchayat related issues. Local editors and journalists should be invited to these workshops so that they could familiarize themselves with the ground realities of a village and in future are willing to include these issues in their papers.

There is also a need to conduct Media Workshops for journalists and freelancers in which the roles of media and people's issues should be the focal point of discussion. That way media person would get an opportunity for developing a deeper understanding of people's issues.

Chapter VIII

CRIME REPORTING

While it is the duty of a journalist to report fearlessly, he must take precautions to safeguard himself from defamation. Defamation is the publication of any material which leads to lowering the reputation of a person in the eyes of people. Reputation is the property of a person.

Defamation is an injury to a person's reputation and it is both a tort and a criminal offence. The criminal law of offence is codified in Sections 499-502 of Indian Penal Code. However, the civil law of defamation is not codified and it rests on English common law. The courts have to apply the principles of justice, equity and good conscience.

The defamatory statement is not a mere insult of injury or abuse, but its test is in is tendency to excite adverse opinion or feelings of others. The essence of defamation is publication as insult per se constitutes no wrong unless it excites hatred, ridicule and contempt.

Defamation could be by:

i) Words, spoken or intended to be read or
ii) signs or
iii) visible representation

Example:
A says that B is an honest man. He never stole C's car
Here A meant that B has stolen C's car

A asks who stole C's car. C standing nearby points towards B
A draws a picture of B stealing C's car

Ingredients:
Defamation requires publishing an information through words, written or spoken, signs or visible representation.

Exception:
Under the English law, spoken words do not constitute a criminal offence. However, in India, slander (oral defamation) and libel (written defamation) are not different.
Visible representation means every possible form of defamation like chalk marks on a wall, signs or caricatures.
Interestingly in English law even if defamatory matter is not published, but it could provoke breach of peace or is likely to cause breach of peace it is libel.

Examples:
Imputation of illegitimacy
Making a false statement that a person was acquitted of a crime though he was never charged or a statement that a woman was raped, though no incident happened.
Inciting hatred, ridicule and contempt for a person by using a caricature, a humorous story or representing an acatress to be much order than actually she is.
Statement in a newspaper that a lady gave birth to a child by making fun that she married only a month ago.

Exceptions:

There some important exceptions to this which provide defence to an accused charged with defamation:

1. Public good: It is not defamatory to impute anything which is true concerning any person if it is in public good. Truth of defamatory statement is a complete justification and defence to an action. The burden of proof rests on defendant that the statement is true. Nothing

is libel which is a fair comment on a matter of public interest or public concern.

2. Public conduct of public servants: It is not defamatory to express in good faith any opinion whatsoever respecting the conduct of a public servant in the discharge of public functions. Every citizen has a right to comment on the acts which concern him without malice and slander. Those in public positions render themselves open to attack and must accept these.

3. Conduct of a person: It is not defamation to express in good faith any opinion whatsoever about the conduct of a person on a public question and character appearing in that conduct.

4. Reports of proceedings of courts: It is not defamatory to publish substantially true report of a Court of Justice.

5. Conduct of witnesses: Expressing in good faith an opinion respecting the merits of a case which ahs been decided by a court or the conduct of witnesses.

6. Merits of public performance: Opinion in good faith respecting the merits of any performance which has been published for the judgement of public. This includes public performances by actors, singers and authors.

7. Bonafide censure: it is not defamation to pass in good faith any censure on the conduct of other person.

Example: Teacher censuring a student before others
Judge censuring a witness or a law officer
A senior officer censuring a junior

8. Bonafide accusation: Complaint by A to B about the conduct of B's servant in good faith.

9. Bonafide imputation: In good faith for protection of his interests

Example: A tells his salesman to not to sell anything to B unless he pas cash beforehand as credentials of B are suspect.
Conveying caution: To convey in good faith a caution to one against another.

10. Other defences:

That the statement was never made

11. It did not refer to the person
12. It is innuendo (oblique reference or insinuation)
13. Privileged communication. It is on public policy and one can speak up his mind freely and without fear of consequences. Existence of malice is entirely irrelevant in the case. Example: a Judge speaking during proceedings.
14. Statement made with the consent of the person
15. The suit is barred by limitation

Now let us talk about sources of news: Sources of news:

Expected sources
Unexpected sources
Or Predictable
Un-predictable sources

Expected sources:

Interviews:
Interviews could be simple involving common people to elicit their views on vital issues concerning them. Like after the Budget presentation, the reporters need to interview a cross section of people to know their reactions. You can request these sources to allow you a few minutes and you can take their opinion quoting them in the story. You need not take an appointment for such interviews. If you are having telephonic interview, you must first introduce yourself, your media and your intent. Then double check the facts and name and designation of the person being interviewed on phone.

Personality interviews:
This is an in-depth interview. Celebrities are usually covered under this head. One tries to dig out something said by the person before. The personality may be a film star, politician, a sports personality and so on. The personality may be an award winner, a scientist known for his invention or a personality that has excelled in any art form.

In such cases seek an appointment, reach on time and before heading for the interview, prepare yourself with questions and supplementary questions. Interview the source politely.

Take note of the dress of the person you are interviewing, mannerism of the person and his reactions, emotions, his strong points and weaknesses.

A good reporter will make the person being interviewed feel comfortable and at home. The reporter can often provoke the person to dig out information. A reporter has to be a good listener, has to sound and look interested in the subject and what the person is saying.

Try to know the tastes, likes and dislikes of the person and you can also carry a tape recorder or record the interview on your mobile phone with the person's permission.

Press conferences:

Press conferences are addressed by a person who wants to give maximum publicity to his cause

Press conferences are usually addressed by the officials or senior people or victims of some crime

All reporters may or may not be invited to the press conferences.

Reporters have to be little aggressive at the press conferences. Raise your hand if you want to ask a question. Shy reporter's questions may remain unanswered and they may not be heard.

Prepare: Ask questions which are pointed and relevant, specific and well formulated, crisp and short. Idea is to dig out information and to not to only engage in an argument.

Be polite: Never show your differences. Ask questions in a light vein and never very long questions. Let the source do most of the talking. Even if you disagree, allow the source to speak his point of view. The reporter should do minimum talking and source maximum.

Don't impute motives

Don't argue

Let source correct himself

Press briefing: This is done by spokesman of a Ministry

Unexpected sources:

All spot reporting comes under the head Unexpected sources. Like the crime beat, here the reporter has to visit

Spot

Courts of Law

Police Stations

Hospitals

Some precautions: Never mention the name of rape victims in your stories.

Never pronounce your own judgement till a person is pronounced guilty by the Courts

Never give clean chit to criminals on the basis of your judgement

Curtain raiser:

What is likely to happen is called curtain raiser. It raises the curtain about the event that is yet to unfold. It tells the readers what would happen on the basis of information in the story.

The Follow-up:

Keep tab on the events in the aftermath of a story done by your or others. That need to be followed-up till the event or an action reaches a logical conclusion.

Other sources:

State Assemblies

Political parties

Eye witness's account

News agencies

Railway stations

PRO's

Universities/colleges/schools

Defence establishments

NGOs

Weather office

Civic bodies

Public meetings

Hinterland or rural areas

On the record: Remember the cardinal principle that we don't have to make reporters faceless, best practice is to quote, quote and quote. It is always good practice to identify, in your report, your sources of information. Explain their credentials, so that your audience can make a decision about how much weight to attach to the information. The more you quote people, the more authentic your reports would look to be.

Off the record:

At times there is certain information that the source wants to be kept off the record. Also at times the source gives the information and he wants his name and identity to be kept off the record. Often the best information comes from sources who wish to remain anonymous. You must be clear with such sources about how the information is to be used and you must be careful to protect their anonymity. That means, in the ultimate case, being willing to go to jail rather than disclosing the identity of the source.

Often this has led to debates in media whether story is important or the source. In certain cases, the sources disclose the information to journalists asking them to consider the information off the record. In such a situation, vital information having great relevance to large number of people is not shared with the readers. Is this not a fraud with the readers, listeners or viewers? After all the primary function of a journalist is to work in the interest of his audience.

Secure data

Information you keep on your computer, personal organiser, mobile or any other electronic device is "discoverable" by the authorities, thieves or hackers. If you keep confidential information in electronic form make sure it is encrypted. Similarly all files or copies of record should be kept safe so that no one can use this information for his use and at the same time, the information is available to use whenever you need it in the event of a case in court of law against such stories.

Integrity above board

Your integrity and conduct should always be above board and your credentials most trustworthy. You can follow your own set of ethics like:

- Do not accept gifts or favours.
- Do not give colour or take sides when doing a story
- Do not at any time take part in or condone criminal activity.
- Be objective and avoid subjectivity
- Do not provoke criminal activity.
- Don't be swayed by emotions while doing a story
- Do not describe criminal activity in such a way that it encourages others to engage in crime.
- Do not celebrate crime.
- Do not glamorise criminals or turn them into celebrities.
- Familiarize with sections of IPC

No place for yellow journalism

For a crime reporter, there should be no place for yellow journalism. You are not supposed to incite passions or sensationalize stories. There is a proven link between the way the news media reports crime, and the public fear of crime. Crime is bad enough. Reporters who make it appear worse than it actually is are doing society a disservice. Do not exaggerate the worst aspects of a crime. Report what has happened rationally and factually. Do not exaggerate crime, report it factually. Hyperboles have no place in journalism. Above all, be fair, be open, be honest, whether dealing with the police or the public, to build and maintain contacts.

Sensitivity

For a crime reporter, sensitivity is of utmost importance. The victims are obviously key people in any story. You need to gain access to them, deal with them respectfully and sensitively, collect their version of events and report them carefully. Remember that these people have been under great stress. Don't add to it by dealing carelessly with them. But remember, too, that crime against a person is an outrage and the victims are entitled to their anger and distress.

Trial by press

Trial by press is an absolute no in journalism. Remember, the presumption is that a suspect is innocent until proven guilty. It is not the job of the news media to prosecute or defend, to deliver verdicts or pass down sentences. Leave that to the courts.

Don't draw inferences

For a crime reporter, it is important to not to jump to conclusions when receiving information. He or she should understand both sides of a story. Remember even a hardened criminal is given a chance to give his side of the story. Crimes are often about battles, disagreements, lies and half-truths (on both sides, police and public) so never trust anyone blindly.

Talking to everyone

The ability to talk to people at every rank, and build and maintain relationships is vital. You have to know when to keep digging for information from an officer, but also know when you've reached bottom.

Thick skinned

A reporter has to be sensitive and at the same time thick skinned. At times it is difficult to get information and the police official may shout at you but as a crime reporter you have to still insist on information in public interest. Crime reporters face a number of ethical problems when doing their job. Perhaps the biggest problem is remembering where they belong in relation to the police, criminals and the public.

When not doing a story

Sometimes authorities will come to journalists with the request that they keep a story out of the news. Often journalists get hold of confidential information about a criminal. If the information is leaked, this may prompt a criminal to escape. Usually it is because it might compromise a continuing surveillance operation, or put someone's life in danger. Occasionally, the motives behind the request are less admirable. It is not for the individual reporter to decide whether to co-operate in these cases. Always refer it to the editor of your publication. Don't agree to a blackout without consulting your editor. We should keep public interest in mind when blocking a story.

Copycat crimes

There have been a number of cases when criminals followed the leads from popular thriller on television and films. This has led to a debate over whether or not people commit crimes because they have seen similar events portrayed in the media

Avoid exposing victims

The crime reporter should avoid exposing victims of a crime. Some crimes are so appalling that it is difficult to report them without breaching the bounds of good taste. Handle such material with care and sensitivity to the local culture and the sensibilities of the community. Remember the victims and their families. Don't offend your audience with lurid reporting because good taste must prevail.

Identity of the victim or criminal

Crimes become more newsworthy if they involve people who are themselves newsworthy. An ordinary person attacked on the street may not be big news, but if that person is a local chief, that will be very newsworthy. A fraud case becomes more important when it involves a leading politician. A robbery becomes bigger news when police reveal that the robber was an escaped prisoner with convictions for murder and rape. It is generally true that a crime becomes more newsworthy if there is a strong chance of it happening again - usually because the criminal is known and likely to strike again.

However, while writing about the rape victims or victims of heinous crime, the identity of the victims is to be kept a closely guarded secret because by making their names and identity public, the reporters tend to further damage the reputation of these victims in the eyes of people.

You should always check with the police before releasing the names of victims of crimes, especially when people have been killed. It is usually the job of the police to make sure that the victim's nearest relatives are told first, so that they can soften the shock.

If you cooperate with the police, they will usually cooperate with you over this. If you know the names of victims but find that relatives have not been informed yet, you can agree to withhold publishing the names on the understanding that the police tell you as soon as the relatives have been informed.

Why report crime?

Crime reporting has long been a central part of news coverage in free press societies, because crime stories are usually newsworthy. There are several reasons why you should report crime and why people want to read about or listen to stories of crime:

- Readers or listeners often want an explanation of why crimes happen. They ask: "Could it happen to me?" They may want to know so that they can prevent a similar thing happening to themselves.
- Your readers and listeners need to know how laws are broken, and how people who break laws are caught and punished. This helps them understand what laws are and what the penalties for breaking them are.
- Most people obey the law, so crime stories are about unusual events - one of the criteria for news.
- Some people are interested in the way criminals get something without much effort.
- Criminals take risks and face punishment if they are caught. This may make them fascinating to read about.

Types of crime

There are many types of crimes, criminals and victims. There are serious crimes and small offences. There are professional criminals and ordinary people who occasionally break the law. As with all news, crime stories should be new, unusual, interesting, significant and about people.

New - Crime reporting has to be as up-to-date as possible. This is partly because some crimes depend for their news value on being current. For example, a story about a violent killer on the loose will lose much of its impact once he is captured. Also, because in some societies crimes are a regular feature of life, todays break-and-enter quickly replaces yesterdays break-and-enter in the public's attention. Crime stories get stale quickly. Remember novelty is news and it applies most in crime reporting.

Unusual - Murders or armed robbery are not every day events in most communities, and so have news value. However, less serious crime can also have unusual elements. Crimes which by themselves are ordinary can become significant when placed in context. For example, the car theft can be one of hundreds in a city, but it may become significant if it is the hundredth car to be stolen this year. A film star stealing a small item but captured live on CCTV may be big news.

About people - Crimes involve people, as criminals and victims. The so-called victim-less crime does not really exist. People who make false declarations to claim government benefits are taking money which could have gone to other

people. Always try to tell a crime story in human terms. Do not concentrate all the time on the police or the criminals. Look at what has happened to the victim. Your readers or listeners are more likely to be victims of crime than they are to be either police officers or criminals. They are more interested in people, their emotions, and their pathos than innate things or objects.

Chapter IX

BUSINESS JOURNALISM

The other day a senior woman bureaucrat asked me that these days everyone talks about money, about cars, about houses and all other things that are material. What could be the reason?

As a Business Journalist, I pondered over the question for a few seconds and then spontaneously replied that it is the impact of pink newspapers or Business Journalism. Over the past few years, Business journalism has assumed a huge significance as this is the branch of journalism that tracks, records, analyzes and interprets the economic changes that take place in a society.

If there is growth in a country's economy, if there is a fastest growing economy or if there is an economy showing negative growth, this all forms the subject of business, financial or economic journalism.

Over the past four years, China has sustained a a double digit average economic growth making it one of the fastest growing economies in the world. The third world countries are giving emphasis on economic liberalization and privatization. The media has the responsibility, as well as the opportunity, to provide society with objective, accurate, and timely information and thorough analysis of economic trends and events.

Today, there is a growing clamour the world over for journalists with knowledge in the fields of business and finance to interpret economic information and present its implications to the public through various media outlets. As we know the very purpose of journalism is to inform, to instruct and to entertain, so this branch of journalism called business journalism has

to inform and instruct people about the economic trends, about time to enter stock market and to get out of it.

It could include anything from personal finance, to business at the local market and shopping malls, to the performance of well-known and not-so-well-known companies. Business journalism is the activity of collecting and presenting news and commentary concerned with business and economy. Business journalism has no universal definition, and the term tends to be used interchangeably with economic journalism and financial journalism, although the former is often conceived as a more encompassing term while the latter signals a narrower definition of the field.

Business and economic reporting is very different from reporting on crime, social issues, entertainment, or political developments. If you turn to the business pages of any daily newspaper or watch any business TV channel, you will find news on the stock market, industry, foreign exchange market, or the economy in general. You will also see that most of these news items use business and economic jargon without giving the reader the context necessary to understand the story, thereby leaving many questions unanswered in the minds of the audience.

Millions of readers are the main consumer of these business stories. They do not rely solely on press releases and go beyond them. The journalist is not a porter who transports press releases from the government or companies to newspapers or television. A good journalist puts the information in a press release into context and explains the significance of the news to readers.

Business Journalist is required to do research as much as possible. They can have a look at the company's financial statements to learn the financial position of the company before reporting on the organization's growth. They can talk to all the players to get a complete picture.

This form of journalism covers news and feature articles about people, places and issues related to the field of business. Most newspapers, magazines, radio, and television news shows carry a business segment. However, detailed and in depth business journalism can be found in publications, radio, and television channels dedicated specifically to business and financial journalism. These are niche publications.

The business and finance option takes the principles of general news reporting covered in the reporting syllabus and applies them to the full range of business and finance reporting. It ensures reporters can produce the different

types of story for all platforms required from each part of the business and finance news discipline.

Business Journalism is akin to political or any specialized reporting because business and finance reporters also need excellent contacts to break exclusive stories, be able to write attention-grabbing features, analytical features and interview major business and finance figures. Live, exclusive and breaking news is an important element of reporting in this sector with a need to file copy in a series of "takes" for various platforms as the story unfolds. At press conferences, it is important to be able to challenge any business and finance changes to explore how this will affect, staff, unions and the public.

A Business Journalist is supposed to be equipped with sound general knowledge with some analytical faculty with sufficient understanding of both politics and economics to be able to report on a wide range of issues relating to business and finance, and to do so with the ability to humanize complex subjects, making them accessible to a general audience. After all, all readers are not experts. Business and finance journalism focuses on all the macro areas of the discipline, such as the history, background and current state of the global banking and financial crisis.

Historically, business journalism began as early as the middle ages, to help well-known trading families communicate with each other. Business coverage gained prominence in the 1990s, with wider investment in the stock market. The Wall Street Journal is one prominent example of business journalism, and is among the United States of America's top newspapers in terms of both circulation and respect for the journalists whose work appears there. Even till this day, The Wall Street Journal has tie up with many newspapers in the world and they use its content prominently. That is the power of Business Journalism and its global appeal.

Business journalists cover news about the local, national and global economies and their rise and fall. We can also draw an inference about new business models. These specialized journalists report breaking news, compose pieces about business trends and write profiles on prominent business leaders. Business reporters need to break down complex economic topics into terms understandable to the general public.

The issues concerning global banking, markets and economies has reminded us all of the importance of financial and business journalism. It has also raised a set of profound questions as to the quality of that form of

reporting. Why didn't we know this was coming? Did the journalists fail to put the financial system under proper scrutiny? Is this representative of a wider problem with the news media? It is applicable across the globe.

Well, the global financial and economic crisis may not be the fault of journalism. For once, we can't blame the news media for creating this mess or for the cost of cleaning it up. However, it does make us ask about the ability of journalism to report upon financial affairs in a way that lets the public know what is really going on. In that sense, the limits of financial journalism may have contributed to the present disaster.

Even before the current crisis, financial journalism was subject to unprecedented circumstances. Economic and business stories then and now move at a digitally driven speed that does not allow as much time for comprehension. Here comes the judgement and knowledge of a Business Journalist that bails him out successfully in such a crisis situation. The financial facts and systems are themselves much more complex. There are also the pressures of commercial interest.

Then there are the ethical challenges for journalists who have access to information and an ability to either influence markets or gain personally. Financial journalism has not been immune from the pressure on resources. The key resource is time. There is also the challenge of time to get context, diverse views, and context and background facts. New technologies have made journalism more efficient but the business model for mainstream media is under strain. So the temptation for hard-pressed editorial management has been to spread those resources more thinly and prioritise productivity over quality.

Then there is the competition and complexity added by New Media financial journalism. The websites, blogs and forums offer extraordinary variety and, perhaps, greater openness. They provide information sources that simply did not exist before. But they also change the terms of journalistic trade. However, in the context of financial journalism it raises particular problems of trust, influence and accountability. The larger issue is whether journalists are now sufficiently capable of independent thought and critical judgment.

Indeed, that there are incentives for financiers that positively promote a herd mentality. The accusation against financial journalism is that it simply follows those crowds.

The development of business journalism is closely connected to the development of a business press but recently business journalism has also

come to play an important role in all-round oriented mass media. Business journalism has evolved from a marginal position in the mass media into a widely dispersed and differentiated activity guided by journalistic norms and performing important societal functions.

Business and economic reporting is very different from reporting on crime, social issues, entertainment, or political developments. If you turn to the business pages of any daily newspaper or watch any business TV channel, you will find news on the stock market, industry, foreign exchange market, or the economy in general. You will also see that most of these news items use business and economic jargon without giving the reader the context necessary to understand the story, thereby leaving many questions unanswered in the minds of the audience. Millions of readers are the main consumer of these business stories. They do not rely solely on press releases and go beyond them. The journalist is not a porter who transports press releases from the government or companies to newspapers or television. A good journalist puts the information in a press release into context and explains the significance of the news to readers.

Business Journalist is required to do research as much as possible. They can have a look at the company's financial statements to learn the financial position of the company before reporting on the organization's growth. They can talk to all the players to get a complete picture.

Ethics for Business Journalists:

The Press Council of India has counselled reporters/financial journalists/ newspaper establishments to refrain from receiving any gifts/grants/concessions/ facilities, etc., either in cash or kind which are likely to compromise free and unbiased reporting on financial matters.

The Council in its Report has observed that the financial journalists today enjoy considerable influence over readers' minds and, therefore, they owe it to them to present a balanced and objective view of the financial dealings, status and prospects of a company. It observed that some companies are given excessive news coverage in the newspapers/magazines because they have issued advertisements to that print media. Sometimes, adverse reports are published of those companies which do not give advertisements to the newspapers or magazines.

Again, when a media is not happy with any company/ management for whatever reason, the negative aspects of the company are highlighted, while in the reverse situation, no negative aspects are brought to light. Some companies are also known to give gifts, loans, discounts, preferential shares, etc., to certain financial journalists to receive favourable and positive reports of the companies. At the same time, there is no mechanism for investors' education or for raising public opinion against such unhealthy practices.

The Council feeling concerned over the malpractice in the Corporate Sector and after holding detailed deliberations and discussions with the representatives of financial institutions and journalists, has recommended the guidelines enumerated below for observance by the financial journalists:

1) The financial journalists should not accept gifts, loans, trips, discounts, preferential shares or other considerations which compromise or are likely to compromise his position.

2) It should be mentioned prominently in the report about any company that the report is based on information given by the company or the financial sponsors of the company.

3) When the trips are sponsored for visiting establishments of a company, the author of the report who has availed of the trip must state invariably that the visit was sponsored by the company concerned and that it had also extended the hospitality as the case may be.

4) No matter related to the company should be published without verifying the facts from the company and the source of such report should also be disclosed.

5) A reporter who exposes a scam or brings out a report for promotion of a good project should be encouraged and awarded.

6) A journalist who has financial interests such as share holdings, stock holdings, etc., in a company, should not report on that company.

7) The journalist should not use for his own benefit or for the benefit of his relations and friends, information received by him in advance for publication.

8) No newspaper owner, editor or anybody connected with a newspaper should use his relations with the newspaper to promote his other business interests.

9) Whenever there is an indictment of a particular advertising agency or advertiser by the Advertising Council of India, the newspaper in which the advertisement was published must publish the news of indictment prominently.

Terms used in Business Journalism:

Ad valorem: A type of tax including property or real estate tax and duties on imported items that are levied in proportion to the value of the goods. An example of an ad valorem tax would be a value-added tax like sales tax. The Indian Government has proposed to levy GST or Goods and Service Tax which will be common to all states in near future.

Advances: Loans given by a financial institution. These loans can take various forms and are repaid with interest. The opposite of Advances is Deposits.

Aggregate demand (AD): This refers Gross Domestic Product or the total demand for goods and services in the economy during a specific time period that is likely to be bought at a given time. The aggregate demand is known as the amount of goods and services people want to buy.

Aggregate supply: It is represented by the aggregate-supply curve, which describes the relationship between price levels and the quantity of output that firms are willing to provide. The total supply of goods and services by a national economy during a specific time period is Aggregate supply. Aggregate supply is generally linked to price; as prices rises, so does the rate of production of goods and services.

Agricultural sector: This is a major sector and some countries have 60 to 70 per cent of their population dependent on it. For instance India's 70 per cent population is under Agriculture sector. It is part of the whole of a country's economy, focused on products that can be grown or cultivated. It may comprise farming, fishing, forestry, agri products and even horticulture.

Aid: Aid refers to assistance provided by one nation to another, one international funding organisation to another or a country in need. It as such refers to International aid or Assistance generally economic assistance provided to communities or countries in the event of a humanitarian crisis or to achieve a socio-economic objective. Like assistance pouring in for Nepal which has suffered a massive earthquake.

Appreciation: A term used in accounting related to an asset's increase in value. It is the reverse of depreciation, which measures the fall in value of

assets over their normal life-time. Appreciation is also the increase in value of a currency in a floating exchange rate system. Like appreciation in the value of rupee vis-à-vis the dollar.

Asset demand: The demand for assets or their creation is the desire to hold wealth or assets. Assets may be held as shares, property and cash or in another value.

Asset: A resource controlled by the enterprise or a company or a government body as a result of past events and from which future economic benefits are expected to flow. Asset is opposite of liabilities.

Average cost: The price most representative of all prices over time. Average cost is equal to total cost divided by the number of goods produced. It is also equal to the sum of average variable costs. Average cost goes up or comes up on the basis of economics of scale.

Average rate of return (ROR): Also 'return on investment (ROI),' 'return.' A measure of profit; a ratio of money earned to the amount of money invested. While entering stock market, primary or secondary, the investors weigh their options like the ROR to take call on investing or not.

Average rate of tax: The total amount of income tax paid as a percentage of a person's income. Different countries have different slabs for tax. In India the lowest slab is 10 per cent, followed by 20 per cent and then 30 per cent depending upon the income of an individual, a company or a partnership or individual firm.

Average revenue: Also 'price.' Total revenue divided by the level of output. While writing about Budget of a country, the Reporter has to study the average revenue, average receipts and average and actual expenditure. Only them one can arrive at whether the economy is in deficit or not.

Balance of payments (BOP): A measure of the payments that flows between a particular country and all other countries. It is determined by a country's exports and imports of goods, services, and financial capital, as well as financial transfers.

Balance of trade: The balance of Trade is the difference between the monetary value of exports and imports in an economy over the course a certain period of time. A positive balance of trade is known as a trade surplus and occurs when a country exports more than it imports; a negative balance of trade is known as a trade deficit or, informally, a trade gap. A positive balance of trade would actually mean that country's forex reserves are rising.

Balance sheet: A company's balance sheet is the best document to study the economic condition of the entity. In formal bookkeeping and accounting, a statement of the book value of a business, organization, or person at a particular date, often at the end of its "fiscal year." A balance sheet is distinct from an income statement, also known as a profit and loss account (P&L), which records revenue and expenses over a specified period of time. While a closely held company may not share its balance sheet with pubic, a listed company has to make its balance sheet audited and made public.

Base year: The year in which calculations, usually indices, commence and with which other years are compared.

Black economy: Black economy is black money in a country. It is like a parallel economy. It is also called an 'underground market,' 'black market.' Economic activity involving unrecorded dealings, typically the buying and selling of merchandise or services illegally is essence of black economy.

Broad money: The most general definition of money. 'Money' includes paper notes and coins held in private hands, bank deposits, and deposits held outside the banking sector.

Budget deficit: A shortage that occurs when government expenditure exceeds government income. It is mostly in economies that allow huge subsidies to a section of population as a popular measure.

Budget surplus: An excess that occurs when government income exceeds government expenditure. It is an ideal situation for a country's economy

Business cycle: The combination of business and cycle refers to the ups and downs in an economy. The cycle involves shifts over time between periods of relatively rapid output growth (recovery and prosperity) and periods of relative stagnation or decline (contraction and recession). These fluctuations are often calculated using the real gross domestic product (GDP) or the GSDP which is gross state domestic product.

Capacity: The degree of use of economic factors of production. When the economy is at full capacity, all factors of production are used to the maximum extent possible. It also refers to optimum utilisation of the capacity of an enterprise.

Capital: A measure that includes factories, machinery, tools, and various buildings. These factors are inputs for production of goods and services.

Capital account: Part of the balance of payments like accounts that measure the flow of capital in and out of the country, especially debt.

Capital expenditure (CAPEX): Company outlay to acquire or upgrade physical assets such as equipment, property, or industrial buildings. In accounting, a capital expenditure is added to an asset account to increase the asset's valuation.

Capital flight: It is investment made by nationals of a country in overseas markets for green pastures or better returns. The capital flight occurs when assets and/or money rapidly flow out of a country, due to an economic event that disturbs investors and causes them to lower their valuation of the assets in that country or otherwise to lose confidence in its economic strength.

Capital gains: Profit those results from the appreciation of a capital asset from its purchase price. There is Capital gains tax and it is imposed in India if property purchased at a certain price is sold at higher price in less than three years of its purchase.

Capital goods: Real products that are used in the production of other products but are not incorporated into the other products themselves, such as factories or tools.

Capital inflows: The movement of money into a country. Inflows may be in the form of the purchase of shares, the purchase of companies, or loans by overseas companies, among others.

Capital markets: Like the Stock markets. In India we have stocks markets or stock exchanges like BSE called the Bombay Stock Exchange or the National Stock Exchange. Capital market also refers to 'securities markets.' Capital market is a place where companies and the governments can raise long-term funds through the sale and purchase of securities. The capital market includes the stock market and the bond market.

Cartel: A group of formally independent producers that collude to fix prices, limit supply, and limit competition in order to increase profits. The cartels often operate in stock markets to artificially jack up or bring down the prices of a stock for its benefit.

Cash crops: Agricultural products that are produced to earn a profit in the market in short term. Mostly cash crops are those that are sown in between two or three major crops.

Cash flow: The amount of cash received and spent by a business during a defined period of time for specific projects.

Central bank: Also 'reserve bank,' 'monetary authority.' Central Bank is the entity responsible for the monetary policy of its country. In India we have the Reserve Bank of India that is the Central Bank of India.

Certificates of deposits (CDs): A time deposit which has a specific minimum term. CDs have a specific, fixed term, often ranging from one month to many years. It is intended that the CD be held until maturity, at which time the money may be withdrawn together with the accrued interest. CDs generally accrue a higher rate of interest than money deposited in a savings account. One can break the CD to withdraw money in case of dire need.

Credit to Deposit ratio: Also called CD ratio. It is the ratio of credit or advances by a bank as against deposits.

Commercial bank: A type of financial intermediary and a type of bank. It raises funds by collecting deposits from businesses and consumers via current deposits, savings deposits, and time (or term) deposits. Those funds are used for loans to businesses and consumers, as well as the purchase of corporate or government bonds. Its primary liabilities are deposits and its primary assets are loans and bonds.

Commercial paper: A money market security issued by large banks and corporations. It generally is not used to finance long-term investments, but rather for purchases of inventory or to manage working capital. There are four basic kinds of commercial paper: promissory notes, drafts, checks, and certificates of deposit.

Commodity Exchange: Like Stock exchanges deal with various companies and their shares the commodities exchange deal with commodities. The commodities sector comprises main commodities produced in a country like agriculture, mining and quarrying, manufacturing, construction, and electricity.

Consumer goods: Items used by households or a community or society.

Consumer Price Index (CPI): The main measure of changes in retail prices. It measures changes in the cost of buying a representative fixed basket of goods and services and generally indicates inflation rate in the country.

Consumption: Expenditure by households on goods and services. It also refers to consumption of any production in a country or in a state. India is a huge consumer market in which entire world is interested to trade.

Construction sector: The construction sector is part of infrastructure sector and is included in the calculation of gross domestic product and includes all construction, repair, and addition, alteration, and demolition activities carried out in the economy by households, private bodies, public institutions, and the government.

Continuous Funding System: A system by which the financier provides funding to its clients or applicants. However, in many cases the financer stops funding to the client if the product of the client does not find ready buyers.

Core inflation: A measure of inflation that excludes items with volatile prices.

Corporation tax: Also 'corporate tax.' A tax on firms' profits, charged as a percentage of a firm's profits.

Cost of living: The average cost of a variety of expenses for living such as rent, transportation, insurance, utilities, etc.

Cost-push inflation: Also 'supply-shock inflation.' Cost push inflation is a situation which is a type of inflation caused by large increase in the cost of important goods or services, where no suitable alternative is available.

Cost of production: The price of an object as determined by the sum of the cost of the resources that go into its making. The cost can be made up of the cost of any of the factors of production, including labor, capital, land, or technology.

Crowding out: In economics, a situation that occurs when the government expands its borrowing to finance increased expenditure.

Current account: An account opened by a company or an individual businessman in a bank. Current account is distinct from a saving bank account. Usually one has to pay certain charges to the Bank for a current account as often the banks provide a limit to have an overdraft facility to a client. It is also an element of balance of payments. Current account is also the sum of the balance of trade (exports less imports of goods and services), net factor income (such as interest and dividends), and net transfer payments (such as foreign aid).

Current account deficit: When a country imports more goods and services than it exports. This affects the balance of payments, generally negatively. This is called current account deficit.

Debt servicing: The repayment of interest and principle to external creditors. In many economies we find that debt servicing entails huge outflow thus leading to mounting debts.

Demand: The quantity of a good that consumers are willing and able to purchase at a given price at a specific time, all other variables held equal. This is opposite of supply in an economy.

Demand for money: The economic demand for notes, coins, and sight deposits.

Demand-pull inflation: Arises when aggregate demand in an economy outpaces aggregate supply. It involves inflation rising as real GDP rises and unemployment falls. Demand-pull inflation is too much money chasing too few goods or services.

Deposit account: An account at a banking institution that allows money to be held on behalf of the account holder. Some banks charge a fee for this service and client interest on the funds deposited. It could be fixed deposit or term deposit.

Depreciation of rupee: Occurs when market forces lower the value of Rs from one rate to another. In other words, when the value of one currency, expressed in terms of another currency, falls, it can be called depreciation. In India we saw rupee falling constantly vis-à-vis dollar in recent past.

Devaluation: The reduction in the value of a currency with respect to other monetary units; for example, the decrease in value of the rupee as compared to the euro or dollar.

Direct taxes: Charges levied by the state on income. The main direct tax in India is the income tax which ranges from 10 to 30 per cent depending upon the income slab.

Discount rate: Also 'base rate,' 'repo rate,' or 'primary rate.' The interest rate that an eligible depository institution (such as a bank) is charged to borrow short term funds directly from the central bank, as secured by government bonds.

Dissaving: A financial situation where spending exceeds income, due to the availability of savings. The governments in such a situation encourage people to save by offering tax soaps on savings.

Dumping: The sale of goods in a foreign country at a price below that charged in the home market. This will often be done at below cost price to dispose of surplus goods or to establish markets. In such a situation many countries dump goods in another country.

Economic growth: The increase in value of goods and services produced by an economy. It is generally a factor in an increase in the income of a nation. It is conventionally measured as the percent rate of increase in real gross domestic product.

Economies of scale: An increase in the number of units produced causes a decrease in the average fi xed cost of each unit.

Entrepreneur: A person who undertakes and operates a new enterprise or venture and assumes some accountability for the inherent risks.

Equilibrium rate of interest: The rate of interest at which the amount of money people want to borrow equals the amount of money others are prepared to lend.

Equity: Type of security that represents ownership in a corporation. Stocks are equities. Investing in equities is risky but leads to higher returns.

European Union (EU): An intergovernmental and supranational union of 25 democratic member states. The European Union was established under that name in 1992 by the Treaty on the European Union.

Exchange rate: Also 'foreign-exchange rate,' 'forex rate,' 'FX rate.' Specifies how much one currency is worth in terms of another. The spot exchange rate refers to the current exchange rate. The forward exchange rate refers to an exchange rate that is quoted and traded today but for delivery and payment on a specific future date.

Exports: Goods, services, and capital assets sold abroad. It is opposite of Imports.

External debt: Also foreign debt. The segment of the total debt of a country that is owed to creditors outside the country is country's external debt.

Financial institutions: Organizations, like banks, that act as agents to provide financial services to clients.

Financial intermediary: An institution, firm, or individual that acts as an agent between two or more parties in fiscal transactions. Typically, the first party is a provider of a product or service and the second party is a consumer or customer.

Fiscal policy: Actions taken by government with regard to its spending or taxation to influence the level of economic activity.

Foreign exchange market: Also 'currency market,' 'forex market,' 'FX market. Location where one country's currency is traded for another is called Foreign Exchange market. It is by far the largest market in the world, in terms of cash value traded.

Free market economy: An economic system in which the production and distribution of goods and services takes place through the mechanism of free markets guided by a free price system rather than by the state. A free market is a market where price is determined by the unregulated interchange of supply and demand.

Free trade: An idealized market model, often stated as a political objective, wherein trade of goods and services between countries flows unhindered by government-imposed artificial costs.

GDP deflator: Also 'implicit price deflator for GDP.' A measure of the change in prices of all new, domestically produced, final goods and services in an economy.

Government expenditure: Also 'government spending.' Amount spent on government purchases, including transfer payments, which can be financed by seigniorage (the creation of money for government funding), taxes, or government borrowing. It is considered to be one of the major components of GDP.

Government policies: Different type of measures the government implements to improve economic functions.

Grant: A form of foreign aid that involves a direct transfer payment from one country to another.

Gross domestic product (GDP): A measure of economic activity within a country; a measure of national income. A country's GDP is the market value of all final goods and services produced within a country in a given period of time.

Gross investment: Total investment without adjusting for depreciation.

Gross national product (GNP): The total value of final goods and services produced in a year by a country's citizens (including profits from capital held abroad).

Household Integrated Economic Survey (HIES): Report that provides data on household income, sources of income, savings, liabilities, consumption expenditures, and consumption patterns at national and provincial levels with urban/rural breakdowns.

Hedging: In finance, an investment that is made specifically to reduce or cancel out the risk in another investment is called Hedging. Hedging is a strategy designed to minimize exposure to an unwanted business risk, while still allowing the business to profit from investment activity.

Household income: The total income of all members of a household.

Human Development Index (HDI): Introduced by the UN in 1990, a composite index based on real GDP per capita (PPP), life expectancy at birth and educational achievement that measures socio-economic development. The index takes into account the goods and services produced, the ability of a population to use them, and the time the population has to enjoy them.

Hyper-inflation: An economic condition where prices increase rapidly as a currency loses its value. No precise benchmark of hyper-inflation is universally accepted. The definition used by most economists is "an inflationary cycle without any tendency toward equilibrium."

Import price: The cost of goods brought into a country through trade.

Import substitution industrialization (ISI): A trade and economic policy based on the premise that a developing country should attempt to substitute products brought into the country through trade with locally produced versions. This is achieved by an active industrial policy to subsidize and orchestrate production of substitute products, protective barriers to trade, and a monetary policy that keeps the domestic currency overvalued.

Income: Money received as a result of the normal business activities of an individual or a business. It is derived by taking the sum total of sales value minus the actual cost and other overhead expenses.

Income inequality metrics: Also 'income distribution metrics.' Techniques used by economists to measure the distribution of income among members of a society.

Income tax: A financial charge imposed on the monetary earnings of persons, corporations, or other legal entities. It is a direct tax.

Index numbers: In economics, a series of numbers expressing change over time in a group of related variables.

Indicator: In economics, a statistic about the economy that is the basis of analysis of past and future performance.

Indirect taxation: A levy collected by an intermediary (such as a retail store) from the person who bears the ultimate economic burden of the tax (such as the customer). Proceeds are later sent to the government by the intermediary through a tax return. Common examples of indirect taxation include sales tax, value added tax (VAT), and goods and services tax (GST).

Industrial sector: A group of businesses or companies that work in the same field, such as textiles, white goods industry, information technology or garment production.

Infant industries: Fledgling industries that typically require protection from the government in the form of tariffs, quotas, or subsidies in order to survive the lower prices and higher quality of the goods or services produced by the industry on the international market.

Inflation: The rise in general prices and the reduction in value of money. Inflation is a sustained increase in the general price level. In India and in many other countries inflation often has led to the change of parties in power leading to an anti-incumbency wave.

Informal sector: Also 'informal economy.' Any exchange of goods or services involving economic value in which the act escapes regulation of similar such acts.

Interest: In finance, the price paid by a borrower for the use of a lender's money. One can earn interest on the funds kept in a bank for a fixed period or in a saving account.

Interest rate: The price a borrower pays for the use of money he does not own, or the return a lender receives for deferring his consumption by lending to the borrower. Interest rates are normally expressed as a percentage over the period of few months or few years.

International Bank for Reconstruction and Development (IBRD): One of the five World Bank Group institutions. It gives long-term loans to member countries for high priority infrastructure, agricultural, industrial, and educational projects.

International Monetary Fund (IMF): International organization that oversees the global financial system by monitoring exchange rates and balance of payments, as well as offering technical and financial assistance when asked.

Investment: To commit money or capital in order to gain a financial return. The major difference in the use of the term investment between economics and finance is that economists usually refer to a real investment.

Joint stock Company: It may also be called Joint Venture. It is a type of business partnership in which the capital is formed by the individual contributions of a group of shareholders. Certificates of ownership or stocks are issued by the company in return for each contribution and the shareholders are free to transfer their ownership interest at any time by selling their stock to others.

Labour: A person or a worker or a group of people who are willing and able to be employed in a factory or industry or in an agricultural farm. As against this the labour market is an area of economic exchange in which workers seek jobs and employers seek workers.

Large Scale Company: an economic sector that includes all large-scale manufacturing establishment.

Lender of last resort: Originally the term referred to a reserve financial institution, often the central bank of a country that secured other banks or eligible institutions against collapse.

Liabilities: In accounting, money, good, or service that is owed to another party.

Liquidity: The ability to quickly buy or sell a particular item without causing a significant movement in the price.

Liquid reserves to money supply ratio (LRM): Measure of monetary stability used to assess the vulnerability of domestic interest rates to fluctuations in the country's external account.

Livestock sector: Agricultural sub-sector that includes the value of livestock products and the value of draught power (the value of draught power is estimated on the basis of number of work animals used in agriculture and their feed and maintenance cost).

London Interbank Offered Rate (LIBOR): A daily reference rate based on the interest rates at which banks offer to lend unsecured funds to other banks in the London wholesale money market.

Macroeconomic policies: Economic strategies designed to influence the level of employment, the price level, economic growth, and the balance of payments.

Major crops: Major crops of the country not necessarily staple diet of the people. This may include wheat, rice, cotton, sugarcane, maize, tobacco, bajra, gram, jowar, rapeseed, and mustard. The crops may also be divided into season like Rabi and Kharif crops.

Manufacturing sector: Economic sector divided into two sub-sectors: large scale manufacturing and small-scale manufacturing.

Market concentration: The concentration or cluster where a majority or units exists. It also refers to function of the number of firms and their respective shares of the total production (alternatively, total capacity or total reserves) in a market. The extent to which the sale of a product is dominated by the largest firms in the industry refers to market concentration.

Market share: Percentage of share a company has in the market of its product vis-à-vis rivals is the market share. It is also the proportion of total sales accounted for by a particular brand or firm.

Merchant bank: Also 'investment bank.' A private banking firm engaged chiefly in investing in new issues of securities and in accepting bills of exchange in foreign trade.

Merger: Combination of two or more business enterprises into a single enterprise.

Mining and quarrying sector: Economic division that includes all mining and quarrying activities.

Monetary policy: Process of managing money supply to achieve specific goals, such as constraining inflation, maintaining an exchange rate, achieving full employment, or encouraging economic growth.

Money: Any good or token that fulfils monetary functions: to be a medium of exchange.

Money market: Financial center for short-term borrowing and lending.

Money supply: Also 'monetary aggregates,' 'money stock.' A macro-economic concept defining the quantity of money available within the economy to purchase goods, services, and securities refers to money supply.

Monopoly: In economics, a persistent market situation where there is only one provider of an individual product or service.

Multinational Corporation (MNC): A company having presence in other countries by way of units whether independent or in joint collaboration is a multinational corporation or MNC. Many pharma units have presence and manufacturing plants across the globe. Ditto for motor vehicle manufacturers and others.

Mutual fund: Form of collective investment that pools money from many investors and invests the money in stocks, bonds, short-term money market instruments, and/or other securities.

Narrow money supply: Also 'monetary base.' Notes and coins held by the public and the banking system as reserves against withdrawals. National debt: Also 'public debt.' Money owed by any level of government, including central, federal, municipal, or local governments.

National income: The total net earnings from the production of goods and services in a country over a period of time, usually one year, and consisting essentially of wages, salaries, rent, profits, and interest.

National income accounts: The system used to measure the value of national income, output, and expenditure.

Nominal rate of interest: The rate of interest not adjusted for the rate of inflation.

Non-tariff barrier: Restrictions to imports that are not taxes.

Oligopoly: Market form in which a market or industry is dominated by a small number of sellers.

Open market operations: Means of implementing monetary policy where a central bank controls its national money supply by buying and selling government securities. Monetary targets, such as interest rates or exchange rates, are used to guide this implementation.

Organisation for Economic Co-operation and Development (OECD): Group of 30 member countries sharing a commitment to democratic government and market economy has been named Organisation for Economic Co-operation and Development. With active relationships with some 70 other countries, NGOs, and civil society, it has a global reach. Known for its publications and its statistics, its work covers economic and social issues from macroeconomics to trade, education, development, and science and innovation.

Output gap: The difference between actual GDP and potential GDP. If the actual is less than the potential, a recession is underway.

Paper money: A promissory note made by a bank payable to bearer on demand, used as money and/or legal tender. Coins and banknotes together make up the cash forms of all modern money.

Policy instruments: Tools used to achieve a governmental or economic objective.

Poverty trap: Also welfare trap. Poverty trap is a situation where a person living with assistance from the state in the form of welfare may decrease his or her net income by finding employment and increasing his or her salary or wages.

Present value: When considering a future cash fl ow, the nominal amount of money to change hands at some future date, discounted to account for the time value of money.

Price ceiling: Government-imposed limit on what price can be charged for a product. A price ceiling can be set above or below the free-market equilibrium price.

Price index: A single number calculated from an array of prices and quantities over a period. Since not all prices and quantities of purchases can be recorded, a representative sample is used instead. Inflation and cost indices are calculated as price indices.

Price: In economics and business, the assigned numerical monetary value of a good, service, or asset.

Private limited company: Also 'limited liability company (LLC).' An incorporated business owned by a few shareholders. Its shareholders enjoy limited liability.

Producer price index (PPI): Measures average change in prices received by domestic producers for output.

Progressive income tax: Type of tax where the tax rate increases as the amount to which the rate is applied increases. Progressive income tax is generally advantageous to poor.

PSUs: Refers to Public Sector Undertakings or Public Sector Enterprises. These are state-owned industry or entity.

Public good: A product that, when consumed by one individual, does not reduce the amount of the good available for consumption by others.

Purchasing power parity (PPP): In economics, theory that states the long run equilibrium exchange rate of two currencies is the rate that equalizes the currencies' purchasing power. This theory is based on the law of one price – the idea that, in an efficient market, identical goods must have only one price.

Quick assets: Current assets that can be converted to cash quickly at close to assessed value. Such items include cash, stock investments, and accounts receivable.

Quota: Limit on the amount of a good produced, imported, exported, or offered for sale. Now quote system is not in vogue and the companies manufacture goods keeping in mind their demand.

Ratio analysis: Comparison of two reported levels or flows of a company. Possible ratios: two financial flows categories divided by each other, a level divided by a financial flow; a flow divided by a level.

Real income: The value of income adjusted for inflation. It actually comes down if and when adjusted for inflation and remains notionally high only.

Real rate of interest: The rate of interest adjusted for inflation.

Recession: Recession or recessionary trend refers to downtrend in the economy. It is a period of simultaneous decline in several measures of overall economic activity, such as output, income, employment, and sales.

Regressive tax: Type of tax that takes a larger percentage of income from people with low incomes. Often it is a fixed tax that everyone pays identically. Alternatively, it may be a tax on consumption, such as value-added tax or GST called Goods and Services Tax.

Regulatory body: like the US FDA. Regulatory bodies are institution that enforces standards and safety, oversees use of public goods, and regulates commercial activities. Securities and Exchange Board called SEBI is example another regulatory body.

Relative price: Cost of a commodity in terms of another; i.e., the ratio of two prices.

Rent control: Law or ordinance that sets price ceiling or floor on residential housing. The Rent Control Act covers all buildings whether commercial or residential given on rent.

Repurchase agreement: Also Repo. The sale of securities now for cash by party A (the cash borrower) to party B (the cash lender), with the promise made by A to B of repurchasing those securities later is Repurchase Agreement. A pays the requisite interest to B at the time of repurchase – the interest rate in this case is known as the repo rate.

Reserves: Deposits held by a local or regional bank in the central bank, plus currency physically held in the bank's own vaults (vault cash). The central bank of a given country sets minimum reserve requirements for all smaller banks. Reserves ratio requirement: Also 'required reserve ratio.' Bank regulation that sets the minimum reserves each bank must hold in customer deposits and notes.

These reserves are designed to satisfy withdrawal demands and would normally be in the form of currency stored in a bank vault or with a central bank. Healthy Reserves are a sure indicator of sound health of the system.

Saving: To set aside or reserve, such as putting money in the bank or in post office.

Savings certificate: A security with a fixed rate of maturity that considers the periodic needs of depositors – profits are paid on the completion of a specific period.

Sensitive Price Indicator (SPI): Figure that assesses the price movements of essential commodities at short intervals so as to review the price situation in the country weekly. The SPI is presented in the Economic Coordination Committee of the Cabinet (ECC). Shareholder: Also 'stockholder.' Sensitive Price Indicator is an individual, company, or corporation that legally owns one or more shares of stock in a joint stock company. The shareholders are the owners of a corporation.

Share: One of the equal fractional parts into which the capital stock of a joint stock company or a corporation is divided; used to raise funds.

Short-term liquidity ratio: Measure of a company's effectiveness at managing its assets. The composite includes the current ratio and the acid test ratio and demonstrates how easily the company can meet its short-term financial commitments.

Single currency: A situation in which separate countries agree to use the same currency.

Soft loan: Also soft financing. Soft loan refers to borrowed funds subject to a below-market rate of interest. Sometimes soft loans provide other concessions to borrowers, such as long repayment periods or interest holidays. Governments may provide soft loans to fund projects they think are worthwhile. The World Bank and other development institutions provide soft loans to developing countries.

Sole proprietorship: A business that legally has no separate existence from its owner. The owner does business in his or her own name and has no partners.

Special drawing rights (SDRs): A form of international money created by the International Monetary Fund that is used to settle debts between countries.

Spread: In finance, the difference between lending rates and deposit rates.

Stagflation: A portmanteau of the words stagnation and inflation. A term in macroeconomics used to describe a period of high price inflation combined with economic stagnation, unemployment, or economic recession.

Stagnation: Also economic stagnation. A prolonged period of slow economic growth (traditionally measured in terms of GDP growth).

Stakeholder: A person who holds money or other property while its owner is determined or designated.

Standard of living: The ease by which people living in a country are able to satisfy their wants. Standard of living is generally measured by standards such as income inequality, poverty rate, and real income per person.

Stock exchange: Also 'share market,' 'bourse.' The Stock Exchange is a corporation or mutual organization that provides facilities for stockbrokers and traders to exchange company stocks and other securities. Stock exchanges also provide facilities for the issue and redemption of securities, as well as the payment of income and dividends.

Structural Adjustments Program (SAP): Term used by the International Monetary Fund (IMF) and the World Bank for the changes it recommends

to developing countries. These changes are designed to promote economic growth, generate income, and pay off debt. Implementation of these changes has been a condition for getting new loans from the IMF and the World Bank for many developing countries.

Structural unemployment: Mismatch between workers looking for jobs and the vacancies available because unemployed workers lack the specific skills required for the jobs or are geographically disparate.

Subsidy: A monetary grant given by the government to lower prices faced by producers or consumers of a good, generally because it is considered to be in the public interest.

Sustainable development: Creating economic growth by protecting the environment, relieving poverty, and not destroying natural capital in the short term at the expense of long-term development.

Sustainable growth: Economic growth that can continue over the long term without exhausting non-renewable resources.

Tariff: Tax, generally on goods imported into a country.

Tax cut: Reduction in levy rates.

Terms of trade: Ratio of the price of an export commodity to the price of an import commodity.

Time deposit: Also 'term deposit.' Money that cannot be withdrawn for a certain period is deposited as Time Deposit. Once the term ends, funds can be withdrawn or held for another term.

Trade diversion: Change in trade levels following the formation of a trading bloc as trade with efficient competitors is replaced by trade with less efficient trading bloc members. Trade diversion is often a result of free trade agreements (FTAs).

Treasury bill: Short-term (3-12 month) government borrowing. Governments issue treasury bills to increase available funds.

Trickle-down: Passing economic gains from growth to society, spurring development.

Unemployment: The state of being able and willing to work at a prevailing wage rate, yet unable to find a paying job.

Unemployment rate: Number of unemployed workers divided by the total civilian labor force, which includes both the unemployed and those with jobs (all those willing and able to work for pay).

Wage rate: Pay per time period, like Rs per day or per month. It is the compensation given to a worker for the work done on monthly or daily basis.

Wealth: An abundance of items of economic value, or the state of controlling or possessing such items.

Wholesale Price Index (WPI): Measure of directional movements in price for a set of selected items in the primary and wholesale markets. Items are precisely defined and offered in lots by producers or manufacturers. Prices conform to the primary seller's realization at an organized wholesale level. The wholesale prices are collected from the single market.

Workforce: Employable labour pool. It is generally used to describe those working for a single company or industry. It also refers to collective work force of a country.

World Bank: International bank that encourages capital investment for reconstruction and development in member countries.

World Trade Organization (WTO): Replaced GATT in 1995. The World Trade Organization refers to International organization that administers the global rules of trade between nations. Its main function is to ensure that trade flows as smoothly, predictably, and freely as possible.

Yield curve: Depicts the various rates at which the same borrower is able to borrow for different periods of time.

Zero coupon bond: Securities that do not pay periodic coupons or interest. Zero coupon bonds are purchased at a discount from their value at maturity.

Some other terms:

SENSEX: Sensitive Price Index. It is the barometer of a country's economy

CASA: Current and Saving Accounts held by a bank

Capital Adequacy: A yard stick fixed by the Central Bank to determine the sound health of a bank or banking institution

NBFC: Non banking financial company. It is like a bank but not exactly a bank. Usually, a private company performing some of many functions of a banking institution is called Non Banking Finance Company.

Ponzi schemes: some NBFCs or other companies running chit fund like schemes to dupe gullible investors with promise of higher returns.

OMBUDSMAN: An institution created to safeguard interest of customers of banks or other institutions

Chapter X

INVESTIGATIVE JOURNALISM

The basic elements

It is often said that the Investigative Journalism is a type of journalism that someone is trying to hide and the reporter is trying to expose. However, while definitions of investigative reporting vary, among professional journalism groups there is broad agreement of its major components: systematic, in-depth, and original research and reporting, often involving the unearthing of secrets. Others note that its practice often involves heavy use of public records and data, with a focus on social justice and accountability.

The best description of the Investigative Journalism comes from the Press Council of India which while explaining its norms and parameters said that Investigative journalism has three basic elements.

a. It has to be the work of the reporter, not of others he is reporting;
b. The subject should be of public importance for the reader to know;
c. An attempt is being made to hide the truth from the people.

The first norm follows as a necessary corollary from

(a) That the investigative reporter should, as a rule, base his story on facts investigated, detected and verified by himself and not on hearsay or

on derivative evidence collected by a third party, not checked up from direct, authentic sources by the reporter himself.

(b) There being a conflict between the factors which require openness and those which necessitate secrecy, the investigative journalist should strike and maintain in his report a proper balance between openness on the one hand and secrecy on the other, placing the public good above everything.

(c) The investigative journalist should resist the temptation of quickies or quick gains conjured up from half-baked incomplete, doubtful facts, not fully checked up and verified from authentic sources by the reporter himself.

(d) Imaginary facts, or ferreting out or conjecturing the non-existent should be scrupulously avoided. Facts and yet more facts are vital and they should be checked and cross-checked whenever possible until the moment the paper goes to Press.

(e) The newspaper must adopt strict standards of fairness and accuracy of facts. Findings should be presented in an objective manner, without exaggerating or distorting that would stand up in a court of law, if necessary.

(f) The reporter must not approach the matter or the issue under investigation, in a manner as though he were the prosecutor or counsel for the prosecution. The reporter's approach should be fair, accurate and balanced. All facts properly checked up, both for and against the core issues, should be distinctly and separately stated, free from any one-sided inferences or unfair comments. The tone and tenor of the report and its language should be sober, decent and dignified, and not needlessly offensive, barbed, derisive or castigatory, particularly while commenting on the version of the person whose alleged activity or misconduct is being investigated. Nor should the investigative reporter conduct the proceedings and pronounce his verdict of guilt or innocence against the person whose alleged criminal acts and conduct were investigated, in a manner as if he were a court trying the accused.

(g) In all proceedings including the investigation, presentation and publication of the report, the investigative journalist newspaper should be guided by the paramount principle of criminal jurisprudence, that

a person is innocent unless the offence alleged against him is proved beyond doubt by independent, reliable evidence.

(h) The private life, even of a public figure is his own. Exposition or invasion of his personal privacy or private life is not permissible unless there is clear evidence that the wrongdoings in question have a reasonable nexus with the misuse of his public position or power and has an adverse impact on public interest.

(i) Though the legal provisions of Criminal Procedure do not in terms, apply to investigating proceedings by a journalist, the fundamental principles underlying them can be adopted as a guide on grounds of equity, ethics and good conscience.

(j) To say that the press should not publish any information, till it is officially released would militate against the spirit of investigative journalism and even to an extent the purpose of journalism.

Some other definitions of Investigative Journalism:

On the other hand, the handbook of Investigative Journalism published by UNESCO defines it thus: "Investigative journalism involves exposing to the public matters that are concealed–either deliberately by someone in a position of power, or accidentally, behind a chaotic mass of facts and circumstances that obscure understanding. It requires using both secret and open sources and documents."

The Dutch-Flemish investigative journalism group VVOJ defines investigative reporting simply as "critical and in depth journalism". Some journalists, in fact, claim that all reporting is investigative reporting. There is some truth to this—investigative techniques are used widely by beat journalists on deadline as well as by "I-team" members with weeks to work on a story. But investigative journalism is broader than this–it is a set of methodologies that are a craft, and it can take years to master.

Investigative journalism requires high standards of research and reporting that the profession aspires to: in-depth inquiries that painstakingly track looted public funds, abuse of power, environmental degradation, health scandals, and more. It is systematic, in-depth, and original research and reporting that often exposes secrets. But it should not be confused with what has been dubbed "leak journalism" or quick-hit scoops gained by the leaking of documents or tips, typically by those in political power. Indeed, in emerging democracies, the definition can be rather vague, and stories are often labelled investigative

reporting simply if they are critical or involve leaked records. Stories that focus on crime or corruption, analysis, or even outright opinion pieces may similarly be mislabelled as investigative reporting.

Veteran trainers note that the best investigative journalism employs a careful methodology, with heavy reliance on primary sources, forming and testing a hypothesis, and rigorous fact-checking. The dictionary defines Investigative Journalism as "systematic inquiry," which typically cannot be done in a day or two; a thorough inquiry requires time. Others point to the field's key role in pioneering new techniques, as in its embrace of computers in the 1990s for data analysis and visualization. "Investigative reporting is important because it teaches new techniques, new ways of doing things," observed Brant Houston, the Knight Chair of Journalism at the University of Illinois, who served for years as executive director of Investigative Reporters and Editors. "Those techniques blend down into everyday reporting. So you're raising the bar for the entire profession."

- An original, proactive process that digs deeply into an issue or topic of public interest
- Producing new information or putting known information together to produce new insights
- Multi-sourced, using more resources and demanding team-working and time
- Revealing secrets or uncovering issues surrounded by silence
- Looking beyond individuals at fault to the systems and processes that allow abuses to happen
- Bearing witness, and investigating ideas as well as facts and events
- Providing nuanced context and explaining not only what, but why
- Not always about bad news, and not necessarily requiring undercover techniques – though it often is, and sometimes does.

An investigative reporter needs to have:

- Curiosity
- Passion
- Initiative
- Logical thinking, organisation and self-discipline

- Flexibility
- Good team working and communication skills
- Well-developed reporting skills
- Broad general knowledge and good research skills
- Determination and patience
- Fairness and strong ethics
- Discretion
- Citizenship
- Courage

Preparing your investigation

Proper research will give you focus and help you to decide who best to interview. If you haven't done your research, it will be obvious when you start interviewing. You will lose credibility and those you are interviewing will be less likely to open up.

Make sure you are up to speed with new developments; know the background; know the main players and people who will talk; know what has been reported already. You should be looking for a new angle, new information - something different that will take the story forward.

Sources

Begin with background reading:

Check out official documents, such as laws, regulations, court documents, the records of an individual's, organisation's or institution's dealings, such as correspondence, meeting minutes or transcripts, internal reports, contracts or financial records, and original materials on which other research or reports are based, such as the first publication of the results of scientific investigations, surveys, fieldwork or interviews.

Consult government or parliament documents and records - laws and legal acts are also often accessible on government websites. Check websites of NGOs or international organisations before calling them for an interview. Their reports and documents posted online will help inform your questions.

Be careful with opinion polls. Often, they are commissioned by government or political parties. Check carefully the background of the organisation that produced the poll and the methodology used.

Always spread your net wide. It is important to represent the interests of different groups, even if minor and/or unpleasant. By doing so means that your article will be balanced and more acceptable.

But beware. It is easy to get lost in piles of research material and to lose your focus. Know when to stop researching and start interviewing. As you accumulate material, think constantly of your angle. If you're following up a story that's already had an outing, what do you have to add?

Setting up interviews and interviewing

Interviews in person are always preferable. If that's not possible, then speaking by phone is also fine but never - unless there is no other option - interview by email. If you do, make clear in the copy that any quotes you use were obtained by email.

If you're recording also take notes at the same time. It forces you to listen and acts as a back-up if the recorder fails. It can also save time later, meaning you may not need to transcribe the entire interview.

Save all notes and tape recordings until well after the story is published. If anyone challenges your work, your notebooks will back you up.

Experts

Start off with the so-called experts. Expert sources will include journalists, activists, independent researchers, scientists, government investigators, academics and authors.

Experts may have an agenda so check and double-check everything you are told. Examine their links with political parties, governments, business interests and check their previous statements/reports to judge how reliable their analysis is.

Former officials who have left a company can be a great source of information. They have the inside track and no longer fear losing their job if they speak out. They may also be able to connect you with current insiders. But again question their motives. Why did they leave?

Don't focus entirely on experts. Each story needs a human face, someone personally affected by the problem, a victim. NGOs or local media outlets might be able to help you find someone, but in the case of NGOs also be careful of their motives and agenda.

Schedule interviews with potentially hostile or evasive subjects for near the end of your research as you will be better prepared to question and challenge their remarks. This is particularly true when interviewing governmental representatives. Always do these last as they will be among the trickiest interviews.

Interviewing the vulnerable

Be extra sensitive when interviewing trauma victims. Set up the interview through someone they trust. Take extra time. Find a secure place to interview them.

If the person refuses to speak to you, don't insist. Respectfully explain why you feel that their story needs to be told (for example, that it may help other survivors). If they still refuse, leave your contact details in case they change their mind later.

Proceed with special caution when dealing with children. Your overriding concern must be to protect the child from harm.

Decide first if the interview is strictly necessary in telling your story. If possible obtain permission from a parent, guardian, school or local authority before beginning an interview.

Be particularly careful when speaking to minors involved in court cases. There are usually strict prohibitions on identifying them and you could find yourself in contempt of court.

Adjust your style for children. Direct questions often don't work and a more effective approach is to allow the interviewee to speak in a less-structured way, ideally in a child-friendly environment. Children often tell adults what they think they want to hear, so be patient.

Children who have suffered trauma will need extra time to tell their story. Get down to their eye level. Proceed slowly and carefully and be alert for signs of anxiety.

Asking the right questions

It may emerge after several interviews that your original premise doesn't stand up. If this is the case, adjust your focus or change the idea completely. Don't struggle to make the original angle work. If this happens, notify your editor.

Prepare a list of basic questions about the main points you want to cover. It may seem obvious, but many journalists don't do it. However, always be ready to improvise and adapt - don't stick rigidly to your list. If the interview turns in an unexpected direction, be ready to drop your original line of questioning.

Always be ready to improvise and adapt - don't stick rigidly to your list of questions.

Many interviewees will want to see your questions in advance. Decide on a case-by-case basis whether you will comply. Technical questions that require some research are examples of when this approach could be useful.

However, giving too much away might kill spontaneity. It could also inhibit you if you feel you must stick to an agreed list of questions.

While interviewing, remember to listen. Thinking about what you will ask next while the subject is still answering the previous question is a common mistake and means you could miss important information.

Avoid leading questions - questions which subtly prompt the interviewee to respond in a particular way. For example, ask "what did you see", not, "you saw the soldier shoot the man, didn't you?"

Use open-ended rather than closed-ended questions. An example of a closed-ended question: "Who will you vote for this election?" An example of an open-ended question: "What do you think about the two candidates in this election?"

Long and rambling questions will often elicit long and rambling answers, or allow the interviewee to duck the question entirely, so be short and precise.

At the end of the interview a good question to ask can be, "Who else should I speak to about this topic?" and "What have I not asked you that I should have asked you?"

An informal chat at the end, tape recorder turned off and pencil put down, often produces useful background information. Quickly check your notes before walking away or hanging up. If you don't understand, ask again. If you don't get it, how will the editor or the reader?

On and off the record

Make sure the interviewee has given informed consent and understands the meaning of the terms "on the record" and "off the record". Check several times throughout the interview what information is on and what is off the

record - especially if the interviewee starts giving details that could put them, or others, at risk.

Try to stay "on the record" where possible.

Use anonymous sources sparingly. There may be times when it is the only way to get someone to speak, but be aware that too many unnamed sources will weaken your story. If you do use an anonymous source, be as specific as possible in identifying their relationship to the issue at hand.

Avoid quoting just "diplomats": it should be a senior UN official, an EU diplomat, an international expert for justice in Kosovo and it should be clearly stated where they are based.

Never make up a quote. It's a lie and it ends careers and taints the profession. You can always find a good source. Truth is always better than whatever you could make up. You will always be found out.

Never pay for information or interviews

Familiarise yourself with local laws and customs relating to your topic.

It is your responsibility to inform yourself about the political and social terrain in which you will be working. For example, in some countries, covert use of a tape recorder is illegal.

Stay within the law when reporting your story. It may be tempting to break the rules to illustrate your point, or to get the story, but this will leave you vulnerable and could even undermine your credibility in the long run.

Telephone taps, breaking and entering, and hacking should not be used.

Remember, journalists are observers and reporters of events, not active participants: spectators at the match not supporters of one team or the other.

Going undercover

There may be times when you wish to conceal your identity as a journalist in order to gain a different perspective on the story.

Undercover journalism can be a force for social change, uncovering a problem that would never have been brought to light by any other means. But by sacrificing transparency and honesty you could leave yourself open to criticism about your methods or even your conclusions.

When deciding whether to go undercover, to obtain information through deceptive means, you should ask yourself various questions.

Is the information you will obtain strongly linked to a broader social purpose and is it of vital public interest? Does the public value of this information outweigh the deception and potential violations of privacy? Could you obtain this information through straightforward means, and have you exhausted all other ways of getting this information?

Always inform your editor in advance who you will be meeting, when, where and when you will be back. Agree a time by when you will check in, and then make sure you do.

Leave a list of contacts with your editor detailing who you would like to be contacted in the event of an emergency.

If you plan to be gone for more than a day, work out a plan to call a designated person (editor, spouse, partner, parent) every 24 hours. Your failure to call by an appointed time should trigger phone calls to emergency contacts.

Several people - including colleagues in the field and back in the office - should also be provided with the list of emergency contacts, as well as instructions for how to get in touch with them.

Ideally, set up interviews via people you know and trust, but social networking sites and online forums can be useful in developing new contacts. Always meet contacts obtained this way in a public place, informing your editor of who you will be meeting and when you will be back.

Staying safe during your investigation

Always carry press identification. In some countries a signed and stamped letter from your editor outlining your mission could be useful. Carry a mobile phone with emergency numbers pre-set for speed dialling.

If travelling in the countryside, or far from medical help, carry a first aid kit (know how to use it) and a torch.

Sensitive files, documents, discs, video and audio recordings should be stored in a secure place.

Always be cautious when using mobile telephones and email to communicate; they may not be secure. Limit phone interviews to non-sensitive information: phones can be tapped. Similarly, emails and letters may be intercepted and read. Sensitive conversations should be held face to face.

Journalists should be aware of local sensibilities. Dress in a manner which is appropriate to the local culture.

Ideally, journalists who do not know the local language should travel with a qualified interpreter who can help them communicate and understand local customs. Journalists should also learn and be able to pronounce the words for press or journalist in local languages.

Organising your material

You must always work from a detailed article outline. An outline is a roadmap; a logical and schematic summary are essential when writing a long piece.

Begin by transcribing recordings and typing out hand-written notes so that all material for your story is in front of you in a clear, easy-to-read format.

Then highlight the most relevant sections in your interview notes and all other documents to which you will refer, for example reports, web pages or emails. The highlighted information should then be slotted into an article outline. Time spent preparing a good outline will cut many hours from the writing process.

The more detailed and carefully thought-out your outline is, the more organised the piece will be. The more detailed and carefully thought-out your outline is, the more organised the piece will be.

The first sentence in the outline should be your intro. This is the point from which the entire outline, and article, will flow. Each paragraph in the outline must then support the intro, with each paragraph flowing logically from one to another.

The basic structure of the outline is simple and mirrors the structure of the story itself - beginning (lead)] - middle (body) - end (conclusion). This may sound oversimplified, but it is depressing how often journalists forget these basic components of a story.

As with the outline, time spent working out the intro long before you start writing the article will save hours later and help prevent an unfocused final product.

Writing your story

Keep your structure in mind at all times - beginning, middle and end. The formula is simple: "Tell them what you are going to tell them; tell them the story; tell them you have told them."

The intro must grab the reader's attention; explain what has happened and why it is important. If you have no lead then you will have no focus and the story will not work.

A good intro should capture the mood, create an image, appeal to the imagination and instantly transport the reader to the location.

The body of the story draws readers into the piece. Each paragraph follows on logically from the previous one, building the argument, referring back to the main point.

Each new paragraph should introduce a new point or topic but keep these transitions smooth. Use linking words such as however, soon after and meanwhile.

Be selective with the information you include. You don't have to use everything in your notebook. Avoid duplication, repetition, and non-essential information.

Avoid long, rambling quotes. Used sparingly, quotes can have a more dramatic effect. Select the poignant sentence, the meaningful or relevant phrase.

Don't get bogged down with unnecessary background and irrelevant details.

Emotive words

Watch your words and avoid sensationalism and sensational language. Avoid heavily slanted adjectives such as arrogant or warlord. Always be precise about what you know and be temperate when describing what you see. Avoid demonising adjectives like vicious, cruel, brutal, and barbaric. These always describe one party's view of what another party has done. To use them puts the journalist on that side.

Instead, report what you know about the wrongdoing and give as much information as you can about the reliability of other people's reports or descriptions of it. Avoid presenting an opinion or claim as an established fact.

Avoid making an opinion or claim seem like an established fact.

Conclusion

The conclusion is the end, not a place for any new information or surprises. Remind the reader why the story is important. Give them a feeling of having read a complete article.

Emergence of Investigative Journalism in India

The period between 1973 to 1980 saw the emergence of Investigative Journalism in India. It was the period that encompasses the challenge to Ms Indira Gandhi witnessed such momentous events as the emergency, the Janata Government and Ms Gandhi's return to power. It was so packed with political drama that it politicized the entire nation. The journalists were drawn into this fray as never before and many youngsters joined the profession and offered to take risks. The Indian Express set a new benchmark with its journalism of courage during the black days of emergency. Power supply to this newspaper was cut, censorship imposed. It was during this period that this newspaper used a tractor to print the copies of newspaper to take on Ms Gandhi. The government retaliated but investigative stories started pouring in at regular intervals. Besides the Indian Express, The Hindu and The Statesman gradually began to shed off their conservatism. The investigative report published by the Indian Express and the Hindu on the Bofors gun scandal is a landmark in Indian journalism. The reports contributed a great deal to the 'Waterloo' of the Congress Party in the 1989 general elections. The Indian Express series on Reliance activities shook the business empire of Ambanis.

Although, in recent years, the Social Media has made inroads and Citizen Journalism is in vogue, the Indian press has been quite vibrant and combative as compared to the press in the world today, yet what has been done in the field of investigative journalism touches only the tip of the iceberg? The press in India is owned by the industrialists who do not encourage investigative reporting for fear of government harassment. The way the government dealt with the Indian Express, The Statesman and The Hindu is a sufficient proof of this. A major development in the form of the Right to Information has come up as a boon for Investigative Journalism. There is also a need to create an atmosphere where the press can function freely.

India is an unusual country, the largest democracy of the world, a depressing reality, a celebration of mind boggling diversity. It is an ongoing saga of unparalleled migrations— millions of illiterates into literacy, equal or more numbers into the world of modern technology, thousands from malnutrition to healthy life.

The problems include lack of clean toilets, drinking water, a roof over the head, over population, corruption, lack of governance and a digital divide. India is also where millions are daily put through the oppressive nature of

modern nation-states—cruel security establishment, corrupt bureaucracy, communal politicians, plutocracy, robber barons. Vultures of modern society are hovering over the hapless, naked ordinary Indian, whose epic struggle to live a healthy life is in itself depressing.

Where else could investigative journalism flourish? Where else on Earth can you find so many people and so many societies, so many races and so many identities, calling out for their fundamental rights, lamenting lack of basic dignity? Where else could independent media, and fearless reporting, find such a great landscape?

India is where good journalism of next generation is going to take deep roots because of a number of factors. The most populated nation-state, People's Republic of China, is beyond iron walls of autocracy. There are many countries with great history of journalism, and there are richer societies. But there is no other India—where a young population with a median age of just 25 is restless, and its diversity is demanding accountability from the state. A generation of robber barons are exploiting every imaginable natural resource, and funnelling most of the money into politics. One of the world's most expensive election processes and flamboyant politics is pumping in billions from the black market into India's democratic veins. India is beginning to look like a drugged out zombie, incapable of distinguishing between the good and the bad, the evil and the angel.

For anti-colonial struggle independent journalism was a hallmark. No one understood the power of media better than Mahatma Gandhi. Nehru, Ambedkar and many other freedom fighters were also founders of media organizations.

However, freedom from the British brought with it apprehensions about the unbridled power of media among the very same leaders, who were now rulers of the world's largest democracy. So, in the very first amendment to the Constitution the Nehru government pushed through limits to freedom of press. That legacy has been followed by every political party, every politician in the past seven decades.

Deep inside the Indian state, in all its institutions, political movements, activists groups and every imaginable gathering there is a bit of intolerance. One of the first, and most oppressive steps initiated during the Emergency was clamp down on free media. Among the most draconian actions taken by most of our present day leaders have been to cajole, harass or intimidate free press.

Most Indian corporate have repeatedly exhibited their intolerance for media. They would buy your silence, if not your words. NGOs, social movements, caste gatherings, they all abuse the media. Many a politician vilify media to get cheap applauds from the ordinary people.

In such an environment several editors have flourished. Selling their profession, they have amassed fortunes, influence and found a pride of place among country's leading power brokers. They don't still mind holding public discourse on journalistic crusade.

It is for these factors that India needs to reinvent, strengthen and stretch the boundaries of media freedom. It is because of these, and many more, factors that India will become home to a new powerful tradition of independent, investigative, path-breaking journalism. It is not that Indian media has not shown repeatedly that it is capable of going after the corrupt and exposing the nefarious nexuses that snatch away our freedom, and the last slice of bread from our poor. But those were only glances of what is possible.

To achieve the glory of true journalism, to use good reporting as a powerful tool to bring bread to the poorest, liberty and freedom to the oppressed, shed truth in obscure corners of governance and hold leaders accountable, to demolish the castles of plutocracy, to usher in all those values long cherished by many a people around the world, India needs to reinvent and reinforce good reporting. And it cannot always be expected from profit chasing mainstream media.

Non-profit investigative journalism centres around the world has created a new mould. India is ready for such ventures, and green sprouts are already visible. Many more should spring up in this oppressive heat and dust of a great concept called India. According to the Press Council of India has also come out with certain norms for journalists.

While working on a story, the Investigative Journalism should keep in mind that the fundamental objective of all kind of journalism is to serve the people with news, views, comments and information on matters of public interest in a fair, accurate, unbiased, sober and decent manner. To this end, the Press is expected to conduct itself in keeping with certain norms of professionalism, universally recognised. The norms enunciated below and other specific guidelines appended thereafter, when applied with due discernment and adaptation to the varying circumstance of each case, will help the Investigative Journalist to self-regulate his or her conduct.

1. Accuracy and Fairness

i) The Investigative Journalism should eschew publication of inaccurate, baseless, graceless, misleading or distorted material. All sides of the core issue or subject should be reported. Unjustified rumours and surmises should not be set forth as facts.

ii) It is incumbent for newspapers to play a positive role in response to rumours affecting the credibility of financial institutions having public interface.

iii) While it is the duty of the press to expose the wrongdoings that come to their notice, such reports need to be backed by irrefutable facts and evidences.

2. Pre-Publication Verification

i) On receipt of a report or article of public interest and benefit containing imputations or comments against a citizen, the Investigative Journalist should check with due care and attention its factual accuracy apart from other authentic sources- with the person or the organisation concerned to elicit his/her or its version, comments or reaction and publish the same alongside with due correction in the report where necessary. In the event of lack or absence of response, a footnote to that effect may be appended to the report.

ii) Publication of news such as those pertaining to cancellation of examinations or withdrawal of candidates from election should be avoided without proper verification and cross checking.

iii) A document, which forms a basis of a news report, should be preserved at least for six months.

3. Caution against defamatory writings

i) Investigative Journalist should not publish anything which is manifestly defamatory or libellous against any individual/organisation unless after due care and verification, there is sufficient reason/evidence to believe that it is true and its publication will be for public good.

ii) Truth is no defence for publishing derogatory, scurrilous and defamatory material against a private citizen where no public interest is involved.

iii) No personal remarks which may be considered or construed to be derogatory in nature against a dead person should be published except in rare cases of public interest, as the dead person cannot possibly contradict or deny those remarks.

iv) The Press has a duty, discretion and right to serve the public interest by drawing reader's attention to citizens of doubtful antecedents and of questionable character but as responsible journalists they should observe due restraint and caution in hazarding their own opinion or conclusion in branding these persons as 'cheats' or 'killers' etc. The cardinal principle being that the guilt of a person should be established by proof of facts alleged and not by proof of the bad character of the accused. In the zest to expose, the Press should not exceed the limits of ethical caution and fair comment

v) The Press shall not rely on objectionable past behaviour of a citizen to provide the background for adverse comments with reference to fresh action of that person. If public good requires such reference, the Press should make pre-publication inquiries from the authorities concerned about the follow-up action, if any, in regard to earlier adverse actions.

vi) Where the impugned publication is manifestly injurious to the reputation of the complainant, the onus shall be on the respondent to show that it was true or to establish that it constituted fair comment made in good faith and for public good.

vii) Newspapers cannot claim privilege or licence to malign a person or body claiming special protection or immunity on the plea of having published the item as a satire under special columns such as 'gossip', 'parody', etc.

viii) Publication of defamatory news by one paper does not give licence to others to publish news/information reproducing or repeating the same. The fact of publication of similar report by another publication does not bestow the status of accuracy on the charges.

ix) It is necessary that the press realize its responsibility to the society due to the unique position enjoyed by it in being able to interact directly with the citizenry and utilize its advantageous position for the

betterment of the society and the advancement of the country rather than indulging in giving credence to rumours and sensationalism. It is also necessary that the press, particularly the small local press, learn to appreciate the clear distinction between matters of 'public interest' and 'those in public interest'. While gossips and social dealings may be found to be of interest by the public but they serve no public purpose or interest and the press should scrupulously avoid wasting its precious space on such matters.

x) Insertion of out -of -context, uncalled for and irrelevant statements likely to malign a person or an organisation must be eschewed.

xi) Even while a newspaper has the liberty or even duty to report political developments, that reporting may not be with angularity. Freedom of Press does not give licence to a newspaper to malign a political leader or mar his future political prospects by publishing false and defamatory writings.

xii) It must be remembered by the Press that the freedom of speech and expression enshrined in the democratic set up and enjoyed by the fourth estate also casts on it a responsibility. The newspapers are not expected to use it as a tool by it creating evidence and later using the evidence to make false propaganda in its own journal.

xiii) The Press deserves accolades for bringing to light the inducements offered to influence their reporting and such exposure will not amount to defamation.

xiv) Locus Standi: In cases involving personal allegations / criticism, only the concerned person enjoying the locus standi can move the plaint or claim right to reply. However a representative organisation of persons attached to an organisation or a sect / group has the locus standi to move complaints against a publication directly criticising the conduct of a leader.

xv) Public Interest and Public Bodies As a custodian of public interest, the Investigative Journalist has a right to highlight cases of corruption and irregularities in public bodies but such material should be based on irrefutable evidence and published after due inquiries and verification from the concerned source and after obtaining the version of the person/authority being commented upon. Newspapers should refrain from barbed, stinging and pungent language and ironical/satirical

style of comment. The attempt of the press should be to so shake up the institutions as to improve their working, not to destroy them or the public confidence in their working or demoralize the workforce.

A corresponding duty of course devolves on them to ensure that in doing so they present a fair and balanced report, uninfluenced by any extraneous consideration. The Press as a custodian of public interest and a protector of its rights is also expected to bring correct information to its notice so that it is able to correctly judge those to whom it has entrusted the responsibility of running the country.

xvi) The media and the authorities are two very important pillars of our democracy and for the government to function successfully in public interest a press as responsible as watchful is an essential pre-requisite.

4. Parameters of the right of the Press to comment on the acts and conduct of public officials

i) So far as the government, local authority and other organs/institutions exercising governmental power are concerned, they cannot bring charge of defamation for reports critical of their acts and conduct relevant to the discharge of their official duties unless the official establishes that the publication was made with reckless disregard for the truth. However, judiciary, which is protected by the power to punish for contempt of court, the Parliament and Legislatures, protected as their privileges are by Articles 105 and 194 respectively of the Constitution of India, represent exception to this rule.

ii) The central and local bodies are not entitled to bring a civil or criminal action for defamation in respect of article/report criticising their functioning.

iii) Publication of news or comments/information on public officials conducting investigations should not have a tendency to help the commission of offences or to impede the prevention or detection of offences or prosecution of the guilty. The investigative agency is also under a corresponding obligation not to leak out or disclose such information or indulge in misinformation.

iv) The Official Secrets Act, 1923 or any other similar enactment or provision having the force of law equally bind the press or media

though there is no law empowering the state or its officials to prohibit, or to impose a prior restraint upon the Press/media.

v) Those that hold public office and by their own conduct give scope for criticising them, cannot be heard to complain against such criticism.

5. Criticism of Public Figures

An actor or singer who appears on a public stage submits his performance to the judgement of public and as such the critics' comments having proximate nexus with the merits of artist's performance cannot be held to be defamatory. However, the critics should refrain from writing anything, which could, be construed as remotely casting cloud on the artist's personal credibility.

6. Right to Privacy

i) The Investigative Journalist shall not intrude or invade the privacy of an individual, unless outweighed by genuine overriding public interest, not being a prurient or morbid curiosity. So, however, that once a matter becomes a matter of public record, the right to privacy no longer subsists and it becomes a legitimate subject for comment by the Press and the media, among others. Special caution is essential in reports likely to stigmatise women.
Explanation: *Things concerning a person's home, family, religion, health, sexuality, personal life and private affairs are covered by the concept of privacy excepting where any of these impinges upon the public or public interest.*

ii) **Caution against Identification:** While reporting crime involving rape, abduction or kidnap of women/females or sexual assault on children, or raising doubts and questions touching the chastity, personal character and privacy of women, the names, photographs of the victims or other particulars leading to their identity shall not be published.

iii) Minor children and infants who are the offspring of sexual abuse or 'forcible marriage' or illicit sexual union shall not be identified or photographed.

iv) Intrusion through photography into moments of personal grief shall be avoided. However, photographs of victims of accidents or natural calamity may be in larger public interest.

7. Privacy of Public figures

i) Right to Privacy is an inviolable human right. However, the degree of privacy differs from person to person and from situation to situation. The public person who functions under public gaze as an emissary/ representative of the public cannot expect to be afforded the same degree of privacy as a private person. His acts and conduct as are of public interest ('public interest' being distinct and separate from 'of interest to public') even if conducted in private may be brought to public knowledge through the medium of the press. The press has however, a corresponding duty to ensure that the information about such acts and conduct of public interest of the public person is obtained through fair means, is properly verified and then reported accurately. For obtaining information in respect of acts done or conducted away from public gaze, the press is not expected to use surveillance devices. For obtaining information about private talks and discussion while the press is expected not to badger the public persons, the public persons are also expected to bring more openness in their functioning and co-operate with the press in its duty of informing the public about the acts of their representatives.

ii) The interviews/articles or arguments pertaining to public persons which border on events that are in public knowledge, if reported correctly, cannot be termed as intrusion into private life. There is a very thin line between public and private life and public persons should not to be too thick skinned to criticism

iii) Newspapers are allowed latitude in criticising persons who are in seats of power because their conduct discloses public interest provided their criticism is not motivated to gratify private spite of opponent/rival of public figure.

iv) The family of public figures are not valid journalistic subject, more so if its reporting covers the minors. If "public interest" overrides the minor's right to privacy it will be proper to seek prior consent of the parents.

v) When the individual concerned himself or herself reveals facts about private life before a large gathering then the shield of privacy should be deemed to be abandoned by the individual.

8. Recording interviews and phone conversation

i) The Investigative Journalist shall not tape-record privileged conversation without that person's knowledge or consent, except where the recording is necessary to protect the journalist in a legal action, or for other compelling good reason.

ii) The Press shall, prior to publication, delete offensive epithets used during such conversation.

9. Conjecture, comment and fact

i) Newspaper should not pass on or elevate conjecture, speculation or comment as a statement of fact. All these categories should be distinctly identified.

ii) Cartoons and caricatures depicting good humour are to be placed in a special category of news that enjoy more liberal attitude.

10. Newspapers to eschew suggestive guilt

i) Investigative Journalists should eschew suggestive guilt by association. They should not name or identify the family or relatives or associates of a person convicted or accused of a crime, when they are totally innocent and a reference to them is not relevant to the matter being reported.

ii) It is contrary to the norms of journalism for a paper to identify itself with and project or promote the case of any one party in the case of any controversy/dispute.

11. Reporting-Proceedings of Legislature

The newspapers have a duty to report faithfully the proceedings of either House of Parliament, Legislative Assembly and in this regard the newspapers

shall not be liable for any proceedings civil or criminal in any court unless it is proved that reporting has been made with malice.

However, the newspapers should not publish any report based on proceedings of a sitting of either House of Parliament or Legislative Assembly or as the case may be either House of the Legislature of a State, which is not open to the media.

12. a) Caution in criticising judicial acts

i) Excepting where the court sits 'in-camera' or directs otherwise, it is open to a newspaper to report pending judicial proceedings, in a fair, accurate and reasonable manner. But it shall not publish anything:- -which, in its direct and immediate effect, creates a substantial risk of obstructing, impeding or prejudicing seriously the due administration of justice; or -is in the nature of a running commentary or debate, or records the paper's own findings conjectures, reflection or comments on issues, sub judice and which may amount to abrogation to the newspaper the functions of the court; or -regarding the personal character of the accused standing trial on a charge of committing a crime.

ii) Newspaper shall not as a matter of caution, publish or comment on evidence collected as a result of investigative journalism, when, after the accused is arrested and charged, the court becomes seized of the case: Nor should they reveal, comment upon or evaluate a confession allegedly made by the accused.

iii) While newspapers may, in the public interest, make reasonable criticism of a judicial act or the judgement of a court for public good; they shall not cast scurrilous aspersions on, or impute improper motives, or personal bias to the judge. Nor shall they scandalise the court or the judiciary as a whole, or make personal allegations of lack of ability or integrity against a judge.

iv) Newspaper shall, as a matter of caution, avoid unfair and unwarranted criticism which, by innuendo, attributes to a judge extraneous consideration for performing an act in due course of his/her judicial functions, even if such criticism does not strictly amount to criminal Contempt of Court.

Chapter XI

PRESS LAWS AND SELF-REGULATION

Press laws of the world vary from each other according to the economy, polity, religion and culture of different societies. In countries which followed communism and totalitarianism, like the former USSR and China, there were limitations of what the media could say about the government. Almost everything that was said against the State was censored for fear of revolutions. On the other hand, in democracies like the USA and India, almost everything is allowed.

To preserve the democratic way of life it is essential that people should have the freedom to express their feelings and to make their views known to people at large. The press a powerful medium of mass communication should be free to play its role in building a strong viable society. Denial of freedom of the press to citizens would necessarily undermine the power to influence public opinion and be counter to democracy.

Freedom of the press is not specifically mentioned in Article 19(1) (a) of the Constitution and what is mentioned there is only freedom of speech and expression. In the Constituent Assembly debates it was made clear by Dr. Ambedkar, Chairman of the Drafting Committee, that no special mention of the freedom of the press was necessary at all as the press and an individual or a citizen were the same as far as their rights of expression was concerned.

The freedom of speech and expression has been characterised as "the very life of civil liberty" in the Constituent Assembly Debates. The freedom of the

press, while not recognised as a separate freedom under Fundamental Rights, is folded into the freedom of speech and expression.

The media is vital in the role it plays in uncovering the truth and rousing public opinion, especially in the face of wrongdoing and corruption. Numerous examples exist where the media has played a central role in revealing corrupt practices and shaping the demand for accountability and good governance.

The media is vital in the role it plays in uncovering the truth and rousing public opinion, especially in the face of wrongdoing and corruption. Numerous examples exist where the media has played a central role in revealing corrupt practices and shaping the demand for accountability and good governance.

The framers of the Indian Constitution considered freedom of the press as an essential part of the freedom of speech and expression as guaranteed in Article 19(1) (a) of the constitution.

However, the freedom of the press is not absolute, just as the freedom of expression is not.

Public interest has to be safeguarded by Article 19 (2) which lays down reasonable limitations to the freedom of expression in matters affecting:

a) Sovereignty and integrity of the state
b) Security of the state
c) Friendly relations with foreign countries
d) Public order
e) Decency and morality
f) Contempt of court
g) Defamation
h) Incitement to an offence

Besides the restrictions imposed in the press by the Constitution, there exist various other laws which further curtail press freedom and the right of the citizens to information as well as the right to freedom of speech and expression. They are all in force in the interest of public order of the sovereignty and security of the state. Before enumerating various Press Laws, let us understand the historic perspective of Media laws.

Historical perspective of Mass Media Laws

Mass Media laws in India have a long history and are deeply rooted in the country's colonial experience under British rule. The earliest regulatory measures can be traced back to 1799 when Lord Wellesley promulgated the Press Regulations, which had the effect of imposing pre-censorship on an infant newspaper publishing industry. The onset of 1835 saw the promulgation of the Press Act, which undid most of, the repressive features of earlier legislations on the subject.

It is necessary to mention here that, this freedom under Article 19(1)(a) is not only cribbed, cabined and confined to newspapers and periodicals but also includes pamphlets, leaflets, handbills, circulars and every sort of publication which affords a vehicle of information and opinion.

Thus, although the freedom of the press is guaranteed as a fundamental right, it is necessary for us to deal with the various laws governing the different areas of media so as to appreciate the vast expanse of media laws.

Different Press Acts:

Social Media and Section 66A of the Information Technology Act, 2000

The ability to disseminate information seamlessly over social media has resulted in a rising need to regulate the content of such information. Section 66A of the IT Act makes it a punishable offence to send messages that are offensive or false or created for the purpose of causing annoyance or inconvenience, danger, obstruction, insult, injury, criminal intimidation, enmity, hatred or ill-will, through a computer device. Since no guidelines have been laid down for identification of offensive information, the wide amplitude of the provision has often been used for politically motivated arrests.

Recently, two professors were arrested in West Bengal for posting a cartoon critiquing a politician. In another incident, two young girls from Maharashtra were arrested – one for posting a Facebook status about the chaotic shutdown of Mumbai due to a popular politician's death and the other for 'liking' the status post. Section 66A is currently under challenge for being violative of the freedom of speech and expression. Though no stay on arrests under this provision has been granted, the Supreme Court has held that no person should be arrested for posting objectionable comments online without permission of senior police officials.

At the same time, social media has often been used as a conduit for instigating ethnic and communal violence such as false rumours online in

August 2012 that led to an exodus of North-eastern migrants from South India. In 2013, the Election Commission introduced guidelines to regulate internet campaigns given the vast use of social media by political parties. Though, the Print and Electronic Media Standards and Regulation Bill, 2012 proposed the establishment of a media regulatory authority, the Bill did not get introduced. Under the present Act, the Cyber Appellate Tribunal is empowered to deal with complaints under the Act but is largely confined to cases of fraud and hacking. In this context the following issues arise for consideration: 1. Should the existing law be amended to define what constitutes "objectionable content"? 2. Should Section 66A of the IT Act be retained in its present form or should it be modified/ repealed? 3. Is there a need for a regulatory authority with powers to ban/suspend coverage of objectionable material? If yes, should the regulatory authority be self-regulatory or should it have statutory powers?

Contempt of Court Act

Contempt of Court Act was enacted for the first time in the year 1952. Later on, the Contempt of Court Act was again enacted in 1971 which was further amended in 1976. According to this act, a person is said to be offender of contempt of courts under following circumstances:

1. Charging the judge with inability.
2. Expressing doubts on the prestige, status, rights or fairness of judiciary.
3. Publication of any comment on the matters which are under the proceedings of the court and which may mislead the general public and which lead them to be prejudiced.
4. To cast aspersions or to attempt to influence the judge, jury, advocates or witness of any matters which are under the proceedings of the court.
5. To interfere in the judicial administration.
6. To threaten the witnesses
7. To attempt to obstruct the police inquiry
8. Against the order of the judge, publication of the proceedings of the curt or the publication of the picture of the accused.
9. Publication of the report of the proceedings of the court and distorting the facts.
10. Wrongful publication of the proceedings of the courts and distorting the facts.

For contempt of court, the punishment is simple imprisonment for a term which may extend to six months or fine which may extend to two thousand rupees or with both.

The Law Commission of India in a consultation paper circulated recently has suggested that with the rise of public interest litigation and a more activist judiciary, courts have been regularly thrust into the limelight in recent years, often provoking confrontations with the media that result in contempt proceedings. The rationale of contempt proceedings is to prevent erosion of public confidence in the administration of justice.

The law of contempt is one of the grounds for reasonable restrictions under Article 19(2) to the freedom of speech and expression. While civil contempt refers to the wilful disobedience to any judgment, or order of a court, criminal contempt is an offence under Section 2(c) of the Contempt of Courts Act, 1971, and is punishable by imprisonment of up to six months. It is defined as the publication of any matter which lowers the authority of any court, or scandalises or tends to scandalise, prejudices or tends to prejudice, or obstructs or tends to obstruct any judicial proceedings, or the administration of justice. It is evident that this definition is extremely wide, particularly as it is unclear what the words "tends to" encompasses.

In India, the courts have generally not distinguished between scandalising the judge as a person, and scandalising the court. Other countries have progressed to a more liberal regime. In UK, scandalising the Court has ceased to be an offence, a change brought in by the Crime and Courts Act 2013. In the USA, the offence of scandalising the court is unknown and courts initiate action for contempt only when they determine that there is 'clear and present danger' to the administration of justice.

There have been repeated calls for reform of contempt of court laws. The NCRWC recommended in 2002 that Article 19(2) be amended to provide for the justification of truth and public interest in matters of contempt. In 2006, Parliament amended the Contempt of Courts Act to introduce Section 13(b), which permitted justification by truth as a valid defence if the same is in public interest and made bona fide. Nevertheless, the manner of application of this defence in the courts has been inconsistent, and a constitutional amendment has not been introduced. Hence, there is a need to revisit the law on contempt and consider the need for further amendments.

The Law Commission of India has observed that in this context, the following question arise for consideration: 1. What are the further legislative or Constitutional amendments necessary to the law on contempt of court to ensure freedom of the press? 2. Should scandalising or tending to scandalise the Court continue as a ground for contempt of court?

The Indecent Representation of Women (Prohibition) Act, 1986

This act prohibits indecent representation of women through advertisements or in publications. Indecent representation of women means the depiction in any manner of the figure of a woman, her form or body or any part thereof in a way as to have the effect of being indecent or derogatory to women or is likely to injure public morality.

As per Section 3 of the act, no person shall publish advertisements which contain indecent representation of women in form. Further Section 4 prohibits publication or sending by post of books, papers, etc. which contains indecent representation of women in any form.

As per section 6, any person who contravenes these provisions shall be punishable on first conviction with imprisonment up to two years and fine not exceeding two thousand rupees, and on subsequent conviction with imprisonment for a term of not less than six months but which may extend to five years and a fine between ten thousand rupees and one lakh rupees.

Laws of libel/defamation

Defamation simply means tarnishing somebody's image. There are two types of defamation libel and slander.

1. Libel: It is written form of defamation.
2. Slander: It is spoken form of defamation.

The defence usually put up are justification, privilege, fair comment and innocent dissemination. To impute a truth about a person for public good, or to express in good faith any opinion respecting the conduct of public servant in discharge of his public function, or of any person in touching any public question is not libel. Similarly, to publish a substantially true report of the proceedings of a court of justice, or to comment in good faith on merits of civil and criminal cases is not considered defamatory.

The remedies available to the aggrieved person in India are two kinds- civil action under the common law, or criminal proceedings for the defamation. In

the first, the claim is essentially for damages by monetary compensation. In criminal proceedings, it is punishment with fine and/or imprisonment.

A consultation paper on Media Laws circulated by the Law Commission of India has suggested a debate on the issue of defamation vis-à-vis the news media because it requires careful consideration. On the one hand, instances of fake sting operations or trial by media give credence to allegations of irresponsible journalism. On the other, threats of legal action with punitive damages under the laws of defamation lead to a 'chilling effect' on the publication of free and independent news articles and puts undue pressure on journalists and publishing houses. Any change to the laws on defamation in India must balance these two considerations.

It has suggested that currently, civil defamation is dealt with under the law of torts whereas criminal defamation is an offence under Section 499 of the Indian Penal Code. A journalist has no special status under defamation laws in India. Although the press enjoys the freedom of speech and expression under Art. 19(1)(a) of the Constitution, defamation is a ground for a reasonable restriction to this freedom under Art. 19(2).

The Consultation paper says that demands have been made in the past by entities such as the Editors' Guild of India, to decriminalise defamation as it pertains to journalists. The proposal has been noted by the Law Ministry as well. In 2003, the newspaper The Hindu mounted an unsuccessful challenge in the Supreme Court against the use of the criminal code for defamation, on the ground that it violates the press freedom guaranteed by the Constitution. Therefore, a comprehensive review of laws regulating the media must consider the question of defamation laws as well. To that end, the following question arises for consideration: Should there be modifications in the law of civil and criminal defamation as it applies to journalists? If so, what should these modifications be?

"Our freedom depends in large part, on the continuation of a free press, which is the strongest guarantee of a free society." - Richard M. Schmidt

The Press and Registration of Books Act, 1867 – This Act regulates printing presses and newspapers and makes registration with an appointed Authority compulsory for all printing presses.

The Press (Objectionable Matters) Act, 1951 – This enactment provides against the printing and publication of incitement to crime and other objectionable matters.

The Newspaper (Prices and Pages) Act, 1956 – This statute empowers the Central Government to regulate the price of newspapers in relation to the number of pages and size and also to regulate the allocation of space to be allowed for advertising matter.

Official Secrets Act 1923:

This Act has become obsolete. But let us explain main points of the Act. As per the Official Secrets Act, no editor, publisher, author or journalist should:

I. Make any sketch, plan or a note which is or may be useful to any enemy.

II. Obtain, collect, record, or publish or communicate to any other person any secret official code or pass word or any sketch, article or note or other document or information which may be directly or indirectly useful to an enemy or to a foreign agent, or which relates to a matter the disclosure of which is likely to affect the sovereignty and integrity of India, the security of the state or friendly relations with **foreign states (Sections 3-5).**

In case of infringement of these provisions, the act provides for punishment with imprisonment for a period which may extend to three years or fourteen years, depending upon the offence committed, as per Section 3.

Parliamentary Privilege

Journalists have to take care while reporting proceedings of Parliament or state legislatures.

The Parliamentary Proceedings (Protection of Publication) Act 1956, which is popularly known as Feroze Gandhi Act, provides that no person should be liable to any proceedings- civil or criminal in respect of a publication in a newspaper of a substantially true report of any proceedings of either house of Parliament.

The Constitution (45th Amendment) act, 1978, passed by Parliament, provides constitutional authority to Feroze Gandhi Act and extends protection to publication of state legislatures proceedings.

Does media need to be regulated?:

The consultation paper on Media Laws circulated by the Law Commission of India has observed that the importance of media in a democracy becomes particularly evident when it comes to challenges surrounding media and the elections. The Law Commission, while considering issues related to electoral reforms, increasingly felt the need to address media-related issues connected to elections, such as the phenomenon of paid news and opinion polls. However

issues relating to the media are not solely limited to elections. Thus this Consultation Paper puts forward several wide-ranging issues relating to the media generally to elicit responses thereon.

In India today, we have every reason to celebrate our news media. However, as society evolves, new challenges are constantly thrown up that require consideration. Technology has expanded our horizons, but has also brought with it new concerns. Recent events related to the news media, such as the proliferation and subsequent curbing of social media, the paid news phenomenon, fake sting operations, trial by media, breach of privacy, etc. pose a set of anxieties. As Lord Justice Leveson wrote in his path-breaking report on 'Culture, Practice and Ethics of the Press' in Great Britain, "With these rights (of press freedoms) come responsibilities to the public interest: to respect the truth, to obey the law and to uphold the rights and liberties of individuals." To this end, the Consultation Paper raises some select concerns, and poses a set of questions that will help foster a larger public debate amongst stakeholders and the citizenry to shape the approach which should be adopted in tackling these issues.

Now a word about the government owned media. Media in India is owned both by government as well as the private sectors. Government-owned media such as All India Radio, Doordarshan, Directorate of Field Publicity, Press Information Bureau, etc., have a significant role to play as the matters they address are not extensively covered by large sections of privately-owned media. Government-owned media is not only a channel through which news about developmental initiatives is passed on to the common man but can also be an independent filter shaping the common man's perception of government policies and their implementation.

However, government owned media is not seen as adequately independent of the government. Hence, the credibility of the development stories they produce may be questioned, especially if they focus exclusively on describing governmental initiatives rather than using their independent judgment on the efficacy of initiatives. Further, issues also arise regarding the quality of such government media when compared to private media.

In India, Prasar Bharti is India's public broadcaster, which is an autonomous corporation of the Ministry of Information and Broadcasting and comprises the Doordarshan television network and All India Radio. Doordarshan, the public television, operates multiple services, including flagship DD1, which reaches about 400 million viewers. There are over 250 FM (frequency modulation)

radio stations in the country (and the number is likely to cross 1,200 in five years). Curiously, India is the only known democracy in the world where news on the radio is still a monopoly of the government.

Any information broadcast by radio should adhere to the government's codes, and should not have any political content. Print and TV media, in contrast, have self-regulating bodies. Radio still has the highest reach across the country; the illiterate poor as well as people in remote areas rely on it for information. But the only news available to them is that of the government owned and controlled AIR. In January 2013, the Ministry of Information and Broadcasting constituted an Expert Committee for the purpose of reviewing the institutional framework of Prasar Bharati including its relationship with Government. The Expert Committee submitted its report on 24.01.2014 suggesting recommendations to make Prasar Bharti administratively and financially autonomous of Government. In this context, the following questions arise for consideration: What regulations can be introduced to ensure independence of government-owned media? How should such regulations be enforced?

Media and Individual Privacy

The exponential growth of media, particularly electronic media, has resulted in a corresponding decline in an individual's privacy. The right to privacy, not specifically enshrined in the Constitution of India, has been held to be implicit in Article 21.[8]Though the freedom of speech and expression, as guaranteed in the Constitution of India, empower the press to disclose information vital to public interest, it often results in intrusion of privacy. In 2012, a news channel aired the molestation of a girl in Guwahati, filmed by one of its reporters. In several instances, sting operations have been used as a medium to exact retribution or have sought to expose information within the realm of an individual's private domain having no bearing on public interest. In 2008, the Delhi High Court took suomotu cognizance of a manipulated sting operation on a schoolteacher resulting in her suspension and assault by a mob and directed the government to consider adopting guidelines for sting operations.

At present, the NBA has principles of self-regulation and a code of ethics. The regulations also provide for a complaint mechanism to the NBSA. Recently, the News Broadcasting Standards Authority imposed a fine of Rs. 1 Lac on a television channel for broadcasting truncated footage of an incident

involving young college students alleged to be drunk, observing that there was no verification of facts. The Authority observed that there was no impartiality or objectivity in reporting the incident and that the broadcast intruded into the privacy of the students. The channel was also directed to air an apology for three days expressing regret over the telecast. Since the NBSA is not a statutory body, the scope of its regulation is limited as being restricted only to members. In 2009, a news channel withdrew its membership after being fined for violating guidelines.

Additionally, EMMC under the I&B Ministry has a set of self-regulatory guidelines for broadcast service providers including guidelines that channels should refrain from using material related to a person's private affairs unless there is an identifiable larger public interest. The Content Certification Rules 2008 under the Cable Television Networks (Regulation) Act define "identifiable larger public interest" to include revealing or detecting crime or disreputable behaviour; protecting public health or safety, exposing misleading claims made by individuals or organizations or disclosing significant incompetence in public office for the larger public interest. Despite the presence of such norms, sting operations invading personal privacy by the media is a fairly common occurrence. The Right to Privacy Bill, drafted as a possible antidote, is yet to be introduced. In this context, the following questions arise for consideration: Should a statutory body have powers to adjudicate complaints of false sting operations? Should there be a specific statutory provision for treating false sting operations as a punishable offence? Should the existing framework of laws be suitably amended to include specific guidelines governing disclosure of private information by the press? Is there a need for detailed guidelines on reporting of sub judice matters? Is the current definition of "Identifiable larger public interest" under the Cable TV Networks (Regulation) Act, 1995 comprehensive?

Trial by media and rights of the accused

There is a widespread view that the difference between an accused and a convict and the basic underlying principle of 'innocent until proven guilty' are regularly overlooked by sections of the media in its coverage of ongoing trials. By conducting parallel trials, the media, it is felt, not only puts undue pressure on the judge but also creates pressure on lawyers to not take up cases of accused.

Further once a matter comes under intense media glare, there is an added pressure on the prosecution to secure evidence which must incriminate an accused, lest the media build negative public opinion against the prosecution. A fair trial and investigation, which are foremost constitutional guarantees, are as much a right of the accused as they are of the victim. The exponential growth and reach of media has shown unhealthy trends of competition, leading to sensationalised reporting giving the well-established rule of sub-judice a go-by.

While this is certainly not true across the board to all media publications, the problem is certainly extensive. Some form of restriction on such media trials has been suggested so as to preserve the administration of justice as also to protect privacy of individual. In response, the Supreme Court in Sahara India Real Estate Corporation v. Securities and Exchange Board of India,[10] gave judges the power to order postponement of publication on a case-by-case basis, the test being, 'where there is a real and substantial risk of prejudice to fairness of the trial or to proper administration of justice'. However, this is a very general test which does not clarify what publications would fall within this category, leaving it entirely contingent on the content and context of the offending publication. This leaves the higher judiciary with wide discretionary powers to decide what amounts to legitimate restraints on media reporting. Due to the possibility of such subjective interpretation, postponement orders could be used by influential parties as a tool to abuse the process of law.

The jurisprudence of postponement might be transported into defamations suits, when the application of such order should be sought strictly as a constitutional remedy. In this context, the following questions arise for consideration: 1. What form of regulation, if at all, is required to restrict media reporting of sub-judice matters? Should the application of postponement orders be narrowed down by introducing guidelines/parameters such as kinds of publications to be covered, categories of proceedings which may be covered? If some form of media regulation is required in reporting of matters which are sub-judice, should the same be in the form of a self-regulated media or should the Courts apply the present law of contempt to check such prejudicial publications?

Previous Reports and Recommendations

There have been a number of reports on specific issues related to media regulations, authored by various government and self-regulatory entities. The

snapshot of the content of the reports published so far lists out main issues. One of the main issues with regard to media regulation has been the question of the nature of regulatory authorities. This has led to proposals for a Broadcasting Regulatory Authority of India. In 2007, a Consultation Paper by the Ministry of Information and Broadcasting sought views from stakeholders on the proposed draft of the Broadcasting Services Regulation Bill. The proposed draft of the Bill is available on the website of the Ministry of Information and Broadcasting. The PCI, in 2012 also recommended that electronic and social media be brought within its regulatory framework and the institution renamed Media Council.

With respect to media and elections, in December 2010, the Committee on Electoral Reforms constituted by the Ministry of Law and Justice, Government of India submitted a Background Paper on Electoral Reforms co-sponsored by the Election Commission of India highlighting key issues in the electoral system. They dealt, inter alia, with issues related to media and elections. The Committee examined the recommendations made by the Election Commission of India in its Proposed Electoral Reforms in July 2004 regarding restrictions on publishing of poll surveys and observed the need for examining restrictions on opinion polls.

Another issue that has received a great deal of attention from various sources is that of paid news. In its report on paid news dated 30.07.2010, the Press Council of India (PCI) recommended self-regulation on this issue, and that the PCI be empowered to adjudicate complaints on paid news. In May 2013, the Parliamentary Standing Committee on Information Technology (2012-2013) in its forty-seventh report examined issues related to paid news and recommended that either there be a statutory body to look into content from both print and electronic media or that the PCI be revamped with powers to tackle paid news and a similar statutory body be set up for electronic media. The Committee observed that there was a need to evolve a comprehensive definition of paid news so that 'news' and 'advertisement' could be demarcated. The Committee noted that the phenomenon of Private Treaties gave rise to Paid News and recommended strict enforcement of existing guidelines and codes to bring transparency in Private Treaties.

The same Report also raised the issue of cross-media holdings, which has been examined in detail earlier by the Telecom Regulatory Authority of India (TRAI). TRAI in its Report dated 26.02.2009 recommended

that there should be necessary safeguards in place to ensure that diversity is maintained across the 3 media segments i.e. print, television and radio. TRAI also recommended that a detailed market study be conducted for identifying safeguards. In pursuance of TRAI's report dated 26.02.2009, the Ministry of Information and Broadcasting awarded a study to Administrative Staff College of India (ASCI) to study the nature and extent of cross media ownership, existing regulatory framework, relevant market and international experience. The ASCI Report released in July 2009 recommended that cross media ownership rules be put in place by an appropriate market regulator based on a detailed market analysis. Taking into account the Administrative Staff College of India's report, on 15.03.2013, TRAI released a consultation paper seeking to examine the need and nature of restrictions relating to cross media ownership.

On regulation of government owned media, on 28.01.2013, The Ministry of Information & Broadcasting constituted an Expert Committee for the purpose of reviewing the institutional framework of Prasar Bharati including its relationship with Government. The Expert Committee submitted its report on 24.01.2014 suggesting recommendations to make Prasar Bharati administratively and financially autonomous of Government.

Other issues related to the media have also been addressed in various reports. In 2006, the Law Commission's two-hundredth report on Trial by Media recommended the amendment of the Contempt of Courts Act, 1971 to include more stringent provisions for prejudicial reporting by the media. The Law Commission Consultation Paper (undated) on sting operations, while referring to the observations of the Committee on Petitions of Rajya Sabha in its report dated 12.12.2008, observed that there was a need to evaluate the misuse of the sting operations and their impact on privacy. In February, 2014, the Parliamentary Standing Committee on Information Technology (2013-2014) submitted its 52nd Report on Cyber Crime, Cyber Security and Right to Privacy wherein the Committee recommended that in view of the recent uproar over Section 66A of Information Technology Act, 2000 there should be a system of periodical review of the existing provisions of the Act. The Committee also observed that the there was a need for a comprehensive policy to protect the privacy of a citizen in the absence of a legal framework on privacy.

Methods of Regulation

A brief overview of the existing legal framework governing the media is essential before attention is turned to methods of regulation. There are distinct systems of regulation for broadcast media, print media and social media. At present, the law applicable to broadcast media is the Cable TV Networks (Regulation) Act 1995. The Act brought into force the Programme Code and the Advertising Code, which prohibit transmission of any programme or advertisement not in compliance with the code. There is no regulatory authority set up under the Act. Instead, the broadcasting sector is regulated by the Telecom Regulatory Authority of India (TRAI), which notifies rules from time to time on matters such as streamlining of the distribution of television channels to platform operators. Additionally, the Electronic Media Monitoring Centre established by the Ministry of Information & Broadcasting monitors the content of all TV channels uplinking and downlinking in India to check the violation of the Programme and Advertisement Code. It also monitors content of Private FM Radio Channels.

Guidelines and regulations are issued from time to time by these regulatory authorities. The Ministry of Information & Broadcasting, for example has issued Policy Guidelines for Uplinking of Television Channels from India, the latest in 2011, which include mandatory compliance of the Cable TV Networks (Regulation) Act 1995. The Guidelines introduce the three-strike and five-strikes rules, whereby permission to broadcast, and renewal of such permission, is revoked upon three or five violations of the Guidelines respectively.

Self-regulation of content in the broadcast media is conducted through a two-tier mechanism of self-regulation by individual broadcasters as well as industry level regulatory bodies. Regulation of content is divided into news and non-news sectors. For the non-news sector, industry level regulation is enforced by the Broadcasting Content Complaints Council (BCCC) within the Indian Broadcasting Foundation (IBF) that oversees channels other than the news and current affairs channels. The BCCC is an independent counsel comprising a thirteen member body consisting of a Chairperson being a retired Judge of the Supreme Court or High Court and 12 other members including broadcaster and eminent non-broadcaster members.

The BCCC hears complaints and may issue directions to the channel to modify or withdraw the objectionable content, and can further fine the channel up to Rs. 30 lakhs. If the direction is defied, the matter may be referred to

the Ministry of Information and Broadcasting for further action, including revocation of permission to broadcast. The self-regulatory body for news and current affairs channels is the News Broadcasters Association (NBA) which has set up the News Broadcasting Standards Authority (NBSA) to adjudicate complaints in relation to broadcast content on news channels. The NBA consists only of organizations that are members and submit themselves to regulation by the NBA. Therefore, the jurisdiction of the NBSA is restricted only to members. The NBA has in place a Code of Ethics to regulate television content. The NBSA is empowered to warn, admonish, censure, express disapproval and fine any broadcaster in violation of the Code a sum upto Rs. 1 lakh.

The Print media in India is governed by The Press Council Act, 1978 that establishes the Press Council of India (PCI). The Council comprises a Chairman and 28 other members. The Chairman is to be nominated by a Committee constituting of the Chairman of the Council of States (Rajya Sabha), the Speaker of the House of the People (Lok Sabha) and a person elected by the members of the Council. The PCI is statutorily empowered to take suomotu cognizance or entertain complaints against newspapers and journalists accused of violating standards of journalistic ethics or offending public taste and censure. It may summon witnesses and take evidence under oath, and issue warnings and admonish the newspaper, news agency, editor or journalist. However the PCI does not have the power to penalize any entity for violation of its guidelines.

With the advancement of Internet technology, the Information Technology Act, 2000 was introduced as the first Act to govern cyber law provisions. Section 66A was inserted in the Act by an amendment in 2008 under which sending offensive or false messages through a computer device is a punishable offence. However, no guidelines have been laid down for identification of offensive messages. The Information Technology (Intermediary Guidelines) Rules, which direct intermediaries to identify and remove objectionable content, were introduced in 2011. Section 66A is currently under challenge as being violative of free speech as it has often been said to have been invoked arbitrarily or with political motive to block access to content allegedly objectionable.

Media regulation in India is therefore not unified, and has a multiplicity of regulatory bodies. Further there are issues surrounding the enforceability of decisions of such bodies. An independent broadcasting media authority along the lines of TRAI was first suggested by the Supreme Court in *Secretary,*

Ministry of Information and Broadcasting v. Cricket Association of Bengal. [3] Thereafter, the Ministry of Information & Broadcasting has made various attempts, the latest in 2007, to draft a Broadcasting Services Regulation Bill in order to set up a Broadcasting Regulatory Authority of India (BRAI).

In 2012, the PCI passed a resolution urging the government to bring electronic and social media within the PCI's regulatory framework and to rename it the Media Council – a resolution that met with much opposition. Though the Print and Electronic Media Standards and Regulation Bill, 2012 proposed the establishment of an overall media regulatory authority, the Bill did not get introduced in Parliament. This was especially as statutory regulation of this nature led to widely expressed fears of censorship and state suppression of free media. Thus the PCI continues to be the regulatory institution for print media, albeit without adequate powers of enforcement.

Similar concerns have been voiced and addressed in other jurisdictions, most notably in the United Kingdom where, following a series of media scandals, a committee headed by Lord Justice Brian Leveson was set up to inquire the 'culture, practice and ethics' of the press, including the media's relations with politicians and the police. The report recommended a strong and independent regulator be set up to replace the existing Press Complaints Commission.

The best conclusion that emerges when you talk to media barons and to the people is that self-regulation is the best. Whether media accountability is better served by such self-regulatory institutions which are diverse and widely viewed as lacking powers of enforcement or replaced by statutory regulations enforced by one or multiple regulators has been a vexed question in recent debates surrounding media reform. Even for social media which currently does not have a dedicated regulator, the key question is whether to regulate and if so, which model of regulatory institution to adopt. In this context, the following questions arise: Do the existing self-regulation mechanisms require strengthening? If so, how can they be strengthened? In the alternative should a statutory regulator be contemplated? If so, how can the independence of such regulator be guaranteed? Specifically: How should members of such regulator be appointed? What should the eligibility conditions of such members be? What should their terms of service be? How should they be removed? What should their powers be? What consequences will ensue if their decisions are not complied with? Should any such change be uniform across all types of media or should regulators be medium-specific that is the big question?

Menace of paid News:

Paid news, defined by the Press Council of India as "any news or analysis appearing in any media (print and electronic) for a price in cash or kind as consideration" is now a common occurrence that poses a serious threat to democratic processes and financial markets. It misinforms audiences and undermines their freedom of choice.

The issue was extensively dealt with by the Press Council's sub-committee report on 'Paid News' in 2009. The report talked about the way in which the illegal practice has become organised, with 'rates' for the publication of 'news items'.[5] Further, the Parliamentary Standing Committee on Information Technology, in 2013, has brought out its forty-seventh report on the phenomenon of paid news, where it has highlighted the 'dangerous trend' of presenting paid-for information as news, that has spread at 'remarkable pace' in some parts of the media.[6] The Report also outlined the practice of 'Private Treaties', where a non-media company transfers shares to a media company in exchange for advertisements, space and favourable coverage.

Guidelines are present both in print and broadcast media that call for clear demarcation of advertisement and news content. These take the shape of norms under the Press Council of India Act, and the Programme and Advertisement Codes under the Cable Television Networks (Regulation) Act. However, these guidelines are either subverted or ignored altogether. Particularly with respect to elections, Section 127A of the Representation of People Act, 1951 make it mandatory for the publisher of an election advertisement, pamphlet or other document to print the name and address of the publisher as well as the printer. However, paid news is not expressly defined or included as an electoral offence.

To curb paid news, the Election Commission has constituted District level Committees to scrutinise newspapers for such items. Given the state of the current law, however, the Commission can only issue notices to show cause why paid news expenditure should not be included in a candidate's election accounts. Complaints are also forwarded to the PCI and NBA for necessary action. However, it has been admitted by the concerned bodies that enforcement mechanisms currently lack teeth and are insufficient to meet the challenge.

In this context, the following questions arise for consideration: Should paid news be included as an election offence under the Representation of the People Act, 1951? 1. How should it be defined? 2. What enforcement mechanisms should be put in place to monitor and restrict the proliferation of paid news?

Opinion Polls

Opinion polls conducted by polling agencies and disseminated widely by television channels and newspapers are an endemic feature of elections in India today. Several concerns have been raised about such polls, including bias in choosing sample sizes, the possibility of them being manipulated to favour particular political parties and the inordinate influence that they exercise on voters' minds especially in multi-phase elections, under the guise of an objective study. Equally, constitutional concerns have been raised about banning such polls.

Currently opinion polls are barred from being published in electronic media for 48 hours prior to an election in that polling area under Section 126(1) of the Representation of People Act, 1951("RP Act"). No other restriction exists. However the Election Commission of India has strongly argued for further restriction on publication of opinion polls. Political parties unanimously agreed that publication of opinion poll results should be prohibited from the date of notification of elections till the end of the elections as is evident from the Election Commission's letter dated 20th October, 2010 to the Ministry of Law and Justice, Government of India. The constitutionality of a modified version of this provision was endorsed by an opinion of Goolam E. Vahanvati, the Attorney-General of India on 13th June 2013. In his opinion, the learned Attorney-General opined that since there is no real basis for distinguishing between opinion and exit polls, opinion polls could also be prohibited from being published from 48 hours before the first phase of an election till after the last phase of polling is completed, analogous to the restriction on exit polls under S. 126A of the RP Act.

The Press Council of India in its "Guidelines on 'Pre-Poll' and 'Exit-Polls' Survey" has similarly mandated that opinion polls cannot be conducted 48 hours before the first phase of polling in a multi-phase election. Further details of the methodology, sample size, margin for error and background of the organisation conducting the poll would have to be indicated whenever such polls are published. Guidelines for Publication of Opinion and Exit Polls were notified by the Election Commission in 1998. However because of doubts about the jurisdiction of the Election Commission to notify and enforce these Guidelines, they were subsequently withdrawn in 1999. Any move to extend the time period for barring opinion polls has met with resistance from psychologists who have defended the scientific merits of opinion polls and

media houses who have underlined their free speech rights in broadcasting them. Further, questions of constitutionality of such restrictions remain open as there has been no authoritative pronouncement on this matter yet by the Supreme Court. in this context, the following questions arise for consideration: Do opinion polls require any kind of regulation? If so, what kind? What are the reasons for seeking such regulation, if any? Will such regulation be constitutionally valid?

Cross Media Ownership

Monopolies in the field of media ownership have a severely negative impact on the quality of media freedom and plurality in the country, specifically with respect to news coverage. Issues related to ownership of media entities have been raised repeatedly in the last few years by both private observers and government bodies. The overarching concern is that media ownership does not receive sufficient public scrutiny and is under-regulated.

On the other hand, hastily imposed regulations in this space could infringe on the freedom of the media, and pave the way towards unwarranted state control. Any regulation on vertical integration, which connotes ownership of both broadcast and distribution, and on horizontal integration, that takes the shape of cross-media holdings, must balance these two competing considerations. A further issue requiring attention is the consolidation of market share by a single media entity in a given geography. Studies have shown that there are clear examples of market dominance by media entities, making it necessary to address the question of regulation. At this point of time, there are no cross media ownership restrictions across print, television and radio in the country. Some restrictions on vertical integration are in place in the shape of guidelines for obtaining Direct-to-Home platforms. Restrictions also exist on the number of licenses allowed to FM radio operators in a given area.

Apart from these specific laws, the general competition law in India applies to the media sector. Media ownership issues have been raised repeatedly by the Telecom Regulatory Authority of India, the Ministry of Information and Broadcasting and the Parliamentary Standing Committee on Information Technology, among others. The call has been for the introduction of regulations in this area, but no such steps have yet been taken. In this context, the following questions arise for consideration:

1. Is there a current need for restrictions on cross control/ownership across the media sector? If so, what shape should such restrictions take?
2. Are mergers and acquisitions guidelines necessary for the sector to regulate concentration of media ownership? If so, what are the key factors such regulations must capture?
3. Do mandatory disclosure norms need to be imposed on media entities? Should certain categories of entities be restricted from entering into broadcasting activities?

Chapter XII

GLOSSARY OF NEWSPAPER TERMS

This chapter is intended to be a glossary of old and new media terms of relevance to the practice of journalism. The newspaper staffer must be acquainted with the jargon used in the industry so that the staffer is able to understand what is being said or commanded in the newspaper house. This glossary of newspaper terms was developed to increase the understanding of the terms and acronyms that may be unique to the newspaper industry.

Above the fold: A broadsheet paper folded in half for display. The top half of the page, above the fold, is held to be the most important because of the visibility factor. It immediately catches the attention of the readers. A reporter's ambition is to get an article on the front page and above the fold.

ABC - Audit Bureau of Circulations refers to an authority that audits newspaper circulation figures. It is an important body to certify the statistics of newspaper circulation. There is also the ABCe - Audit Bureau of Circulations Electronic - division of the ABC that audits traffic figures for online publications.

Add – It refers to addition of any kind to the news story. Add means adding more information or visual to a story already written. It is mostly used in the case of developing stories. Suppose there is a major event. The reporter would file the details immediately available in the copy and then add details as these keep on pouring. If the copy has already been sent for printing, the sub editor would mark the new information 'add.'

Adobe InDesign - Desktop publishing program, now being used more widely in place of QuarkXPress is named InDesign. However, many newspapers in India still prefer QuarkXPress.

Ad: It is used for Advertisement paid for by the advertiser.

Ad impression - Term used to describe the number of times an advert is seen. Advertisers usually sell space based on the exposure per thousand impressions.

Advertorial - An advert in the form of a complementary editorial piece, usually labelled as an advert. It is different from paid news because paid news is for the story that has been paid for by the interested person or persons. Advertorial clearly indicates that it is advertorial.

Advance run: Sections of the newspaper that are printed before the publication date, and then inserted into the paper.

Agate: It is a unit of advertising. A type size, approximately 5-1/2 points or 14 lines per inch, used mainly in sports scores, legal notices, stocks, credit lines and classified line advertisements. One column inch is equal to 14 agate lines.

AM's: Morning Newspapers

Artwork: Any newspaper illustration. It also refers to materials other than text, such as photos, illustrations and diagrams or some creative material prepared by the designer or art director.

All Caps -	A word or sentence written in all capital letters. The all caps sign is used by the sub editor or copy editor directing the printer to publish the text in all caps. If it is C and LC that would mean capital and lower case material.
AM Mark-	The symbol used for denoting the end of a feature story in a periodical.
Angle –	The slant given to a story by the reporter. The approach or focus of a story. This is sometimes known as the news peg.
AP -	The abbreviation for the Associated Press.
Assignment -	A job or duty assigned to a reporter by an editor. It could be the task to do a specialised story or routine job.
Attribute -	to quote the original source of material, whether it be a quote of copyrighted work. This is in contrast to innuendo where source is not spelled out.
Audit -	An independent assessment of the validity of statistics used in adverts, newspapers etc.
Average issue readership -	Number of people who have read the newspaper or magazine in the period that it was issued, also known as AIR.
Background –	Information or details given in the story by a reporter to explain the context of a situation or information. It also refers to information given to a reporter to explain more about the situation and details of a story.
Back bench -	Senior journalists in a newspaper.
Balloon:	A cartoon device, used in comic strips and occasionally in other ways that show the words of a person coming directly from his mouth or thoughts from their mind.
Bank:	Also called Deck. It is the part of the headline that follows the top.

Banner: The main headline that runs across the top of the front page. It is the headline and the story, stretching across all the columns on the top of a page. Please do not confuse it with Binder which refers to a headline that runs across all columns on top of an inside page.

Beat: Area assigned to a reporter for regular coverage: for example, police or city hall. It is an exclusive territory assigned to a reporter to gather or collect news. Also, a term sometimes used for an exclusive story. This is the area or subject that a reporter regularly covers. It is the reporter's regular assignment, for covering news like sports, crime, art or music.

B1: Refers to setting the copy in black and bold faces. It is heavier, darker and bolder than the usual type.

Black and White: Black and White in Newspaper jargon means reproduction of photographs and illustrations in black and white.

Bleed- When an illustration or photographs runs through the edges of the page it is called bleed. It is an illustration filling one or more margins and running off the edge of the page or border; used frequently in magazines and advertisements. It also refers to instructions given to printer to follow.

Body - The main part of a story. It is that part of the story that follows the lead or intro.

Body Type- Type used in stories, not in headlines; generally under 12-point size; opposite of display type. It is the name of the type in which regular matter is set in a newspaper.

Box - Refers to type that is framed in a border to give it prominence. It is used to highlight stories that need public attention. Usually it is the column lines on all the four sides but many newspapers use only top and front columns to make a box. Those inserted in the middle of a story are also referred to drop-ins.

Budget - The line up of news stories scheduled for the next day's newspaper. Also called The daily budget, or list of pending articles, either completed or imagined, typically discussed at an afternoon news meeting at which preliminary decisions about what is to go on the front page are made.

Bulletin: Brief despatch containing major news contained briefly in 40-50 words. Usually when newspaper is already under print and some important news arrives, a brief bulletin is used to not to miss out on the information.

Bumped Heads- Similar headlines running side by side that create monotony and the tendency to read across.

Byline – The by-line is signature on a story to identify who had written the story. The author's name, which is printed at the beginning of an article or a news story not to be confused with credit line which is given to photojournalists or cartoonists for their pictures or art work.

Blind interview - An interview with an unnamed source.

Blurb – It refers to publicity material. Brief introduction to the writer, usually following the headline. Blurb is usually written on the backside of a book or magazine.

Boil down: This term is used when a story is reduced or shortened to bring it to manageable limits to fit in the space available.

Breaking news – Breaking news is unanticipated events developing during the publication cycle, requiring updates and occasionally wholesale revision of pages. Breaking news is conventionally greeted by profane expressions on the news desk, city desk, or copy desk.

Bulk copies - Copies distributed free, normally for promotion.

Bulldog -	it is an early edition. Sometime newspapers publish a bulldog edition of the Sunday paper that appears a day before on Saturday. In India it is also called "daak edition" or postal edition because it is sent by post to far flung areas not served by other means.
Bleed:	To print past the finished image area into the trim area. There is another term called Bleed Through which is the printed image on the reverse side of the page that can be seen through the paper.
Blowups:	An enlargement of an advertisement or message. Sometimes blowups are referred to as portrait of a person.
Body:	Refers to the main story distinct from intro and headline. Rest of the story or copy is called body of the story.
Border lines:	Line rules used to make a box to prominently display a story. Border lines are also used to separate one story from the other when they bleed into each other.
Bump -	To move the position or timing of a story. Bump is a story in time, or to another location in the newspaper.
Bundles:	Packets of newspapers delivered put in bundles of say 50 ot 100 in truck to various drop points for distribution in the city or in the region.
Buried lede –	Buried lede is the central element of an article mistakenly appearing deep in the text. The point of the story that is buried in the story instead of being in the first paragraph is Buried lede.
Bureau:	Head of the reporting section is called Bureau Chief or Chief of the Bureau and his or her office as Bureau which may comprise of a number of reporters and photojournalists.
By-line:	A line at the beginning of an article that gives the name of the writer(s) not to be confused with caption that is used beneath pictures or illustrations.

Burn off - To dispose of articles that have previously been rejected for the front page or section front by running them on a day of low circulation.

Campaign - The campaign launched by a newspaper to catch public eye and to focus on issues concerning public at large. It is sometime to put pressure on authorities to take action.

Cap – In newspaper jargon called uppercase or capital letter.

C and LC: Caps and lower cases. Words written in capital letters and in lower case are described with the instructions of C/LC.

Caption - Text printed below a picture to describe the picture and who took it. It is sometimes called a cutline. It is the title or brief description of a picture; a cutline.

Caseroom: The area or room where the printer works.

Centre spread: Two pages in the centre of the newspaper. Mostly lengthy stories or features with pictures and illustrations are used as Centre spread. Sometime a big story titled "Spotlight" or "Focus" is used as Centre spread.

Chase: Metal page form in which type is locked.

Cheesecake: Photographs used in a newspaper in which female form is revealed to attract the attention of male readers.

Circulation: Number of copies sold by newspapers or magazines. In most countries like India and the United Kingdom these figures are monitored by Audit Bureau of Circulation. It also refers to the number of newspaper copies sold or distributed. Interestingly, many newspapers print more copies to show more circulation though many of these copies are returned as "unsold". Circulation figures of established consumer media are audited by the Audit Bureau of Circulations (ABC). Circulation figures do not determine the number or quality of a publication's readers and should not be confused with readership.

Clean copy: Copy without mistakes or errors. The news desk prefers to have such a clean copy from reporters. Clean copy also refers to a report filed by a reporter which does not require much editing.

Column: Vertical dimensions of a newspaper page that change in width depending upon the product. Editorial and Retail Advertising are composed of eight columns per broadsheet page: Classified Advertising is composed of 10 columns. The Column is also a regular feature often on a specific topic, written by the same person who is known as a columnist.

Column inch: One vertical inch of a column or leg. The length of stories is sometimes calculated by column inches, sometimes by number of words.

Columnist: A specialised writer usually a senior journalist or a senior functionary or an authority on a subject.

City Editor: The editor in charge of the City Edition of a newspaper. He or she is responsible for collection, writing and editing of local news.

Classified advertisement: Advertising arranged according to the product or service advertised, and usually restricted in size and format. The ads are "classified" into various categories such as Property, Situations Vacant, Vehicles for Sale, Plots for Sale, Flats for Sale, House or Flat for rent etc. It is distinct from display advertisements which is bigger in size and charged as per column centimetres.

Clip: Clipping of newspaper for reference. Clip refers to a tear sheet or photocopy of a published article in a newspaper or magazine. Editors usually require them as proof of previous publication or to evaluate a writer's suitability.

Cheque book journalism: Practice of paying for the news. Many small time newspapers get paid for news published.

Closed question:	A Yes or No question that does little to encourage an interviewee to open up is a closed question.
Copy:	It is universally known as material written by journalists. Material submitted with the layout for inclusion in an ad or news reproduction. Also used for a single copy of a newspaper. It is the main text of a story.
Copy Desk:	The place where copy is edited, headline given and where Sub Editors and Copy Editors work.
Copy Editor:	A newspaper staffer who corrects or edits copy written by a reporter and writes headlines. Like a Sub Editor, the Copy Editor is the unsung hero of journalism. However, some newspapers and magazines have started giving the name of the Copy Editor along with Reporter.
Copy Holder:	While proof reading a news story or material, the person who holds the Copy is called Copy Holder.
Correspondent:	A Reporter who is not posted in the city from where the newspaper is published. As he corresponds with the newspaper and sends his or her reports through correspondence, it was given the nomenclature of a Correspondent.
Copyright:	Ownership rights over intellectual property such as a book, story or photograph. It protects the owner's right to decide where, when, and by whom the work is published. No material can be used or published without the permission of the Author.
Composing Room:	The place in which printers, now vanished, once assembled pages in hot type or cold type.
Contempt of Court:	The criminal offence of ignoring Court rules or publishing proceedings held in camera. In camera proceedings are usually held in cases relating to rape or those involving security of the country.
Copy approval:	A source or interviewer asking to see the text of an article prior to publication.

Copywriting: Creating the text for an advertisement.

Cover line: Caption on a magazine cover.

Cover: Covering an event by a Reporter. Also the leading story used on the front cover.

Credit line: Credit line is like by-line given to a Reporter. It is given to identify photographer, artist, illustrator, or an agency usually placed at the bottom right corner of the art.

Crop: Cutting non essential parts of a photograph to sharpen the image. The trimming of an image for publication mean cropping.

Crosshead: A headline in small type within the set matter to highlight what follows. A few words used to break up large amounts of text, normally taken from the main text. Crosshead is used in interviews.

Cub: An untrained journalist, a trainee reporter. Also known as a rookie or junior reporter. Cub is a beginner reporter.

Cutline: Caption or text near a photo that describes the action or identifies the subject(s).

Cut: To remove text to make a tight copy. An engraving

Cuttings: A journalist's collection of published print work. Also known as clips and sometimes presented as a portfolio.

Cuttings job: An article that has been put together using research culled from a number of other articles or news items.

Dateline: Place from where a story has been sent with date of filing the story. It is like Chandigarh, Feb 11 or London, March 26 and so on. It is a line at the beginning of a story stating the date and the location. Dateline is the line at the beginning of a story identifying the place of origin of the story, but not the date. It denotes the time at which an editor requests a journalists to finish an assignment.

D/C: It refers to Double Column. You can describe a two column story as double column story or give instruction to the Sub Editor to make a D/C of the matter filed by a Reporter.

Deadline: The last minute or the time set for filing a news report. Meeting deadlines is the most daunting task for all staffers working with any newspaper. The newspapers work like a battle field and everything has to go in a clock like precision. Desk: the news desk where sub editors or copy editors work.

Death-knock: Calling at the house of a bereaved relative or friend when reporting on the death. Also known as door-stepping.

Deck - Part of the headline which summarises the story. Also known as deck copy or bank.

Defamation - Information that is written by one person which damages another person's reputation. Defamation can be both civil and criminal. The onus lines on the person who files defamation suit to prove that the defamation was an intentional act to bring him or her to disrepute in the eyes of public.

Desk: An editor's section, such as the city desk or foreign desk. The Copy Editors and the Sub Editors sit on this desk which is chaired by the Chief Sub Editor or Chief Copy Editor. In some newspapers the News Editor heads the desk.

Digital edition: A supplement to a newspaper appearing on the Internet. These days most newspapers have digital or internet or online editions.

Direct quote - The exact reproduction of a verbatim quote in quote marks and correctly attributed.

"Dinkoy: A quarter roll of newsprint

Dope: Inside information brought by a Reporter from a source. The Editor often asks "What is the dope on this story".

Drop Letter:	Drop Letter is the first alphabet that is bigger than the size of normal letters or alphabets used in the rest of the story. This enhances the looks of a story and many newspapers make Drop Letter, a part of their style sheet.
Drop Headline:	A headline in which the first line begins on the left side and the rest on the right side.
Dummy:	A draft page layout which indicates the position of each story, picture, headline and advertisement on a newspaper page.
Ears:	Boxes on either side of the nameplate or masthead of the newspaper on page one. At times, these are above the name on the front page of the newspaper or sections of the newspaper. Most newspapers use the ears for small advertisement for which the advertisers pay a hefty amount in view of its positioning on the front page top. Some papers use this space at the top of the front page on each side of the newspaper's name to place weather news, index to pages or announcement of special features appears.
Editor:	A person who heads the editorial department of the newspaper and decides what goes where in the news hole, or one who reviews and revises stories submitted by Reporters. There are many Editors in a newspaper these days like Editor-in-Chief, Managing Editor, Chief Editor, Group Editor and so on.
Editorial:	An article appearing on the editorial page presenting the opinions of the newspaper. It is the Editors opinion or viewpoint on a burning issue. In some newspaper there are two or three editorials on the edit page. The first editorial is called the Leader. In special occasions, Editorial may be placed on the front page to highlight the issue and the view of the Editor. Also refers to the department where editorials originate.

Edition:	A newspaper may run one or more editions daily like the City Edition or the City Edition. Sometime these are classified as "Daak Edition" or City Edition with a Single or two stars to explain which edition came first. It could also be like home edition, state edition or provincial edition etc.
Embargo:	A deadline for the release of a story. Embargo thus refers to a restriction on releasing material before a specific time. Embargo is usually put on by the source in case of speeches of people in power so that the same is released simultaneously across the length and breadth of the nation but with the instructions to use it at a certain time simultaneously.
Em-	Em is a unit of measuring column widths which is based on the square of M in a type usually 12 points. An em (for the letter M) is a square of any given size of type, and is most frequently used as the unit in measuring "pica" (the width of an Em in 12-point type).
En -	Half of an em. It is also called nut.
Exclusive -	A story printed by only one paper; a scoop.
Feature:	A story of interest beyond the news which can be used according to convenience of the reporter because the information contained may not be time bound as in the hard news. It is also an in-depth look at a subject that interests readers but is not necessarily related to breaking news.
File:	Filing of a news report or story from the newspaper office or from outstation centres.
Filler:	Small items used to fill out columns where ever needed and where copy cannot be expanded. Material used to fill space, usually promotional in nature. A single sheet printed on front or on front and back, usually 8.5" x 11" that is inserted into the newspaper.

Five	Ws AND H: The questions (Who? What? When? Where? Why? How? That should be answered in the lead of an article written as an inverted pyramid.
Flag:	The banner or name of the newspaper on the front page.
Flash:	A rarely sent message denoting in few words some extremely important information.
Flat rate:	An advertising rate not subject to frequency or quantity discounts.
Flier:	A single sheet printed on front or on front and back, usually 8.5" x 11" that is inserted into the newspaper.
Flush:	Set copy without para indenting.
Flush left or right:	Type composed with successive lines aligned to the left, but not on the right; also called flush left/ragged right. Fully justified type is aligned on both margins. Flush right is successive lines aligned on the right, but not on the left.
Fold:	Line at which the newspaper is folded.
Folio:	A line at the top or bottom of a newspaper page that gives the newspaper name, section.
Follow-up:	Further development in a story which has already done by the reporter of a newspaper or by reporter of another newspaper. Usually, the reporters are made to follow the story and the developments till these reach a logical end.
Font:	Font is type of one size used for a story. Front in composition, a complete assortment of type and a given size and design, including letters, numbers, punctuation marks and symbols.
Forme:	A page of type locked and ready for going to press for printing.
Fourth Estate:	Traditional term for "the press" which originated in the 18th century English Parliament. The other Estates refer to Parliament or Legislature, Executive and Judiciary.

Freelancer:	An independent writer or photographer who works for another person or publication as needed. He or she is not a regular staffer with a newspaper.
Gallery:	Final proof print before publication.
Gray bar:	A narrow screened strip composed of the three process colours which are placed across a color image to check evenness of ink. The gray scale is a strip placed at the side of an original with various tones of gray bars, used to measure negative exposure and development. Gray bar is also called a "step wedge."
Glossy:	Shiny print or shiny newsprint or paper used for printing of books and periodicals.
Gutter:	The margin of white space between two columns or where two pages meet.
Half stick	Matter usually plate in half column size.
Halftone:	Tiny dots that make a photograph suitable for printing.
Handout:	Generally used for press releases given at press conferences or sent to newspaper and news agency offices.
Hard news:	Timely news of an important event. It is distinct from soft stories like features.
Hawkers:	Vendors who sell newspapers on sidewalks and medians and are responsible for distribution of copies at homes or at corporate offices.
Headline:	The title of a story or article. It is usually given by the copy editor of the sub editor
Hook:	The stylistic device used by a reporter to draw a reader into the story
HO:	In newspaper jargon, it refers to Holdover. Hold Over means that the story can be held back for subsequent use.
Human interest story:	A story with emotional appeal. It is usually in offbeat story. The human interest story has human or emotional appeal for the readers unlike hard news.

Indent:	Begin matter at a distance from the margins.
Insert:	New matter added in the body of the story already sent for use. Any pre printed material "inserted" into the newspaper.
Italics:	Typeface in which characters are slanted to the right to differentiate the matter from rest of the story. It is used to lay special emphasis on that part of the information.
Inverted pyramid style:	The traditional organization of a news story, with the most important facts at the top and less important details at the end, where they can be lopped off if necessary. It is most popular style of writing a news story in which all five Ws and one H usually come at the top or in intro itself. It gives liberty to desk to crop rest of the story keeping in mind space constraints.
Jump:	Continuation of text on another page. It is usually done in case of front page stories as some matter is carried on front page and rest jumps to some other page.
Jump line:	The continuation line giving the succeeding page numbers.
Kill:	Command to delete or spike the story of part of the story or an ad or story that is being cancelled. It is also called spiked.
Late News:	News that arrives too late to make it to front page. Such news is accommodated in column under title "Stop Press".
Layout:	A page plan or arrangement of illustrations. Layout is rough sketch which gives the general appearance of the finished printed product, indicating the relationship between ads, text, photos and illustrations.
Lead:	The first few sentences or paragraphs of a story. It is also referred to as an intro. The lead follows the headline.

Leader: Row of dashes or dots used to guide the eye across the page to text or figures. In some newspapers editorial is called leader.

Legal notice: An advertisement required by law to be published in a newspaper of general circulation. It is also a notice from an advocate to a newspaper if some story is found to be defamatory.

Leg-man: A reporter who gathers news but does not write the story. The hard work that he puts in to collect information is called leg work.

Letterpress: Method of printing from raised images on plates. There are four types of letterpress presses: platen, flat-bed cylinder, rotary and belt.

Libel: Any defamatory material or statement expressed in writing, printing, through visuals like pictures or caricatures or through gestures. Publish false or defamatory information about an individual or organization. The reporter and the editor can be tried for libel if the information is defamatory and intentional.

Lino: Lino refers to Lino type, a machine for setting type.

Lithography: Printing process that prints from flat plates using water to repel ink from non-image areas of the plate.

Lockup: Deadline in the composing room for getting all page formes off the floor and into the stereotype department.

Logo: Unique graphic or type element used for identification of a business or product.

Make up: Assembling the newspaper in the composing room. Art of designing and making the newspaper look aesthetically designed. Make up is selection of the typeface and point size of ad copy. Designers and Copy Editors do the makeup.

Managing Editor: The person who coordinates news usually a senior journalist responsible for managing the newspaper.

Masthead: The name of the newspaper often called Flag. Not to be confused with box or section printed in each issue, listing the publisher, owner, editors, the location of office which refers to Print line. It is a statement mostly on the Editorial page about the newspaper.

Matrix: Often called Mat it is the hard cardboard impression of a page or advertisement. Matrix is also called a Flong.

Mono: Short form of Monotype, a machine for cutting type.

Morgue: Newspaper library of past editions. It also refers to Reference Section of the newspaper house.

Must: When this instruction is given on the copy, it means that the said story must be used. Only editors or senior journalists in authority can issue this instruction.

Nameplate: The name of the newspaper given on the top of front page in bold and prominent size. Nameplate is also called flag.

Newsprint: Paper made mostly from ground wood pulp and small amounts of chemical pulp; used for printing newspapers.

Obit (Obituary): It is announcement of a death. Obit reference is a biography of person who died and other necessary information including time and place for memorial, wake and/or funeral.

Offset: Printing method in which ink is transferred from plate to a rubber surface before it is transferred to paper.

Off the record: Information provided on the condition that the source not be revealed. There is an unwritten code that information given off the record by source should not be used.

OP-ED: An opinion column or article, especially one that appears opposite the editorial page.

Overnight: A story filed by a reporter but turned down by the rewrite journalist for the first edition of the newspaper.

Overrun: Copies printed in excess of the quantity needed for distribution in the newspaper.

Overset: Material left over from an edition. Usually wasted and a cause of concern for newspaper establishment because of wastage.

Page proof: Full size copy of a composed page that is sent to the editorial departments to be checked for errors. It is the proof of the page on a paper sheet. Sometimes it is also called a "galley proof".

Pagination: To create a page layout on a computer screen instead of cutting and pasting paper. Designers and Copy Editors do pagination.

Paster: Process used to transfer an expiring newsprint roll to a new roll to allow continuous flow of paper. A person working on this is called a Paster.

Pica: Point type size 12. A linear measurement of 12 points refers to Pica.

Plagiarism: Intellectual theft; using the work of another person (written words or other intellectual property as one's own. There are stringent laws against it.

Pix: Picture(s)

Picture Plate: Sheet of metal, plastic, rubber or other material used to produce an image that transfers ink to newsprint.

Play: The display given to a story or a picture. Stories of national importance are played up in national editions and local stories in local pull outs or city editions. Plate: A page of type cast in metal fitting in press for printing.

PM: In newspaper jargon it refers to afternoon newspapers.

Position: Location of an advertisement or news story within the newspaper.

Point: Basic printing measurement. Point is the smallest unit of type measurement. There are 72 points in an inch.

Postscript:	Output language used by some computer systems. Postscript is also written at the end of the article or story.
Prepress:	Departments of composing that prepare pages for printing and distribution. Then there is preprint which refers to advertising or editorial sections that are printed before the daily run and inserted in the newspaper before delivery. Also known as FSIs
Press conference:	A meeting called to give information to the news media. Press conference can be called by a political figure, an administrative authority or a common person aggrieved for a cause.
Press release:	A specially prepared statement for the news media.
Process colour:	Printing process which uses halftone plates in the three primary colours and black to produce a full-colour image for publication.
Promos:	Promotional items, often called teasers.
Proof:	A print made to check for errors.
Proof Reader:	One who reads proofs to check mistakes and to carry out corrections in the copy and to sends it back for revision. Now technology has made this position almost redundant in newspapers because sub editors and copy editors with the help of spell check can bring out flawless newspapers.
Pull out:	Copy extracted from a story and enlarged or highlighted to draw readers' attention. Usually a special supplement can also be called a Pull out.
Publisher:	The chief executive of the newspaper, sometimes the owner of a newspaper or other publishing firm. He or she can be printer publisher both.
Puff:	Publicity material.
Pull:	Proof because proof is pulled out.
Put to bed:	When all pages of newspaper to be printed have been locked up and the press is about to print these, it is called put to bed.

Quote: Words spoken by someone in a story. In page-design jargon, a lift out quote is a graphic treatment of a quotation, often using bold or italic type, rules or screens. Without quotes, the newspaper become faceless and direct quotes add to the credibility of the story.

Reach: Total number of households to which a given publication is exposed.

Readership: The average estimated number of readers of a given publication. Readership includes primary readers (those who buy or subscribe) and secondary or pass-along readers. This is different from circulation.

Rewrite man: A writer who re-writes a story.

Retainer: A person who works on retainer ship basis-an amount fixed by the establishment. Not to be confused with salary. The person is not only the staff of the newspaper and is not assigned a regular job of the reporter.

Retouching: Methods of altering original artwork or photography to make corrections improve or change the character of the image.

Reverse: Instructions that picture plate should be made in reverse, the right coming on the left and vice-versa for layout effects.

Run: The Reporter's beat. Also refers to the printing of the newspaper from the time press starts until the required number of newspapers has been printed. Also the number of papers printed for each edition.

Running story: A chronological story of an event marked by different leads as the information changes means running story.

Run over: Another term for jump.

Round-up: A detailed story which may contain information received from different reporters or from different sources. The information so collected is rounded up in a single story.

Run-on:	Linking passages together to make them go in the same paragraph.
Rush:	Instruction given by the Night Chief, the Night Editor or the Incharge of the News Desk to rush the story for printing. This instruction is given when there is a news break.
Sans serif:	Sans means without and as such this is the type style without fine cross strokes on the ends of the letters. The face is generally even in overall weight with very little contrast between thick and thin strokes.
S/C:	Single column. It may refer to single column headline and the story in a single column.
Schedule:	List of assignments. It also refers to Schedule of Advertisements for which there is a separate and dedicated Scheduling Department in big newspapers.
Scoop:	An exclusive story for a newspaper for which a reporter has done hard work. A story obtained and distributed ahead of competitive media. It may be called an exclusive story as well.
See copy:	Instruction to Proof Reader to see original copy.
Short:	A short item, a small news story also called a brief.
Shoulder:	this refers to top line of headline which is set to in smaller type on one side which the rest of the headline is set as usual.
Slant:	An angle of a story.
Slog:	Editorial code used on stories and photos that corresponds with code on the page. It is usually a single word to describe a story.
Slug:	Each story has a small name called slug. The slug is given on each pager number. Say if the story is about fashion, the slug would be Fashion with different pages marked Fashion 1, Fashion 2, Fashion 3 and then Fashion-last to tell that this is the last page of the Fashion story.

Source: A person, document, or organization that provides information.

Space: Empty space between type lines or space left after a story.

Space out: An instruction to printer to give more space between parts of the matter so that the page does not look too crowded.

Spread: An elaborate layout

Spike: To kill a story. A portion of the story or whole of it can be killed or spiked.

Standing matter: The matter already edited and cleared for printing but not used that day and left for the next day.

Stet: Proofreading term signifying that copy marked for correction should remain as originally written. Let the copy go as it is.

Stick: The type size of about two inches.

Stone: The table on which the printer makes the pages.

Stringer: A correspondent who is not on the rolls of the newspaper but is paid for the stories used. Stringer is an independent writer or photographer who sells materials for publications. The name comes from a time when payment was determined by measuring the story or photo with a piece of knotted string. Stringer refers to the lowest paid journalist reporter in a newspaper in most of the cases.

Style book: The guide for grammar, capitalization, and other word usage for a publication. All newspapers have their style book. Like some may use Mr before a name or Ms or Miss but others find it redundant and waste of precious newsprint.

Subhead: Small headline within the text used to break up a long story and make it more readable. One is the heading of the story and rest could be sub heads before paragraphs.

Syndication:	An organisation that sells articles or features on behalf of the writer or writers. Selling material—comics, columns etc. to a number of publications at the same time. A group of journalists could form a syndicate to sell their stories.
Tabloid:	A newspaper about half the page size of a broadsheet. Blitz was a well known tabloid at one stage but has now gone into oblivion. The world over many tabloids thrives on sensational or sex and crime stories. However, there are many
Tailpiece:	Usually a paragraph with finishing touches to the story. It may be a joke or light material at the end to make the write up interesting.
Teaser:	A small promotional item to whet interest for something inside the paper.
Tip:	small piece of information that could lead to a big story.
Top:	Instruction that the story should be used on the top in a single column.
Take:	A page of the story or part of the story. If the story is too long, the sub editor would send the story in parts for printing marked "Take1" "Take2" and so on.
Transpose:	To interchange two items, i.e. as to switch the positions of photos running on the same page.
Trim:	To cut down the story to keep essential details.
Turn:	A story that cannot be completed or accommodated in the front page because of its length. Such a story is marked Turn to use rest of the story on Turn page.
Type book:	The book showing various type families that can be used by the newspaper.
W/F:	Wrong font that may have been used inadvertently.

Yellow journalism: Fabricated or sensationalized news that may have been unduly exaggerated. That puts the newspaper in a low category because sensationalism may sell but spoils the aesthetic taste of readers. Mostly crime and gossip stories come under this head.

Wire Service: Refers to News Agencies.

Chapter XIII

ORGANIZATIONAL STRUCTURE OF A NEWSPAPER ORGANIZATION

Journalism is not concerned only with writing and editing of newspaper and periodicals. The gathering and transmission of news, business management, advertising and other processes connected with the production of a newspaper also come under the purview of journalism.

A Newspaper publishing company is made up of several functions, which work together to investigate, gather and report news, and other relevant information, to consumers in local, national and global markets.

The organizational set-up varies from newspaper to newspaper depending upon the size of the newspaper and the different services catered for the readers. Advertising Sales, Assignment Desk, Editorial, Information Graphics, News Collection and Reporting, Photography, Publishing, Sales Performance Management are among some of the key functions and departments in a newspaper.

Generally speaking, most of the newspapers have three main departments-editorial, business and mechanical. The job of the editorial team is to make high-level executive decisions about what stories get coverage and what direction of content the newspaper takes, as well as to conduct the day-to-day business of fact-checking, editing for clarity, writing headlines, page layout and coordinating reporting activities with hard deadlines.

Editorial Department

The editorial or news department is the heart of a newspaper. It deals with news, features, comments, columns and editorials. At the head of the department is the editor or editor-in-chief.

The editor is assisted by the city editor, or chief reporter who has a team of reporters to cover the local events. In some newspapers, there are separate desks for national and foreign news, which are fed by new agencies and also by papers own correspondents.

The editor is also assisted by critics in special fields such as theatre, music, films, etc. One important desk and its functionary head, i.e., the copy editor edits the copy and writes headlines.

The assignment desk has one of the busiest functions in the newsroom. The desk distributes time-critical information in the newsroom and often makes rapid decisions about leads. It handles incoming dispatches from the field, monitors emergency scanners and manages news teams and breaking stories. The editor of a small newspaper combines in himself almost all the functions, i.e., gathering editing and printing of news. He also solicits advertisements and looks after the business side of the paper.

Editor-in-Chief

Atop the editorial hierarchy ranks the editor- in- chief who plans and directs the day to day operations, supported by a team of news editors, chief sub editors, senior sub editors and sub editors. It is the top most position in the editorial board. He does not involve in day-to-day activity of a newspaper yet he controls the newspaper. He appoints the right person for the job. A good Editor in Chief would know how to use his power &influence for the betterment of the publication as well as for the betterment of the society. He would use his office to draw attention to humanitarian issues and fight for the cause of the oppressed and the weak. The Editor in Chief is the soul of the Newspaper.

The news desk usually operates in shift and each shift is headed by a chief sub, also called as 'slot man'. Ideally in a newspaper, it is the news editor who plans and directs page making while the chief sub helps implement his decisions. Reporters and sub-editors are the pillars of organizational hierarchy. The chief reporter supervises the bureau while the chief sub editor supervises the desk. The hierarchy of authority in the reporting and editing section is given below.

Editor

The editor holds the key position in the newspaper organization. He is responsible for the editorial content of the newspaper including everything from comics to news stories to editorials. It is the editor who can be sued for libel, who can be hauled up before Court, Parliament and legislatures for contempt.

A good editor of a newspaper is aware of the scope and interpretation of news. He takes all important decisions connected with the publication of news and expression of opinion on vital national and international issues and events.

Typically the daily routine of an Editor or Editor-in-Chief

It is important for an Editor or Editor-in-Chief to be in constant touch with his audiences like the Government officials from Ministers downwards to authorities in the government like senior bureaucrats and others who can be potential sources of news.

Senior editors can easy call on the ministers and in turn the ministers and senior officials often interact with them. The later need government policies published in newspapers and such it suits them to befriend the Editors. The editors cannot live in isolation and their public interaction is becoming increasing important in view of nature of their jobs to lead the society by example. The very purpose of journalism is threefold-to inform, to instruct and to entertain. It is very important for editors to understand public pulse to advise the people and to instruct them on vital issues.

The fact is that all Editors are very busy persons from morning to evening which is often to late night work. They often complain of extremely busy schedule and are not even able to give time to their families or to pursue their own hobbies. Little doubt they have coined terms like quality time that they spend with their families, their children and friends.

Daily Routine of an Editor:

6.00 AM:	gets up
6.30 AM:	has a cup of tea and a cursory look at the newspaper
7.00 AM	Gets ready for a walk/jogging or to go to a gym
8.00 AM	Returns home to get ready
8.30 AM	spends an hour on newspapers mainly rival newspapers
9.30 AM	has a quick breakfast

10.00 AM	leaves for morning meeting with staff of editorial dept to look for what the newspaper had scored and what it had missed. Assignments are given to reporters for the day
11.00 AM	is free from morning meeting
11.15 AM	Meeting with senior journalists like the News Editor, the Chief of the Bureau and the City Chief over a cup of tea to discuss about day's schedule.
12.00 Noon	Assistant Editors and Editorial writers meet the Editor or Editor in Chief to discuss and plan editorials to be written and articles to be outsourced from experts and freelancers.
1.00 PM	Editor or Editor in Chief does his own writing work
2.00 PM	is free for lunch at office or rushes to his home if it is nearby to have a quick bite.
3.00 PM	comes back to his office room to meet senior editors to again interact on developing stories, the breaking stories, interviews and what has to go in the newspaper the next day.
4.00 PM	usually meets visitors including politicians, the bureaucrats or people who have grievances to be published in the newspapers and other friends etc.
5.00 PM	the evening meeting begins in Editor's room. The city team, the Photo Section Incharge, the Desk Incharge attend the meeting. By this time most of the stories start arriving at the desk and the News Editor has fair idea of what would be the newspaper lead the next day. It is the time that most outstation reporters send their schedule and start filing stories by the deadline of say 6 PM.
6.00	PM The Editor or Editor-in-Chief calls up his friends and others in other newspapers. He also has a look at the television installed in his room to know about what is going around in the country and about breaking news.
7.00 PM	The editor cares for a cup of tea or coffee to ponder over how the newspaper would look like tomorrow. He can again summon news editor to discuss a few points or the ideas that come to his mind.

8.00 PM	leaves for dinner or cocktail party organized by various authorities in the government or corporate sector or media circles.
10.00 PM	PM Editor is free from dinner and leaves for home.
10.30 PM	PM Editor again calls up newsroom to enquire about the progress of the newspaper
11.30 PM	The office boy delivers a copy of the "daak edition" or early city edition to the editor.
11.45 PM	Editor may call up Night Editor or Chief Sub Editor incharge of the newspaper if he has some suggestion upon reading of the first edition.

Post 11.50 PM Desk can call the Editor any time on his mobile number if there is some earth shaking news or any problem in the publication of the

Newspaper.

Resident Editor

The Resident Editor heads a particular edition of the newspaper like the Editor in Chief he is fully responsible for the entire content of the edition. He has a legal and moral responsibility for all that goes in the edition of his newspaper. The resident editor sets the policies of his office and his main job is to chalk out the plan for the growth of his edition.

The resident editor handles the issue of the newspaper published from a particular centre. Though on his part he reports to Editor-in-Chief, yet he has full autonomy in day to day editorial operations. In any edition of a newspaper which has multi-editions, the resident editor would work like the boss without interference from the Editors because neither a resident editor would like interference nor an editor would do that because of time constraints.

News Editor

The actual news production process is handled by the news editor in a newspaper. The fact is that a good newspaper is the baby of good news editors. The news editor is one who is in actual charge of all editorial departments in the newspaper. All major decisions regarding coverage of news stories are taken by the news editor in consultations with the bureau chief.

The news editor decides which news will appear, how it should be displayed and what not to be used. The news editor coordinates the news collection process, the editing and the final presentation of news. He is the head of the news desk. His team comprises deputy news editor, Chief Sub editor, sub editor, trainee sub editor.

As the head of the desk the news editor plays a very important role in the layout of the newspaper. He is responsible for the day-to-day running of a newspaper. The chief reporter too reports to him on day to day activities and tells about the stories on which different reporters are working.

He or she plans layout of newspaper edition, receives news copy, photographs, and dummy page layouts marked to indicate columns occupied by advertising. He interacts and confers with management and the editorial staff members regarding placement of developing news stories. Determines placement of stories based on relative significance, available space, and knowledge of layout principles. The news editor marks layout sheets to indicate position of each story and accompanying photographs. Approves proofs submitted by composing room. May write or revise headlines. News Editor may edit copy and may perform related editorial duties as required.

News Editor is the chief link between the Editor and the Reporting team and other editorial staff. He has the final veto to stop press if the news editor thinks that some extremely important news must be used as the lead on page one or entire page one needs to be changed. He is an institution known for his erudition.

Chief Sub Editor or Chief Copy Editor

Chief Sub Editor prepares the dummy of Page 1. He calls photo-journalists, senior sub editor, senior copy editor, copy editor or sub editor to edit copies and to crop pictures. Chief Sub Editor ensures that copies are judiciously distributed among the sub editors and also ascertains that the copies are edited properly and that they conform to publication style and editorial policy. He may initiate or reply to correspondence regarding material published or being considered for publication. A chief Sub-editor monitors the pages of a publication and sorts through the articles to decide on those that will be included. Advertisement department too interacts with him or her.

The Chief Sub Editor sanctions leave of his juniors and makes daily duty chart with one or two weekly offs and sends this to news editor for final approval.

If the news editor is the supremo, the chief sub editor is the actual incharge in his absence and during night shift when editor leaves.

He ensures that copy flow is smooth and sub editors are assigned equitable copies for editing. He looks at the copy, at the headlines and ensures that stories are not defamatory in nature.

The chief sub also ensures that deadlines are met and edition is sent to press for printing on scheduled time.

Sub Editors or Copy Editors

The sub editor or copy editor is described as "the midwife to the story" and "an unsung hero of a newspaper". Sub editors work on the copy prepared by reporters. They have no direct involvement in news events. Still they make the copy attractive.

The sub editors or copy editors work under chief sub editor and sometime directly under the news editor. He or she select news events, removes unnecessary parts and arranges available information in order. He/she has to check and recheck facts, style, grammar, etc. while editing a story in newspaper. They are also required to put suitable headlines for each story. A good copy editor is an intelligent reader, a tactful and sensitive critic. As the saying goes "any fool can write, it needs a heaven born genius to edit". The trainee sub editor or trainee copy editor is generally fresher, directly recruited from a college or university and becomes regular copy editor or sub editor after the training ranging between six months to one year.

They are the foot soldiers in the Army and the newsroom is like a battlefield where they rush against time. Though sub editors and copy editors are the unsung heroes of journalism, no editor, news editor or chief sub editor can ignore their importance. They learn the hard way the Quark Xpress and other softwares like Adobe Photoshop etc to bring out perfect layout and flawless copies.

Proof reader:

A proofreader checks typeset proofs and/or computer printouts to detect errors in typesetting or keyboarding before the final printing of a publication. These days in most newspaper organizations the post of proof reader has become redundant. Earlier proof reader used to read copy after printing. Now technology has made this redundant and the sub editor or copy editor performs this job as well.

Reporters and Freelancers

Reporters are people who know how to dig out information whatever the source and no matter how hidden or obscure it is. A reporter gathers news and writes for his/her organization. A newspapers reputation and credibility depends on the reporters. A reporter should have a nose for news, i.e., an understanding of news and news values and the ability to recognize a story when it comes along.

Reporting is the center of any news organization, and newspaper reporters have one of the most storied and iconic jobs in media. News collection and reporting involves building rapport with trusted sources, developing story ideas for the editorial staff to evaluate and writing professional-quality content often on tight deadlines.

Reporters should be skilled at:

1. Seeing and hearing. Should have nose for the news
2. Taking notes or recording the conversation.
3. Finding information from different sources.
4. Asking questions at interviews and press conferences.
5. Checking and verifying information and then cross checking the same.
6. Analyzing and interpreting information. Going into depth of the story. Besides these skills reporters should also possess such qualities as alertness, curiosity, speed, punctuality, integrity, tactfulness, fearlessness and clarity of mind with knowledge of law of the land and constitution.
7. Speed would add to his qualities as breaking stories demand work at fast pace.

Freelancers

Freelance journalists are not attached to any newspapers or magazines. One who writes on all kinds of topics in several newspapers and periodicals without having a regular payroll is known as freelance writers.

Freelancers quite frequently keep in touch with media organizations and do assignments as per their needs. With a view to meeting their needs, freelancers have to complete these assignments as per the schedule of the publications.

Virtually, anybody can be a freelance writer. You must have the grit, determination and willingness to work hard besides possessing a good language.

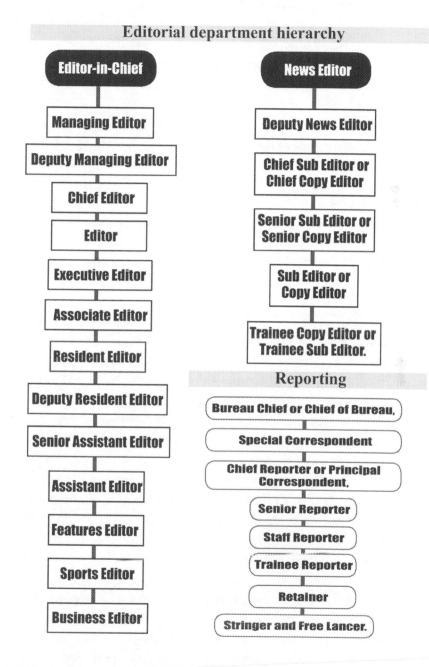

Editorial department hierarchy

Editor-in-Chief
- Managing Editor
- Deputy Managing Editor
- Chief Editor
- Editor
- Executive Editor
- Associate Editor
- Resident Editor
- Deputy Resident Editor
- Senior Assistant Editor
- Assistant Editor
- Features Editor
- Sports Editor
- Business Editor

News Editor
- Deputy News Editor
- Chief Sub Editor or Chief Copy Editor
- Senior Sub Editor or Senior Copy Editor
- Sub Editor or Copy Editor
- Trainee Copy Editor or Trainee Sub Editor.

Reporting
- Bureau Chief or Chief of Bureau,
- Special Correspondent
- Chief Reporter or Principal Correspondent,
- Senior Reporter
- Staff Reporter
- Trainee Reporter
- Retainer
- Stringer and Free Lancer.

Photo Journalism

In the early twentieth century, the newspaper industry overcame the technical hurdles to perform mass publishing of photographs in periodicals.

This happened approximately in concurrence with the development of reliable camera technology, and photojournalism has been a mainstay of newspapers ever since. Photography departments of a newspaper assign and coordinate with photographers in the field to shoot subjects relevant to the timely print coverage from the editorial team. Photo editors select and edit images from the field and assist in page design for a particular story. Photography is occasionally a source of controversy in a news operation. In particular, photo-editing software like Photoshop introduced to the profession new capabilities, as well as ethical quandaries.

Information Graphics

Newspaper stories often feature informational graphics to help the reader understand aspects of the story. Graphics appear in print, and online they can take advantage of interactive web technologies. An information graphic can contain different kinds of charts and data visualizations, maps, photographs or even audio and video.

Space Selling, Accounts and Business department

The second important department in a newspaper is the business department, which earns revenue for the newspaper. It is divided into two main division- advertising and circulation.

The advertisement department may have further sub-divisions such as advertisements for local display, classified advertisements etc. It may also have a research bureau and an art section to help in the preparation of advertisements. Traditionally, subscriptions generate much of the revenue for newspapers, but the Internet has undermined the subscription model and increased the importance of print and online advertising. Advertising sales in newspapers rely on knowledge of circulation and readership statistics, as well as negotiations about ad placement and page design. For online ads, sales may involve coordination with technical teams to accommodate specific client requests, as well as knowledge of the newspaper's web metrics such as page-views and bounce-rates.

The sales performance management function sets goals and key performance indicators for the sales team based on company objectives. They are responsible for defining sales quotas, territories, profit-based sales targets, sales forecasts and maintaining a high level of performance within the sales group.

Traditionally, subscriptions generate much of the revenue for newspapers, but the Internet has undermined the subscription model and increased the importance of print and online advertising. Advertising sales in newspapers rely on knowledge of circulation and readership statistics, as well as negotiations about ad placement and page design. For online ads, sales may involve coordination with technical teams to accommodate specific client requests, as well as knowledge of the newspaper's web metrics such as page-views and bounce-rates.

The circulation department deals with the dispatch of copies to the city and beyond the city through road, rail and air. It may also have a promotional wing to boost up the circulation of the paper.

Mechanical department

The mechanical department generally is divided into four parts-composing, engraving, stereotyping and press. In the first, the copy is set into type. The engraving wing is concerned with photos and drawings and makes cuts for printing. In the stereotyping room, the plates for the press are cast in the molten metal from the page form. The papers are printed, folded, trimmed, counted and delivered to the mailing section by the press room.

The bigger newspapers have also separated administrative or coordinating as well as promotional departments. The administrative department looks after administration of different departments while the promotional department deals with all the promotional work in respect of advertisements and circulation. Also it helps to build up the image of the newspaper and endeavours to earn goodwill and understanding of the clientele.

The newspaper is an organization where cadres are fixed. Unlike any other organization newspapers are different in functioning because of the time limit it has, there is a chaos in the organization, everyone in busy in its work. To maintain the speed of the work and proper functioning of organization even newspaper need a structure, this organization structure differ from one organization. That means there are very few chances that two organizations have similar structure.

Chapter XIV

HISTORY OF PRESS IN INDIA

Pre-independence period

1456

Gutenberg was the father of Printing Technology in medieval India. Calligraphy flourished during this period. Christian missionaries brought printing technology to India to convey news to public through books, dictionaries, Bible translation. Daily news was published and conveyed in small pictures during this period.

1556

First printing machine was set up in Goa on September 6, 1556. In year 1557 first book 'Doutrina Christ' was published by St. Francis Xavier. The evidence of the art of printing first entering India through Goa is found in a letter to St. Ignatius of Loyola, dated 30 April 1556 where in Father Gasper Caleza speaks of a ship carrying a printing press setting sail for Abyssiniafrom Portugal, with the purpose of helping missionary work in Abyssinia. Circumstances prevented this printing press from leaving India, and consequently, printing commenced in India.

There is strong evidence that the use of the concept of mass duplication in India dates back to the time of the Indus Valley Civilization. Grants of land were originally recorded by engraving the information on copper plates and etchings on different surfaces like wood, bone, ivory and shells.

However, printing arrived about a hundred years after the Gutenberg Bible was first printed. When the Viceroy of Goa, on behalf of the King Joan III of Portugal, opened schools for Indians, Francis Xavier pressured Portugal to make printing presses available in India and Ethiopia. Acceding to the request, the printing press was sent to for Ethiopia on March 29, 1556 by a Spanish ship. The route from Portugal to Abyssinia then required ships to touch Goa and reach Abyssinia. The press thus reached Goa, but soon after, news reached Goa that the Abyssinian Emperor was not keen on owning a printing press. Around the same time, the clergy in Goa felt the need for a printing press and on their request to the then Governor-General the press was made available to them. Thus, the press stayed in Goa.

1578

The first book 'Doutrina Christ' was translated in Indian languages. This year the second printing press set up in Coramandal Coast and 'Flos Sancprum' newsletter was printed on it. The following year, the third printing press was set up in Bombay where 'Bhimji Parekh' was printed. The fourth printing press came up in Kerala where 'Tamil Portuguese Dictionary' was printed. The fifth printing press came up in Thanjore district in Tamil Nadu.

1823

Press Regulation –1823 imposed by British Government in India to control newspapers. The regulation was used as a tool to deport James Silk Buckingham, Editor of Calcutta Chronicle. Raja presented a petition to Supreme Court to protest the regulation in favour of J.S. Buckingham. It was his bold step for the preservation of press freedom, however he defeated the case. Anti reformists Hindu fundamentalists published Samachar Chandrika weekly to challenge Raja's social reforms. Raja passed away in 1833.

Amrit Bazar Patrika inspired freedom fighter Lokmanya Tilak to start Kesari in Pune. He used Kesari to build anti-cow killing societies, Ganesh mandals and reviving the Chhatrapati Shivaji cult. He used mass communication as a powerful political weapon.

1878

In 1878 'Hindu' monthly started by six people - G. Subramania Aiyer, M. Veeraraghavachariar, T.T. Rangachariar, P.V. Rangachariar, D. Kesava Rao Pant and N. Subba Rao Pantulu. Alongside, The Hindu (1878 Chennai),

Keshari (marathi) and The Maratha (English) (both in 1878 from Pune by veteran freedom fighter Balgangadhar Tilak) came up. The pioneer Indian Journalists of this era included Bal Gangadhar Tilak, Mahadev Govinda Ranade, Dadabhoi Naoroji, Gopal Rao Hari Deshmukh, Vishu Shastri Pandit, Karsondas Mulji and Bal Sashtri Jambhekar.

The same year, British Government enacted Vernacular Press Act-1878 to suppress Indian language newspapers.

1881 (emergence of The Tribune)

On February 2, 1881, The Tribune, a leading English language daily newspaper published from Chandigarh and four other centres-New Delhi, Jalandhar, Dehradun and Bathinda started initial publication from Lahore, now in Pakistan. It was founded by Sardar Dyal Singh Majithia, a philanthropist. Considered voice of the people, it is run by a Trust comprising of eminent personalities having distinguished credentials. The Tribune which has been a witness to history, now has two sister publications viz Dainik Tribune and Punjabi Tribune. The internet edition of the Tribune was launched in July 1998.

After partition, The Tribune resumed publication after suspending it for 40 days. After the Partition, the first issue of the paper appeared from Shimla on September 25, 1947. The newspaper was looking for a suitable place for its publication. Amritsar, Ludhiana Ambala city were considered for the same. Eventually, Shimla was chosen. After his return from Kashmir, Rana Jang Bahadur Singh resumed his duty as Acting Editor and The Tribune started publishing from Simla. The location of The Tribune printing press in Shimla caused immense difficulties regarding its supply, delivery, and circulation in Punjab and Delhi. It was then shifted to Ambala from where it resumed publications on May 13, 1948. After publishing The Tribune from Ambala for about 21 years, the trustees felt that the right place for The Tribune's further growth and expansion was Chandigarh, the newly built town and the state capital. Subsequent editions came subsequently.

1883-1889

In 1883 Hindu published as Tri-weekly (Monday, Wednesday and Friday evening). In 1885 the Indian National Congress was founded with A.O. Hume as the founder. The INC was led by many nationalists like Surendranath Banerjee, Balgangadhar Tilak, Dadabhoi Naoroji, Motilal Gosh, Bipin Chandra Pal and G. Subramania Aiyer who were active journalists as well. After

its coming into being, the Indian National Congress, the Indian press became an important part of struggle for India's freedom. The Hindu supported the government activities and gave it wide coverage. In 1889 the Hindu was made a daily newspaper.

1900-1910

In year 1900, the 'Bangalee English Daily' by Surendranath Banarjee commenced publication. A year later in 1901, New India English Weekly by Bipinchandra Pal was launched. The same year in 1901, Bande Mataram, Bengalee weekly by Bipinchandra Pal came into being. In 1906, Yugantar, Bengali daily by Barendra kumar Ghose was started. In 1909, Leader by Madan Mohan Malviya was launched.

By this period, the English and vernacular press had become pretty professional. Political leaders and social reformers were regular contributors to newspapers. Some prominent writers of the time were C Y Chintamani, G A Natesan, N C Kelkar, Phirozshah Mehta and Benjamin Horniman.

This period also saw sanctions against the Indian Press. The Viceroy Lord Curzon was against the Indian Press and as such during this period, a number of legislations and acts were done against the media. In 1907, there were series of arrests and prosecutions against the journalists. India Press Act 1910 was heavily tilted against Indian press and had imposed heavy security deposits. As many as 963 publications were prosecuted under this Act. This led to at least 173 new printing presses and 129 newspapers closing down their publications in view of heavy security deposits that had been made mandatory.

1910-1913

In 1910 USA, started 'Associated Press' news agency and it launched it in India as the 'Associated Press of India'. New India by Annie Besant and Bombay Chronicle by Phiroj Shah Mehta were launched in 1913.

1915

In 1915 Mahatma Gandhi returned from South Africa and started a chain of newspapers, 'Young India' and 'Navegiean' weekly in Gujarati. His writing styles were simple and clear to the readers, hence unity and liberty spread among Indians. Gandhi's disciples started the same newspapers in other languages in India and took part in freedom struggle. The newspapers were thus the mouthpiece of freedom fighters.

Same year, 'Free Press of India', the first news agency was founded by Indians. It's fully concentrated on Indian news. It was during this period that British Government implemented strict laws to control the news agencies growth. Due to the law, 'Free Press of India' moved over to become a newspaper in the aftermath of news laws.

1916

In 1916, Home Rule League was established by Annie Besant and Bal Gangadhar Tilak. She started 'Madras Standard' and renamed it as 'New India'. New India came with full page editorial; news reflected the nation and freedom struggle. Her writing and ideas of editorial were appreciated; she involved herself in print medium.

1918

In 1918, Motilal Nehru started the Independent of Lucknow as a newspaper of extreme Indian opinion. The Home Rule Party started Young India, which later became Mahatma Gandhiji's mouthpiece. As more on of emergency in the country. During emergency, 35 printing presand more locals started learning English, many became reporters, editors and even owners. The Anglo-Indian press began to lose ground except in Bombay and Calcutta.

In 1918, Justice by Dr.T.M.Nair, Searchlight, and English biweekly by Shachindranath Sinha also commenced publication.

1919

In 1919 government introduced Rowlett Act which empowered Government to arrest people without trial. Annie Besant sharpened her arsenal and fought for the freedom of press through her writings in the newspapers. In 1919, The Independent by Pandit Motilal Nehru and Young India by Mahatma Gandhi began publication.

1920

In 1920, Annie started National University to bring discipline in journalism. Little doubt she is referred to as the 'Torch Bearer of Indian Liberty' and 'Pioneer of Journalism'.

This period also saw setback to newspaper industry due to the outbreak of First World War. Printing costs were increased leading to sharp slide in the

newspaper subscribers in India. The year 1920 also saw the emergency of Nav Jeevan, a Gujarati weekly by Mahatma Gandhi.

In 1922, Swarajya by T.Prakasham began publication while a year later, Forward by Chittaranjan Das was launched.

1923

This year saw the coming of being, a major English daily, the Hindustan Times then edited by K.M. Panikar, which incidentally was the first daily newspaper of Delhi.

1927

In 1927, industrialist G D Birla took over Hindustan Times and placed it on a sound financial footing. In the same year, S Sadanand started the Free Press Journal, a newspaper for the poor and the middle-class in Mumbai. Newspapers in this period started reflecting popular political opinion. While big English dailies were loyal to the British government, the vernacular press was strongly nationalist.

After 1827 Indian press was vertically divided into two groups, the one supported by Indian freedom fighters and the other by the Anglo-Indian Press supported by British.

1929-1932

In 1929, Liberty by Subhash Chandra Bose came into being. In 1930 many newspapers joined hands to form 'United Press of India'. In the year 1932, 'Harijan', a Gujarati weekly with Mahatma Gandhi as its Editor was launched.

1938

In 1938, 'National Herald' newspaper was started by INC; it's fully supported the INC activities. Jawaharlal Nehru, who after independence became India's first Prime Minister, was the Editor of the National Herald.

1940

In 1940's, Indian Eastern Newspaper Society came into being. Now it's Indian Newspaper Society, it acts as a bridge between newspaper organization and the government. News prints were allotted by the government according to the requirement of newspapers. - Vernacular press came into play to develop the Indian languages.

1941-1942

In 1941, 'Dina Thandi' Tamil newspaper daily was launched with its first edition from Madurai. Heavy restrictions imposed on Press during Quit India movement of 1942. However, major newspapers continued publication of their editions defying restrictions imposed by British Government. These newspapers carried stories about the arrests of freedom fighters, treatment meted out to them and reports of demonstrations and protests against the British.

Post Independence

1947

After partition role of press changed considerably as before independence, press was either supporting the freedom struggle or siding with the rulers. However, in the post independence scenario press was absolutely free and was raising issues concerning common people.

After partition of India and Pakistan, six radio stations came up in Bihar, Calcutta, Delhi, Trichy, Lucknow and Madras. Newspapers too came up in different parts of the country.

1950

After India attained independence, Delhi edition of the times of India was launched in 1950 with K. Gopalswami as the first Indian Editor.

1951-1952

The Press (Objectionable Matters) Act was passed. The press covered extensively the first national election held during this period. The following year, the Press Commission, 1952 gave its Recommendations for a Press Council, Press Registrar and minimum basic salary for working journalists and strengthen the role of the editors etc. Filmfare, a magazine from the Times of India group was launched in 1952.

1955

The Working Journalist Act, 1955 enacted. The comprehensive Act explains in details about the working conditions, the service conditions and rules governing Working Journalists in India. Till date, all journalists working in India are governed by this Act while non-journalists working in newspaper

industry are covered under labour laws; the Working Journalists have the benefit of both the Working Journalist Act and the Labour Laws. The next year The Newspaper (Price and Page) Act, 1956 comes into being.

1954-1959

In 1954, the appointment of Press Registrar and setting up of Press Council of India recommended. In 1956m the Press Act was allowed to be replaced. It was during this year that the first Press Commission was set up. Femina, a magazine from the Times of India group was launched in 1959

1961

Six newspapers joined hands to form 'Press Trust of India', the leading news agency of India. The 'United News of India' also came into being in 1961. The same year in 1961, top business daily, the Economic Times from the Times of India group was launched.

1964

A Committee of Broadcasting and Information Media was set up under the Chairmanship of A.K.Chanda.

1966-1967

Like an Ombudsman, the Press Council of India was established in the year 1966 by the Indian Parliament on the recommendations of the 1st Press Commission to preserve the freedom of the press and of maintaining and improving the standards of media in India. It is headed by a Judge of the High Court and has members drawn from media houses and journalist associations and eminent journalists. The present Council functions under the Press Council Act 1978. It is a statutory, quasi judicial body which acts as a watchdog of the press. It adjudicates the complaints against and by the press for violation of ethics and for violation of the freedom of the press respectively.

In subsequent year, 1967, two independent Corporations were formed for Radio and Television. Vividh Bharati, the commercial wing of All India Radio was also formed during this year. Commercials were introduced initially in the Vividh Bharati Service in 1967 on an experimental basis. Realising the role of advertising in accelerating the social and material progress of the country, commercials were extended to AIR.

1975

The then Prime Minister, Mrs Indira Gandhi imposed internal emergency in India. There was a complete clamp down and over 10,000 people were arrested who opposed imposition of emergency in the country. During emergency, 35 printing presses were seized.

Emergency was a shocking blow to the freedom of press because it ignored the press freedom guaranteed by article 19 (1) of the constitution. Heavy censorship was imposed during the emergency period under Defence Rule "in order to maintain public order". During 19 months of emergency 253 journalists detained and 7 foreign correspondents were expelled during emergency.

Bold newspapers either carried blank pages in the place reserved for editorials or defied government restrictions or published these newspapers. Rajmohan Gandhi's Himmat defied the press censorship and launched a campaign against the emergency. Similarly, the Indian Express, Statesman, Freedom First and other newspapers vehemently opposed emergency.

1976-1977

Doordarshan, the Government owned Television channel commences functioning. The next year in 1977, the Janta Party Government appoints a working group for media.

1982

Second Press Commission recommends delinking of Press from other industries. Same year, National Development Commission recommended to be set up.

1986

In 1986, the Times of India and Navhharat Times, the Hindi daily from the Times of India group were launched from Patna.

1987

The then Prime Minister, Rajiv Gandhi tried to bring Anti-Defamation Bill but thanks to strong opposition by media persons, he had to withdraw the same.

1988-1991

In 1988, The Times of India celebrated 150 years of its existence. In 1991, British Broadcasting Corporation says that the Times of India is among world's six largest newspapers.

1994

Attempts were again made to gag the press when V.N. Gadgil, former Union Minister of Information and Broadcasting introduced Right to Reply Bill but in view of strong opposition, it met the fate of Anti-Defamation Bill.

In year 1996, the Times of India crossed one million mark in circulation. In year 2000, the Times of India reached two million mark in circulation.

2009-13

In year 2009, the Times of India group launches ET Now, a business news channel. Editions of the Times of India at Nagpur, Goa, Chennai had already been launched. In 2011 saw launch of the Times of India, Coimbatore, Madurai, Trichy and Punducherry editions. Next year 2012 saw launch of Kerala, Visakhapatnam, Aurangabad and Raipur editions of the Times of India. In 2013 the Times of India launches Kolhapur edition.

2015

By 2015, the company had 16 publishing centres and it claimed that the Times of India had become world's largest English-language broadsheet daily in terms of circulation while the Economic times had become, country's largest financial daily, and the world's second largest in terms of circulation after the Wall Street Journal.

Role of press in India's freedom struggle

Press marched shoulder to shoulder with 'satyagrahis" and freedom fighters. Mahatma Gandhi had raised the demand for the freedom of speech and expression. Mahatma Gandhi would not accept advertisement and government support and firmly believed that newspapers should survive on the revenue from subscribers as sale of copies. At the same time, he was against any restrictions imposed on the newspapers. His writings were widely circulated and reproduced in the newspapers all over the country. The masses

had declared non-cooperation movement against British rule in India and Indian press fully supported it. When Gandhi declared 'Salt Satyagraha' in 1930, the nationalist press played a memorable role, which perhaps is unique in the history of any freedom movement.

Chapter XV

NEED FOR SENSITIVITY IN MEDIA

The Indian media has grown rapidly in scale, dimension, reach, impact, influence and advertising revenues and a successful business model as well. In the early years and particularly before Independence, the motive of newspapers was to arouse public sentiment and motivate masses to join freedom struggle. It changed a lot after India attained Independence.

It is at this stage that all stakeholders have to understand and realise that the ethical underpinning of professional journalism in the country has weakened and that the corrosion of public life in our country has impacted journalism. So what needs to be done to check media credibility?

In the sixty seven years of independence, the position of media has taken a radical shift in India. The ingrained transformation of the Indian society during its journey in the last seven decades, especially in the post-globalization period, has left an indelible mark on media. This has placed new challenges before the Indian media which it had never before faced. Challenges, no doubt, were there even before. The earlier challenges were mostly in the form of regulations and attempts to gag press but the newer challenges are in the form of paid journalism, commercialisation of news and trivialisation of journalist and the But the character of those challenges kept on changing with the mutating socio-cultural-political context.

Media and freedom struggle were interlinked. The patriotic spirit of media persons cum freedom fighters can perhaps never had been seen in history before as in India. The Indian media had a sound complementary as well as supplementary role in the struggle for independence.

Media was like a mission and journalists were born missionaries. However, post globalisation, their role changed dramatically and journalists became more of professionals and journalism like any other profession. Subsequently the Foreign Direct Investment entered into all forms of media. There was much collaboration with foreign publications. Though the entertainment media industry has been the prime area of FDI, the other genres like print, electronic even radio industries are now becoming lucrative targets of FDI. Though many people focus on the expansion of facilities or creation of new geographic market to speak high about FDI in media sector, experience and apprehensions manifold several negative aspects. It is being felt that the uneven competition, haphazard and hurriedly done collaborations, may create hindrance in the blooming of several indigenous local media houses.

To add to this was the introduction of 'Contract' system in newspapers and other media houses. There are pros and cons of this system. The loss of job may be an area of concern. The conglomeration in the name of FDI, therefore, raises several questions for the experts in media. Several ethical issues also appear thereafter. Commoditisation of the media industry, many opine, is pushing the role known as social responsibility far behind. Researchers may find the area interesting to go for an in-depth study. The trivialisation of news, erosion of the authority of Editor and paid news has done irreparable damage to this great institution.

The fast changing ownership pattern may also be another important genre to be handled. The aim of this particular issue is to look into these diverse angles in those discourses.

Post internet era

Journalism is a different ball game post internet. As it is, having a journalism degree pre-internet is like having a degree in under water basket weaving. While the ethics are constant, it's just a different world now and it seems criminal to use these outdated textbooks. Indian journalism students deserve better. It was mentioned that journalists were trained on the job in India in the old days by sitting on the bench at a newspaper while getting hands on training. Now, this training has been converted into a business.

Most media houses have now set up their own media schools. This kind of profit driven training is along the lines of the grab money and push them out model that is the trend with most training programs today. With no uniform curriculum this method too fails the Indian journalism student.

There are instances of yellow journalism and ethical issues had been coming up in many ways. Infotainment plagues the local language media more than the English media. Very few working journalists in local language media appear to have formal university-type training. There are many stringers whose sole qualification is location. Many also serve as advertising agents for the publication. Salary disparities exist between the English and local language media staff. Advertising revenue, too, is higher for English papers as opposed to local language papers despite greater readership. We can't blame stringers alone because they get peanut from media houses as such they have to double up as advertisement collection agents. All this highlights the greater issue of English elitism and the associated prestige at the cost of our local languages and the many who speak them.

Problems of media in fact reflect the problems of today's India.

The way out

How the media, while having to report on violence, conflict and bloodshed, should go beyond short-term goals, and tell stories that connect communities, foster unity and promotes development and peace is a question mark? Citizens as well as media professionals must strive to make media in India more real, objective, truthful, dispassionate, and last but not least socially responsible. Media is deviating from the laws, ethics and principles that it should follow.

Today the society demands a change. There is need to making the media more sensitive towards the aspirations of masses and their responsibility for all the stake holders related to media. The question of social responsibility in the media continues to be timely and topical. The Ministry of Information and Broadcasting has asked the Indian Press Institute to study the phenomena of "paid news" and come up with suggestions to counter this dangerous phenomenon.

On major newspaper has a tag line "Truth involves all of us" but sadly, the truth is being put to test and sacrificed almost daily in the many media houses. Speed and competition have reduced media's commitment to verify and counter check information. Accuracy has become a major victim in the age of instant communication. Today it is easy to plant a big lie or distortion along with truth and get some of the media audience to believe it.

This century has seen information explosion. The information glut or overload or quantitative increase in the news and information has considerably

reduced the possibility of being critical, of verifying facts and checking veracity of sources. Often the readers lack the time and wherewithal necessary to check and double check and verify what they read, hear or watch. There is urgent need for professional competence and social responsibility as essential requirements for media house and the media persons which will help in ensuring that they report events objectively and accurately.

Unfortunately, readers or viewers are left with the option of either accepting the lie as truth or suspend judgment and strives to look for other perspectives. It is not easy considering the fact that they do not often have the adequate tools to check the veracity of news and information concerning people and places which are far away from them. Even if such tools did exist, they are not fool proof due to many subjective factors under which media might undertake to do the verification. Normally the masses tend to trust the media, and therefore, the media must ensure that the trust the audience repose on it is not belied and taken for granted.

Media must care about the responsibility that it has towards the public, the responsibility of bringing the truth ethically and objectively without interfering in personal lives, or without hurting anybody's sentiments and the consequence of this is over-hyped news. Media is left with actually sensationalizing news. Giving out facts and details to the public which are not true or half baked or even worse, using them under the garb of paid news has become the latest trend. Time has come that we draw a line.

Sting operations these days are mere attempts to sensationalize news and gain television rating points (TRPs), increase the readership rather than highlighting legitimate public interest issues. They have become a source to fill in time-slots on 24-hour news channels which constantly need something on air and the extra pages in the supplement section of the newspaper or magazines. And they hardly follow the principle on which they are supposed to be conducted, which is to reveal the truth to the public about various concerning issues.

With this entire media has distanced itself from the common masses. Today's media looks for big, grand issues to be covered as news stories instead of stories at the grass root level. We hardly go to rural India to write about the plight of people who still live in miserable conditions. All this points to some unanswered questions – where are we heading to? Is media meant only for elite? Why isn't the media fulfilling its responsibility? Do we really need

strict laws and regulations? And why has it become so laid back? The media has very conveniently chosen to ignore all this and continues to be in a mess. It is high time now and we are in desperate need of media that becomes an effective instrument of social change and not one that ignores society altogether. Otherwise, media will be nothing but an industry or business like any other venture, which has no ethics, no essence and no responsibility.

The newsroom definition of "media ethics" can translate into the broader concept of "social responsibility", which is appropriate for the purpose of reasoning in sociological or legal terms. In dealing with media ethics, there is some confusion between the different terms: accountability, liability, responsibility, etc. Within journalism one could define accountability narrowly as being able to produce records, e.g. evidence to support what has been reported on. However, the meaning of this term is often extended to overlap with the concept of liability and responsibility: in other words, a journalist is also accountable in that he or she is held liable for the consequences of his or her reporting. Liability in this case can be taken to signify being ethically or legally responsible for one's actions; the concept of whether or not to consider journalists as being liable for their reporting hinges on the question of whether or not their profession entails a social responsibility.

Responsibility is in this sense the obligation for proper custody, care and safekeeping of one's audience. More specifically, social responsibility entails the necessity for the journalist to keep society's interest as a top priority. This can also be seen as a collective responsibility or public interest responsibility. The social responsibility of media is an extremely important issue and that to in a developing democracy like India. In a diverse country of 1.2 billion people, there are bound to be differences in opinion, preference and taste, in attitude and ideology and in language and political likings. The plurality of our society is reflected in the diversity of our media. Media has a significant and indispensable place in our lives. But there is urgent need to sensitise media and to make it accountable through self-regulation.

Chapter XVI

YOGA AND SPIRITUALITY FOR MORE POSITIVITY IN MASS MEDIA

Mass media

Next only to teachers, journalists have the noblest profession called mass media. In fact, journalists are a step ahead of even teachers because they are both teachers and preachers. They create an impact on the lives of readers and on the lives of masses in view of credibility of media and its wide reach.

But unfortunately many journalists are experiencing the downside of consumerism early in life. A young journalist recently confided that she has enjoyed everything and now has nothing to live for. News organizations and journalism groups are beginning to widely acknowledge that many photographers, reporters, and cameramen do not come away from trauma-filled assignments emotionally unscathed. New research, including a study released in April, found three in 10 journalists suffer post-traumatic stress after working on dangerous assignments. Depression, anxiety, alcoholism, and relationship problems have also been reported.

Journalism, by definition, is a stressful profession. Ask any reporter who has worked on deadline, reported on conflict or crime, or lived and worked in a war zone or disaster area. The demanding nature of the job, coupled with issues outside of work, can make it difficult to cope. All journalists are constantly negotiating stress in both positive and negative ways. There's a point where stress becomes overwhelming and performance declines."

In the wake of major natural disasters, journalists are often caught in the middle. It is upto journalists to tell stories about what's happening, and that requires them to sometimes continue functioning even when the world is falling down around us.

It does not affect only the journalists covering the event but also the readers and viewers. The fact is that there are many people who are unable to resist news coverage of traumatic events, such as disasters and terrorist attacks. As horrific as they are to watch on television and read about in newspapers and magazines, many still find it nearly impossible to turn away. It is difficult to know why the information is so hard to resist. Some say that people are hoping for information because they are fearful of future events and want to be prepared; others say that people are watching and reading in an effort to digest and process the event; still others say the media is intentionally creating seductive and addictive images almost like those seen in an action movie.

Whatever the reason, it is important to understand the effects on the community that this type of exposure may have. Research generally finds an association between watching media coverage of traumatic events and stress symptoms. However, most studies cannot answer the important question of whether watching television of the event makes people worse or if people who have more severe stress reactions are the ones who choose to watch more television coverage of the event.

Now new and online media networks are growing at a fast pace. Some are modelled on traditional news models, while others bring together journalists as a community of stringers. Journalists in the latter category often work without the institutional support, including insurance and legal backing that many staff journalists have long enjoyed. In this changing and dangerous climate, be guided by some basic principles: Be fully informed about security issues, make your safety a primary consideration, prepare yourself thoroughly for each assignment, look out for other journalists in the field, and take care of yourself before, during, and after assignment.

And they way out

Once you acknowledge that stress is an occupational hazard for journalists, it can free you up to take stock of the things you can control. One of the gravest hazards of stress is that it can lead to a downward spiral health-wise. It's particularly important for journalists to take care of themselves physically.

That means that no matter what's happening in your personal and professional life, you should still strive to eat well, get enough rest, take enough breaks from working and get exercise. The aerobic exercise is particularly associated with resilience.

Media organizations have long made counselling available to staffers, but analysts say newsrooms have been slow in adopting the extensive trauma support and training long used by other "first-response" organizations such as medical care and disaster relief agencies.

Now, several large news companies say they have begun more sophisticated and proactive programs to support staffers exposed to trauma. Many of these efforts have dangerous assignments. Depression, anxiety, alcoholism, and relationship problems have also been reported. A study of 140 combat journalists -- titled "A Hazardous Profession: War, Journalists, and Psychopathology", concluded that nearly 30 percent of the participants showed serious signs of post-traumatic stress. They were not likely to get treatment, either. Across the world journalists in conflict zones face extraordinary stress and personal danger but there is a hope.

Spirituality can enable the latent idealism to flourish. Many see in it a way to forge bonds and eventually transcend differences altogether. In the absence of credible role models in today's world, coming in contact with a guru who has an inspiring conduct and personality can have a powerful influence on young people and their morals and value system. Balance, equanimity, and kinship with fellow humans, these are the weapons with which today's youngster connects. Body and mind are somehow connected to one another. Therefore, to have a sharp and intelligent mind, we need to have a healthy physical body. Regular physical exercises not only detoxify the body from used up energies, toxins and waste materials, but it also helps to increase the blood and energy circulation. Meditation in general helps to calm emotions and clear thoughts. It increases both the clarity and sharpness of the mind.

Meditation as an effective medium to wipe out doubts and it is a very powerful technique that can flush out the clouds of unfavourable thoughts and emotions by bringing down tremendous amounts of divine energy to the system. Meditation can create positive effects on the brain and nervous system by improving memory, focus and clarity. Then the more we think positive, the more blissful and happy we are and so is our writing and the mass media.

Positive feelings nourish the soul. Negative emotions and thoughts clog the aura and contaminate our chakras, which in return clouds our perception and distracts our attention. Positive thoughts and emotions create a soothing and calming effect on the mind and body. Have you noticed that whenever we are positive, our minds get clearer and our attention gets focused? We even become more productive. In order to think clearly and become smarter, it is very important to regulate emotions and think positive thoughts.

Yoga brings immense positive energy, mental and physical health and inculcates spirituality. We come to know better of our inner self, with yoga and meditation. Yoga as we know is an ancient practice, honed by seers and sages in India for centuries. Yoga brings immense positive energy, mental-physical health and inculcates spirituality. We come to know better of our inner self, with yoga and meditation. Not only it brings good health, good thoughts and good lifestyle, but also binds different cultures and civilisations. It takes one through inner peace and eventually world peace too.

More and more journalists were now getting attracted to yoga and spirituality. They are interested in seeing nature, flora and fauna, learning yoga, doing meditation and turning to spiritualism for better and positive mass media.

We should understand that most of the problems that we face including journalists are due to bad and negative thoughts which need to be eradicated from its root itself. For this, yoga can be a very powerful tool to inculcate positive energy and thoughts. Spirituality that can be attained via yoga makes us mentally tough and positive. Spirituality is not only about religious rites or rituals but spirituality in itself is a way to live positively. That is the panacea for all the ills in the society and that can inculcate positivity in mass media to serve society with full gusto.

A Foundation Course conducted in Brahma Kumaris Raja Yoga Meditation centres across the world includes several main themes or lessons: Consciousness and Self-Realization, Our Home of Silence, Relationship with God, Law of Karma, Reincarnation, Eternal World Drama, Tree of Life and a Spiritual Lifestyle.

The topics covered in this course lead to a deeper understanding of yourself, your intrinsic positive qualities and your innate value. In time, this understanding becomes a natural part of your day to day awareness, constructively influencing how you see yourself and how you relate to your world.

In the process of exploring these universal concepts in the privacy of your own inner world through meditation, you will come to a firsthand awareness of the interconnectedness of the human family and the rights, roles and responsibilities of individuals. This is very important in your spiritual development and will give you a fresh perspective on values such as justice, freedom, respect and love.

The concepts presented in this course are simple yet profound and are accessible to individuals of all backgrounds and beliefs. Simple and honest effort is the only prerequisites for success in meditation. As in any field of endeavour, the rewards of meditation and spiritual study are in proportion to the time and effort you invest. The Foundation Course in Raja Yoga Meditation is offered at all Brahma Kumaris centres free of charge. Each course consists of a series of lessons, generally held once a week. The course is taught on an individual basis or in small groups.

There are some ways to control stress which included taking a deep breath and muscle relaxation methods to take control of the situation, regular physical exercise for thirty minutes per day, getting connected with people, sharing problems, and by devoting time for oneself, on things that one enjoys doing.

A problem shared is a problem halved. The journalists should find more time to do what they enjoy the most and by challenging themselves to do new things like learning a new language, music, painting or by doing well to others. Progressive muscle relaxation, breathing exercises, meditation and yoga will help stressed journalists to relax.

About the Authors

Charanjit Ahuja

Charanjit Ahuja is a recipient of the prestigious National Award in Developmental Journalism that is awarded by the Government of Himachal Pradesh to only one journalist in a year who is chosen by a jury from across all states and union territories in India. Masters in English from the Panjab University, with Bachelors in Laws, Bachelors in Humanities, Post Graduation in Journalism and a Certificate Course from National Film and TV Institute, Charanjit Ahuja has worked with national dailies, both the Indian Express and the Financial Daily, The Financial Express as Sub Editor, Staff Reporter, Senior Staff Correspondent, Principal Correspondent, the Special Correspondent and has headed the Bureau for many years. He has taught journalism at Bharatiya Vidya Bhawan and DAV PG College as a guest faculty. As such he combines in him the experience of both business and general reporting and of teaching to make it a perfect blend of theory and practice. Thousands of his news stories and articles can be found and read in Google search(Charanjit Ahuja, The Indian Express/The Financial Express). Charanjit Ahuja can be contacted at charanjitahuja@gmail.com

Bharat Hiteshi

Bharat Hiteshi quit banking as a senior functionary to make forays into journalism. He began his innings as a TV journalist when he worked on script writing, anchoring, reporting and editing for a national TV channel. Then he moved to a national daily, the Hindustan Times to write for this newspaper. He also worked for a popular Hindi daily newspaper, the Punjab Kesari and made a name for himself in a short span. Finally he established himself as a columnist and wrote numerous articles/middles for national dailies like The Tribune and the Daily Post to name a few. He also penned scholarly articles for the prestigious magazine of Press of Chandigarh. His write-ups, articles and middles can be seen in any search engine with the link Bharat Hiteshi, The Tribune/The Daily Post/The Hindustan Times. Bharat Hiteshi can be contacted at bharathiteshi99@gmail.com

Printed in the United States
By Bookmasters